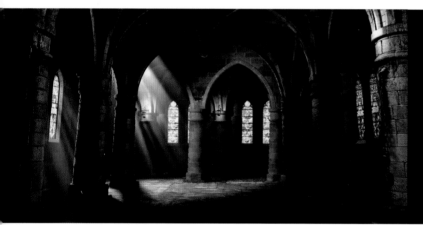

# How to Draw and Paint

# Fantasy Architecture

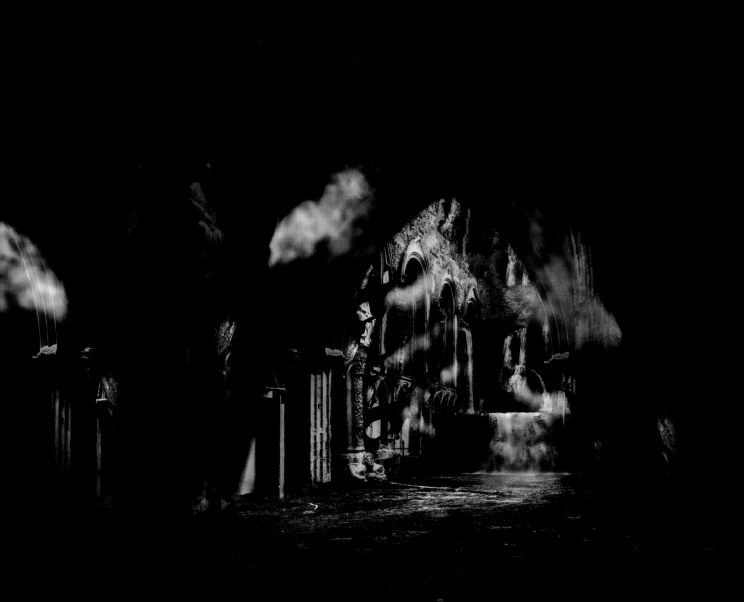

# How to Draw and Paint
# Fantasy Architecture

## Rob Alexander

**BARRON'S**

A QUARTO BOOK

First edition for North America
published in 2011 by
Barron's Educational Series, Inc.

Copyright © 2011 Quarto Inc.

All inquiries should be addressed to:
Barron's Educational Series, Inc.
250 Wireless Boulevard
Hauppauge, New York 11788
www.barronseduc.com

Library of Congress Control No.: 2010928093

ISBN 13: 978 0 7641 4535 3
ISBN 10: 0 7641 4535 5

QUAR.FREN

Conceived, designed,
and produced by
Quarto Publishing plc
The Old Brewery
6 Blundell Street
London N7 9BH

Project Editor: **Emma Poulter**
Art editor and designer: **Jacqueline Palmer**
Picture Researcher: **Sarah Bell**
Copyeditor: **Sally Macachern**
Proofreader: **Tracie Davis**
Indexer: **Richard Rosenfeld**
Art Director: **Caroline Guest**

Creative Director: **Moira Clinch**
Publisher: **Paul Carslake**

Color separation by Pica Digital
Pte Ltd, Singapore

Printed by Hung Hing Printing (China) Co., Ltd, China.

9 8 7 6 5 4 3

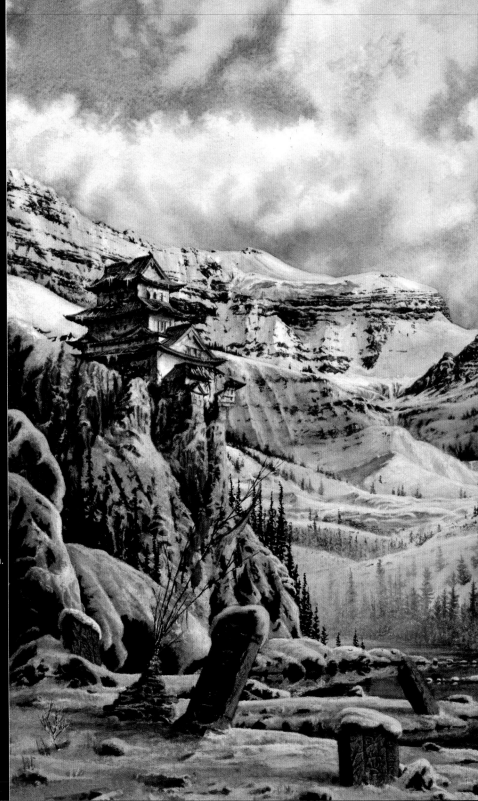

# Contents

# FOREWORD

I have always been fascinated by architecture, especially older styles of architecture. The thought of someone taking stone or wood, working it and shaping it, and fitting it all together to create something as magnificent as a Mayan pyramid, or the Hagia Sophia, Notre Dame cathedral in Paris, or the Naritasan Shinshoji Temple in Narita always made me want to reach for a paintbrush. I think it's the light. The way that great architecture becomes part of the environment, integrated with it, or dominating it, capturing, holding, or reflecting the light, so that what was complex, manmade, and possibly sterile or cold becomes instead majestic and awe inspiring. That sense of wonder has become something fascinating for me, something to capture and explore in everything I paint, and, ultimately, has led to the book you now hold. Study, enjoy, and let yourself fall in love with architecture the way I have.

Thank you to the wonderful artists who contributed to this book: names appear alongside work; all uncredited art is by Rob Alexander.

# ABOUT THIS BOOK

This book is about painting architecture for the fantasy and science-fiction artist. You probably know that already, and it's likely that was a factor in your picking up the book in the first place.

While it won't provide you everything you need to get through your first-year university architecture course, it will give you a very solid understanding of how some of fantasy arts' most influential architectural styles came about, why they look and work the way they do, what influences they had on other architects and artists alike, and provide the understanding you need to make use of real-world architecture in your own creations.

The book is written from a visual artist's perspective. Rather than compare minor nuances that distinguish German Gothic from French or English Gothic, the book looks at architectural styles in a broader sense to give you a firm knowledge of their most common forms, elements, and characteristics, and an understanding of their styles, the cultures that created them and the ways in which they tend to be used in fantasy and science-fiction art. It will not provide you with a handful of shortcuts to picture making, nor will it teach you one specific technique for painting. What it will do is teach you about architecture, about how and why the buildings look as they do, why they were built the way they were, and show you how to understand them in a visual, artistic sense so that you can create your own images from a position of knowledge, confidence, and understanding.

## The book is organized into four chapters

### CHAPTER 1: INTRODUCTION TO ARCHITECTURE
This chapter examines the basics of Middle Eastern, Romanesque, Gothic, Mesoamerican, Viking, Asian, and Modern or Futuristic architecture.

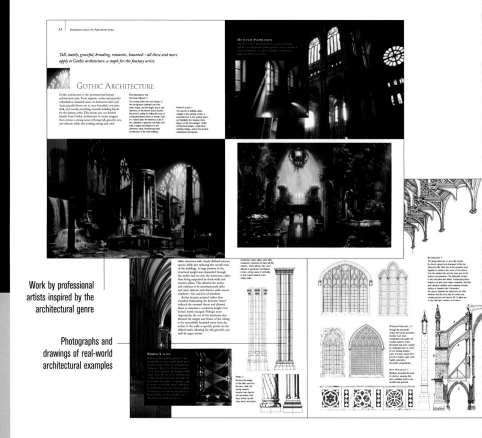

Work by professional artists inspired by the architectural genre

Photographs and drawings of real-world architectural examples

## CHAPTER 2: PICTURE-MAKING TECHNIQUES

How-to techniques slanted toward artists painting architecture.
Perspective, lighting, color theory, composition, mood, and
concept are all examined and explained as they relate to painting
manmade structures.

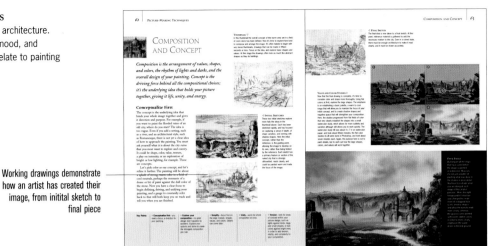

Working drawings demonstrate
how an artist has created their
image, from initital sketch to
final piece

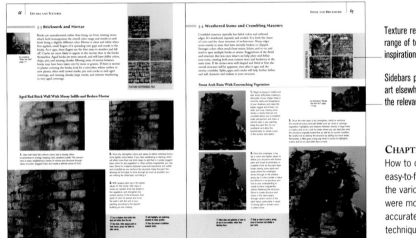

Texture reference files present a
range of textural effects as an
inspirational resource

Sidebars point you toward finished
art elsewhere in the book that uses
the relevant textures

## CHAPTER 3: DETAILS AND TEXTURES

How to draw and paint specific details, textures, and materials in clear,
easy-to-follow steps. Particular attention is given to understanding the way
the various forms look, how they age and weather, and what materials
were most commonly used as well as how they were worked and how to
accurately and convincingly draw and paint them, making use of the art
techniques discussed in Chapter 2.

## CHAPTER 4: CREATING YOUR OWN WORLDS

Look over the shoulders of some of today's best artists. Their working
methods are clearly explained with step-by-step examples that show you
their thought process, their creative process, and how they approached
their paintings. It's a rare chance to see behind the eyes of these artists
as they bring together all their considerable knowledge of history,
architecture, and painting techniques to craft something truly wonderful.

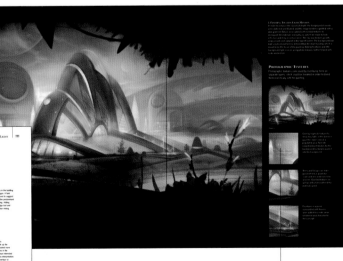

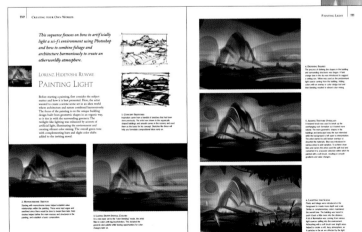

Panels identify key technical
aspects of the painting

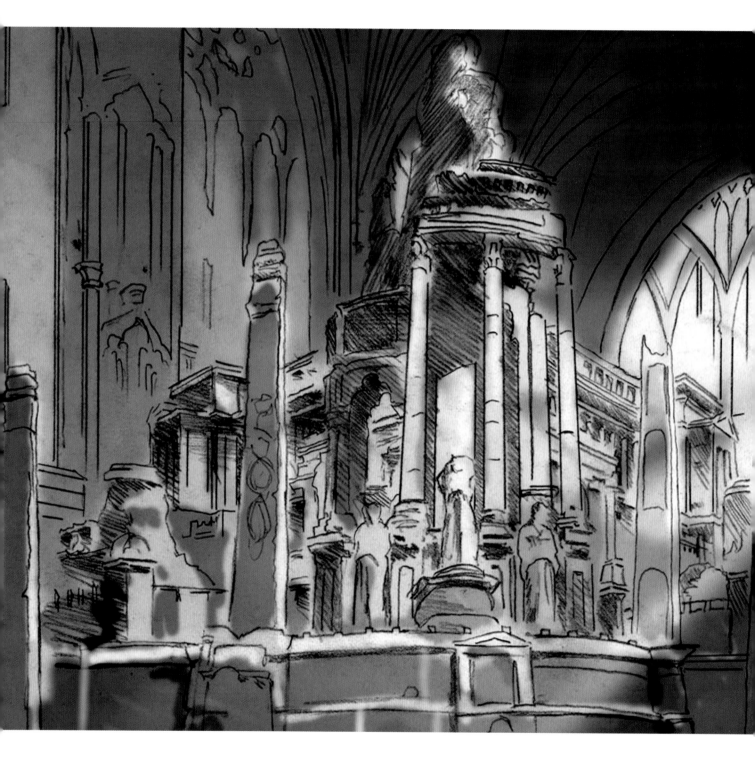

# CHAPTER 1

# INTRODUCTION TO ARCHITECTURE

*This is intended as a basic introduction to architecture, as seen through the lens of the fantasy artist. Details, history, methods, features, and construction are all discussed from the point of view of the artist who wants to understand the architecture from a visual perspective, in order to create his or her own fantasy worlds and buildings in a more convincing, realistic, and believable way.*

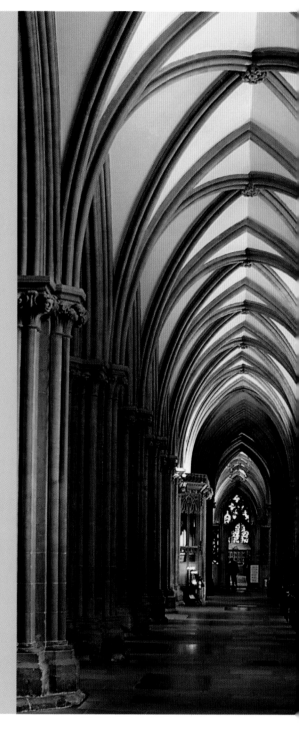

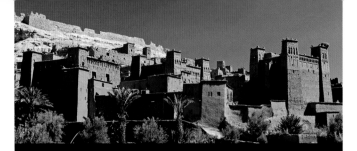

*Middle Eastern architecture refers primarily to the styles and designs of Muslim or Arabic architecture, and is distinct in being the architecture of a religion, rather than a region or empire.*

## DEFENSIVE LIVING

This is a typical "ksar," or fortified city, in Morocco. The houses are all joined into a single, central mass, often built into the side of a mountain for extra defense, with a single outer wall to protect it.

# MIDDLE EASTERN ARCHITECTURE

The Byzantine (New Rome) styles and ideas of architecture, which heavily influenced European architecture, eventually leading to the Romanesque style, also had a profound influence on Arabic or Middle Eastern architecture.

Combining Byzantine influences with those from Persia and Egypt, the architects of the Middle East developed a style markedly their own, with domed roofs, tall thin minarets, and large, open doorways decorated in bright colors and repeating patterns. The primary building layout is one of an open courtyard surrounded by four walls and covered arcades to provide shelter from the sun, with a flat or domed roof. This basic layout holds for houses, inns, mausoleums, and, most importantly, mosques.

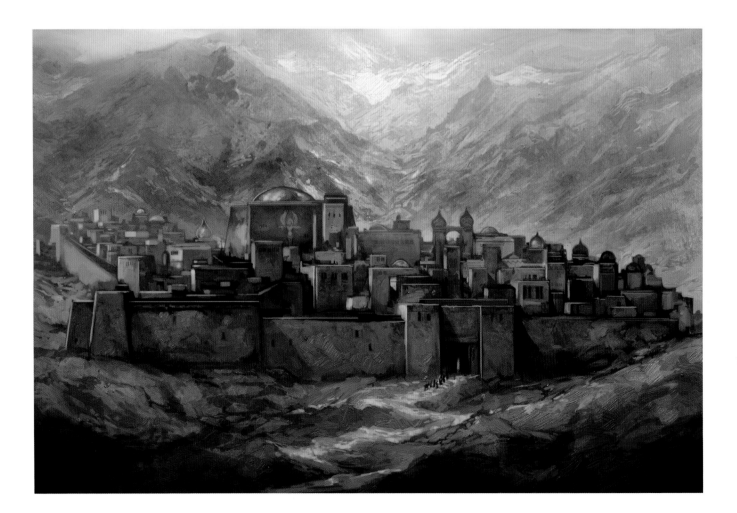

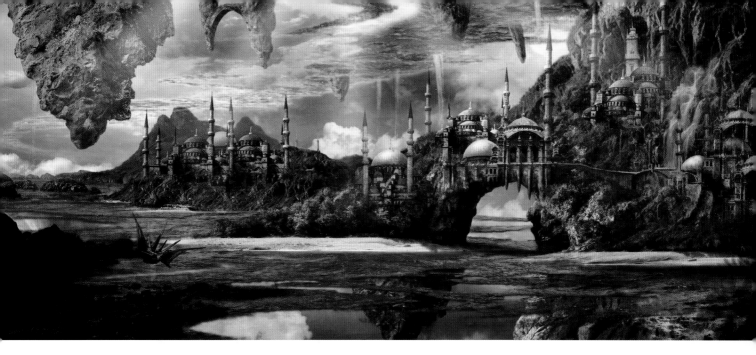

## ◁ SOLKU THE CITY—UNITY THROUGH COLOR AND SHAPE • JON HODGSON

This painting is an excellent example of using color and form together to create a visual identity. The rugged, brown mountains and dry, warm palette colors leave no doubt that this is a hot desert climate. Combined with the strong, clean but simple architectural forms, especially the central domed structure at the heart of the city, the viewer is left with an unmistakable impression of age, of a walled city fortress in a desert that has existed for centuries. The use of one-point perspective creates a series of flat planes (the tops of the walls), which both generate a sense of depth and space as they recede and break up the mass of the city, providing just enough definition to create structure and volume in the shapes of the buildings.

## VARIATIONS ON A WATERY THEME • ROB ALEXANDER △ • JAIME JASSO ▽

These two images are a wonderful example of taking something out of its context and creating a new world as a result. Both make extensive use of the soaring minarets, thick stocky towers, and domed roofs to create a world at once both alien and familiar, and both are set in water-based environments, though with very different ways of depicting them. Notice how, even without significantly altering the forms of the towers, domes, and minarets, but playing with their compositional arrangement, size, and placement, the artists were able to create a fantasy world from familiar objects and shapes.

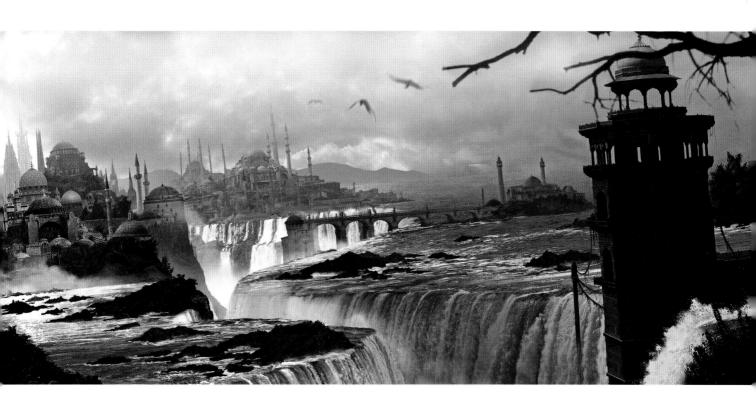

| Distinguishing characteristics | • **Domed roof**—a central dome, often with many smaller, off-center, or partial domes covering the mosques and other important structures. | • **Minarets**—tall, thin structures that may be freestanding, or attached to the mosque. | • **Mathematically based, abstract decoration**— the use of geometric, decorative repeating patterns or calligraphy to adorn the structures, as representational art was forbidden. | • **Central waters**— a fountain or pool will be in the center of each courtyard. At a mosque, it will be for ablutions, in a house it will help cool the home in the summer, and provide a private indoor garden. | • **Cresting**—external walls of mosques were frequently capped with decorative crests, similar to, and possibly the inspiration for, crenellations. |
|---|---|---|---|---|---|

# MIDDLE EASTERN DETAILS

△ **HORSESHOE ARCH**
The Horseshoe or keyhole arch is very common in Middle Eastern architecture. Highly decorated with endless arabesques, it provides the fantasy artist with a wealth of possibilities for personalization and decoration.

▽ **CRENELLATION**
Crenellations echoed the shapes and designs of the arabesques found elsewhere in the structure. Beautiful and delicate, they were often designed more for beauty than defense.

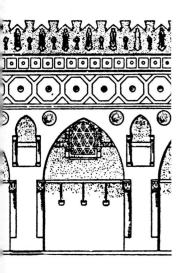

Byzantine architecture was a dominant force in the Middle East from the time the Roman Empire moved its capital there in 330 A.D., renaming the city Byzantium Constantinople, until its fall to the Turks in 1453, while Arabic or Muslim architecture was the dominant style in many nearby countries, starting around the year 600. Therefore, there was considerable exposure, communication, and influence between the two styles.

The architectural styles of the Byzantine Empire also influenced architecture in many Slavic countries, including Russia, Bulgaria, and the Ukraine, and stretched East past the Black Sea and into Asia Minor, so from an artist's perspective, any discussion of Arabic or Middle Eastern architecture must be related in some way to Byzantine architecture and sensibilities, as well as those of Persia, Turkey, and Egypt.

The region covered by Middle Eastern- or Arabic-style architecture is vast, and while there were definite stylistic differences between the regions, the fantasy artist is mainly concerned with the similarities between the

forms and the techniques. Chiefly, these are the crenellated walls, domed roofs, and tall, thin towers called minarets, all built around the central open courtyard.

The most distinctive structure of Middle Eastern architecture is the mosque, and perhaps the most distinctive feature of the mosque is the multidomed roof. The Ottoman Turks introduced the central-dome mosque after they captured Constantinople in the fifteenth century, most likely inspired by the Hagia Sophia, a monument to architecture and the largest cathedral in the world for nearly 1,000 years. It was in Hagia Sophia that architects perfected the system of placing a round dome over a square-shaped room via the use of pendentives. The multiple domes and partial domes were most often round, shallow, and slightly pointed at the top. The bulbous, onion-like shape or the full rounded domes were not common in most parts of the Middle East.

Minarets, the tall, thin towers from which worshipers are called to prayer, are another extremely distinctive and Arabic feature. They can be round, tapering, faceted, or square in

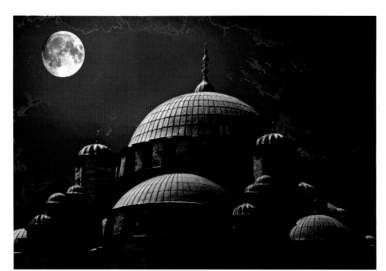

◁ **MULTIDOMED ROOF**
Set against the moonlit sky, the multiple domes and partial domes generate a fantasy image all by themselves, the strong, powerful shapes leading the eye upward. A marked departure from the single domes, which are the staple of many Western cathedrals, these cascading forms speak of a culture both ancient and sophisticated, and convey an enduring timelessness. Taken out of context, or combined with non-Arabic styles, they can help you to create a complex and convincing world, rich with culture and history.

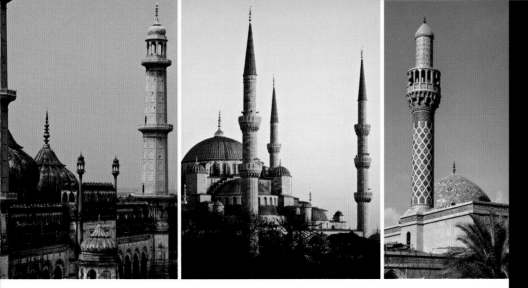

shape, but all will have a base, a shaft, and a gallery, with stairs winding up the exterior in a counterclockwise direction, providing access to the upper gallery, and much-needed structural support for the tower itself. Designed to be a very visible point of focus, and deliberately different from the steeples or bell towers of the Christian religions, the variations in their shape nonetheless serve the fantasy artist well.

The majority of those domes and minarets, as well as entryways, walls, and ceilings were decorated extensively, but since the depiction of realistic, representational forms was forbidden, repeating, geometric colors and patterns were often used, as well as calligraphy. Some were brightly colored, some plain, or created by alternating bands of light and dark bricks, or interlocking stones and voussoirs. Again, this is a feature that the fantasy artist can make good use of, both for its aesthetic value as well as to lend a delightful Middle Eastern feel to an image. This love of the decorative and passion for intricate detail is continued on the walls, and on occasion, the roofs in the form of cresting. Sometimes thick and protective, but at other times delicate, thin veneers; they were at all times beautiful, intricate, repeated shapes.

The use of the pendentive allowed Hagia Sophia to achieve its incredibly large interior space.

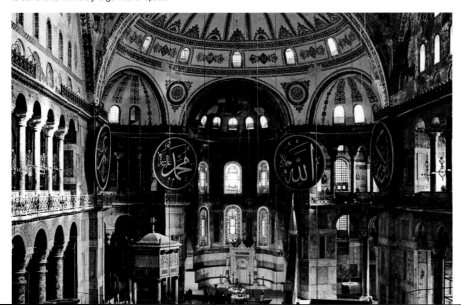

### MINARET △
These three styles of minaret clearly show the base, shaft, and gallery construction, and the dominance they have over the surrounding structures. The similarities outweigh the differences; for the fantasy artist, as free-standing or attached, round, faceted, or square, short, or tall, they all have a very distinctive character that is unmistakably Middle Eastern.

### PENDENTIVE ▽
A pendentive is an arch that spans a wide space and arcs upward and inward at the same time. One arch caps each of the four walls of a large, square open space, and as they rise to meet each other, the increasing wall thickness allows the architect to bring them together in a circular, rather than square shape, so that a dome can be placed on top of it. In this way, a round dome can be placed over the square room, and if need be, an oblong-shaped dome can be placed over a rectangular room.

## ARABESQUE
Since the realistic, representational depiction of animals, nature, and people is forbidden in the Koran, the architects and craftsmen of the Middle East developed an intricate, abstract form of decoration. These decorative details are exquisite in their complexity and beauty. They can be found adorning doorways, doors, windows, walls, and domes. Of particular note for the artist is the fact that it is almost impossible to distinguish where exactly a given design originated, as the mathematics that underlies the designs is consistent within the Arabic region. Mathematical precision, symbolic meaning, and the desire to create a pleasing design govern all the calligraphy, abstract motifs, and patterns.

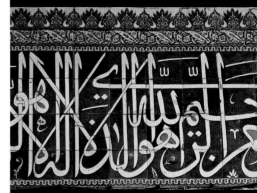

### PAINTED CALLIGRAPHIC TILES △
The use of the Arabic script as a decorative motif is quite common, whether it be on a painted tile, or long thin banners or panels, for example, the side panels of a doorway. Often, it is used to represent natural forms, such as animals. Notice how the script echoes some of the design sensibilities of the row of tiles above it, which may in turn echo the row of crests or crenellations on the top of the wall.

### ABSTRACT PATTERN ▽
The complex, mathematical form is continuous, each part leading to the next, each ending a beginning of another part of the whole, the pattern repeating endlessly.

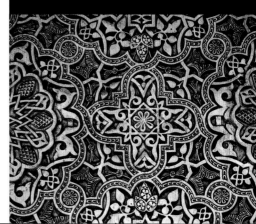

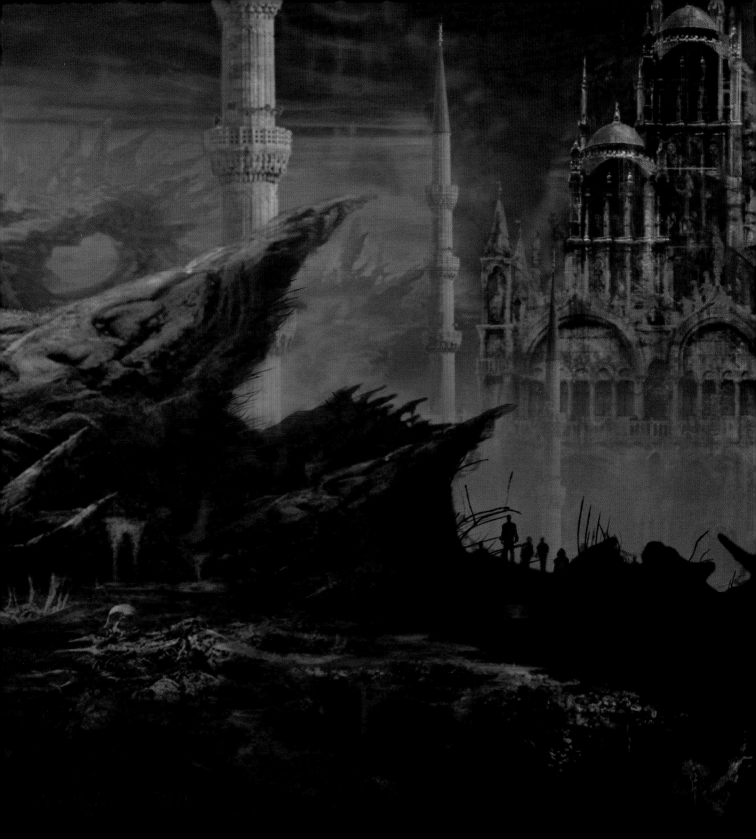

## The Dead City

Coming upon the ruins of a strange city on an even stranger, alien world, a group of travelers pauses to stare in wonder. The figures give scale and secondary focus to the image, revealing the skeletal remains to be that of giants, and the world an epic, primal place.

The Middle Eastern-inspired city emerges, tattered, ancient, forgotten by time, but recognizable to the viewer primarily through the use of the repeated minaret shapes and the arches and domes we associate with that type of architecture. These familiar shapes work to ground and establish the image, in spite of the alien qualities to the world itself.

The image is driven by the concepts of order and pattern in the midst of organic shapes, a contrast of vertical and horizontal planes, and light against dark. Those concepts inspired the creation of the image and

guided it, helping to shape the city forms, to emphasize or minimize specific points, and to provide a point of reference to balance the foreground elements against the mid-ground city.

## Color and Form

Choosing a near monochromatic color palette provided the world with an alien feel, but it also meant that value control would be more important than usual for the image, since the normal color relationships were absent. In spite of the details in the foreground, it is kept darker, more subdued, the features massing together. This is achieved primarily by making sure that the farthest edge from us in the foreground is a near silhouette, so that even with the details in the foreground, the shape itself will read as a shape,

clearly set off from the mid-ground, and creating depth and distance from the city. The strong, clear, and crisp features of the minarets and tops of the city towers contrast with the softer, distressed, ethereal qualities of the rest of the city, giving the whole structure a ghostlike quality, almost as if it were only partially here, existing in this world and another simultaneously.

The strange, angled rocks of the foreground work with the tree limbs, light passages, and debris littering the ground to direct the eye toward the city, maintaining it as the focus of the image, but they also serve to emphasize the horizontal aspects of the foreground. Even the large, triangular shapes on the far left and right of the image appear like massive, horizontal chunks of the earth that have been pushed up or broken off, both setting off the city and bracketing it; focusing the viewer's eye on the center of the image and creating contrast with the vertical structures and lines of the city itself.

This contrast of the familiar against the unusual or unfamiliar is a good way of creating a world that is different from our own, or an architectural style that is new and different, without losing all points of reference for the viewer and alienating him or her. For the fantasy artist, it's a powerful tool for storytelling, world creation, and allowing you to explore and experiment visually, building on what exists to convincingly create those things and places that do not.

*Romanesque architecture is massive, sturdy, timeless, and enduring with an incredible strength and solidity; it is equally capable of telling stories of grandeur and glory or of faded dreams and empires.*

# ROMANESQUE ARCHITECTURE

Along with Gothic architecture, Romanesque architecture forms the backbone of most traditional European fantasy imagery. Contrary to popular belief, Romanesque architecture is not a continuation of the architecture that the Romans brought into Europe. Much of that knowledge was either lost when the empire collapsed, or never really took hold across most of Europe. Instead, Romanesque architecture sprang from the architecture of the Middle East, particularly the Byzantine Empire, where the Roman style remained in use—with some changes and evolutions—for centuries while Europe fought a series of wars, endured the "Dark Ages," and experienced the eventual emergence of large, powerful nations, primarily Spain, France, and Germany. The Crusades exposed large portions of the European population to a style of building and design that was grand, durable, and well suited to the construction of churches and castles, which were the most common types of structure being built at the time.

### UNITY THROUGH REPETITION ▷

While several different architectural styles were used in this image to create a sense of a world built and rebuilt upon itself time and time again over the centuries, the use of a single, dominant style lends coherence and strength to the image. The repeating forms of the freestanding Romanesque arches and the exposed supports of the ruined wall and arches work with the ruined pillars and statuary to suggest a culture, a place, long ago fallen to ruin.

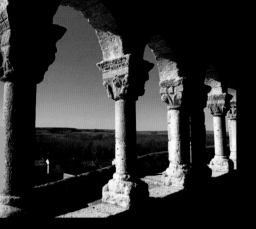

### SEEKING OUT THE LIGHT

This view from the inside of an arcade clearly shows why they were such a common feature of Romanesque architecture. They created an exterior walkway that was open, inviting, light, and airy, in stark contrast to the dark and oppressive interiors that were so common.

### USING ELEMENTS TO SUGGEST A STORY ▷

Even though only a portion of a wall or arch is visible, the characteristics of Romanesque architecture read so strongly and clearly that they can instantly give character and direction to your image. The thick walls and rounded arch of this gatehouse are clearly Romanesque in style, and speak of a remote but enduring outpost from a long-lost culture finally swallowed by the sands. With no other architecture in the image, a whole culture is nonetheless suggested, along with a history, generated by painting nothing more than an arch and part of a wall.

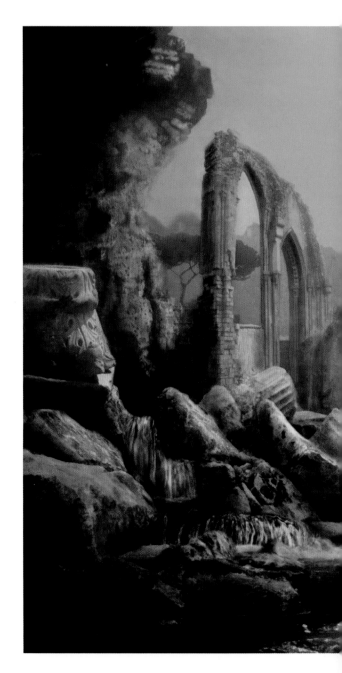

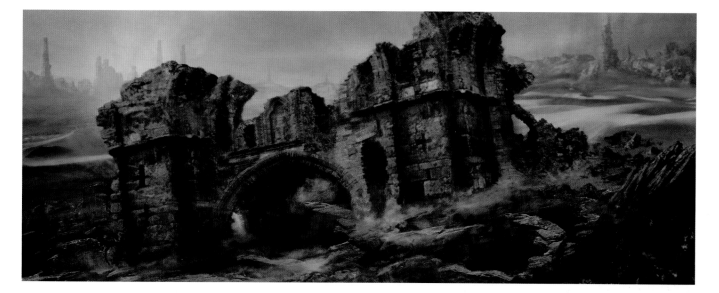

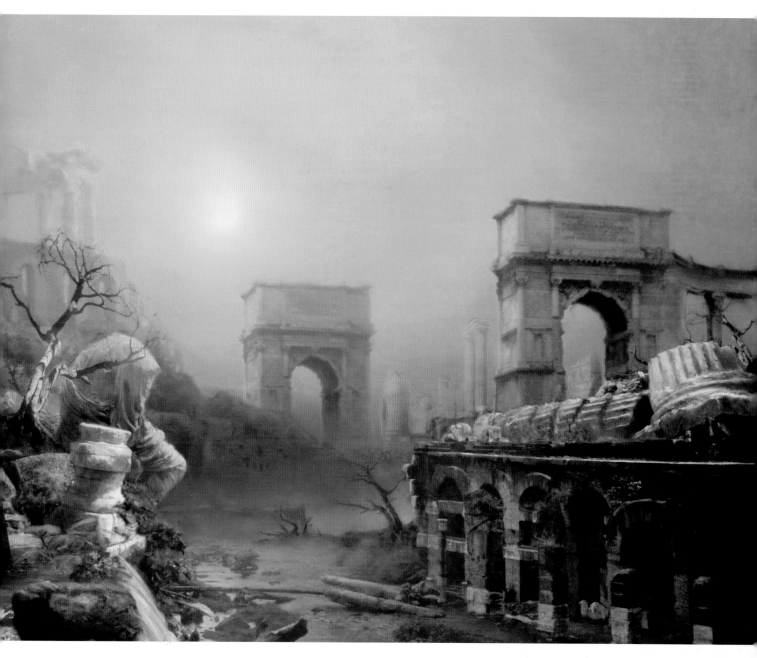

| Distinguishing characteristics | • Rounded arches—strong and stable, but very limited by the fact that the shape and the height to width ratio are fixed. | • Thick walls—sometimes massive stone blocks, sometimes two thinner shells with rubble between them, their thickness alone clearly indicates Romanesque architecture, even when in ruins. | • Massive, sturdy piers—a staple of Romanesque architecture, and an excellent resource for the fantasy artist, the piers are like massive tree trunks, heavy and unmovable. | • Barrel and groin vaults—the simplest of vaults, and the most restrictive; a fact that led to the development of the pointed Gothic arch and a whole new style of architecture. | • Small windows—the thickness of the walls dictated that windows be small and few in number, lending Romanesque architecture a dim, moody quality of light that is perfect for dark and shadowy fantasy imagery. |
| --- | --- | --- | --- | --- | --- |

# ROMANESQUE DETAILS

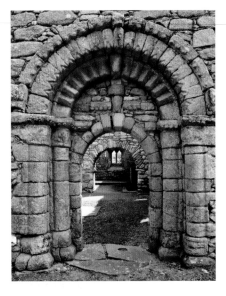

**SQUAT AND HEAVY** △

Everything about an architectural style has a purpose. The doorway, bold and open, is also solid and heavy. The size of the stones, the spaces between them, and the sturdy pillars all indicate a need for strength and support. Study these characteristics, and when you are going against character, consider how the changes will fit with the rest of your design.

The primary characteristics of Romanesque architecture are mass and solidity. Whereas Gothic architecture is tall and delicate in appearance, with an emphasis on the vertical, Romanesque is squat and sturdy, with an emphasis on the horizontal; it is enduring, with a sense of permanence that can lend a sad beauty and poetry to fantasy images when it's in ruins, and a sense of sophistication, credibility, and longevity to a culture when it is intact. Visually, Romanesque architecture can be thought of as compartmentalized. Whereas Gothic architecture was all about creating a large, open, and unified interior space, Romanesque architecture sought to create numerous separate compartments.

In general, Romanesque architecture has a dark, somber look and is more sturdy and functional than elegant or decorative. The large stones, small windows, and thick walls can create a wonderfully moody, shadow-filled image, or ruins that seem to have stood for thousands of years.

**CAPITALS** △

Form must follow function in architecture, even if the forms are also decorative. Capitals had to support the weight above them. Decorative elements tended to protrude from the base, and were neither weight bearing, nor in any way diminishing from the structural support that the core of the capital provided.

## TOWARD GOTHIC

Groin vaults could be strengthened if ribs were added along their diagonal axis, but the height of the diagonals and the main arches were then different. Attempts to solve this problem eventually led to the use of the pointed arch, one of the most characteristic features of the Gothic style. Unlike the ribbed, Gothic arches, which transmitted their weight vertically as well as outward to specific points along the walls, and could be supported by the flying buttresses, barrel vaults transmitted their load evenly and uniformly outward. Therefore, they needed to be supported along their whole length by thick walls and oversized piers.

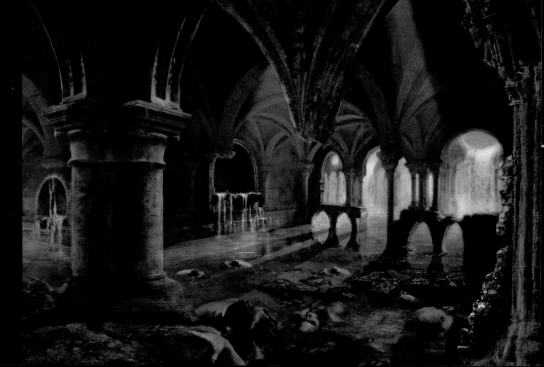

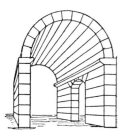
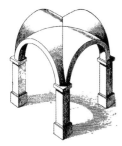

◁ **BARREL AND GROIN VAULTS**

A barrel vault (left) is the simplest type of vaulted roof. It consists of a single circular arch that stretches from wall to wall over the length of a specific space. However, because they transfer the weight they support outward, barrel vaults generally need to be supported on both sides by thick, solid walls, with either small windows or no windows. A groin vault (left) is simply two barrel vaults set at right angles to each other. Because the height to width ratio of the circular arch is fixed, groin vaults almost always enclose a square shape.

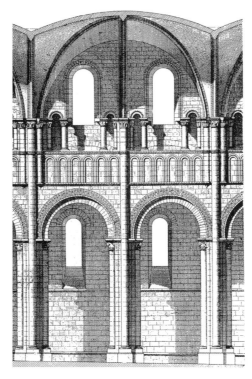

◁ **ROUNDED ARCHES**

The semicircular arches were made of wedge-shaped bricks or stone. They were strong enough to support the considerable weight of the roofs, but by virtue of their shape, they transferred all the weight outward to the side, and they were very limited in that they had to maintain a constant shape. If the width of the opening changed, so too did the height of the arch. Because the rounded shape was similar to the arches used in Roman architecture, architecture historians dubbed the style Romanesque before they understood that the buildings were not based directly on Roman structures, but instead were influenced by Byzantine architecture.

◁ **SMALL WINDOWS**

The thickness of the walls and the structural support they had to provide meant that any windows had to be small openings, which greatly reduced the amount of light inside the cathedral or castle, giving it a very dark, gloomy feel that is perfect for fantasy imagery. Very small windows might have a simple lintel over them, but most had a rounded arch, as did the majority of the doorways or other openings, in order to reduce the weight directly on them and transfer it to either side of the opening. Use this knowledge to help you determine how far apart ruins can realistically be spread before they would collapse, solve visual problems such as where or how far out of position a wall or pier can be before it would fall apart or the arch collapse, and imagine how the stonework over a door or window might sag and shift after years of abandonment.

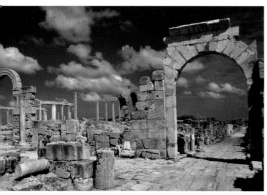

The arch of Tiberius at Leptis Magna, Libya

**THICK WALLS** △

Especially thick walls were needed to bear the weight and pressure transmitted outward by the arches. Often the walls were actually two thinner shells, with a space between them that was filled with rubble. It was also common to use smaller pieces of masonry with lots of mortar between them to create walls. The increased mortar added strength and durability to the walls, occasionally giving rise to ruins with wonderful, near abstract shapes, when parts of a wall remain tall and intact while others crumble, allowing you considerable flexibility in your design and compositions. In fantasy art, the ruins of these distinctive walls, or their foundations, can convey a great deal about your world.

**ARCADING** ▷

One of the most prevalent decorative features of Romanesque architecture is the use of arcades, or rows of columns with rounded arches between them. These could be flush with a wall (blind arcade), or used to create a walkway, such as the dwarf arcades at Speyer Cathedral, Germany, or internal aisles like those at Santa Maria della Pieve in Arezzo, Italy.

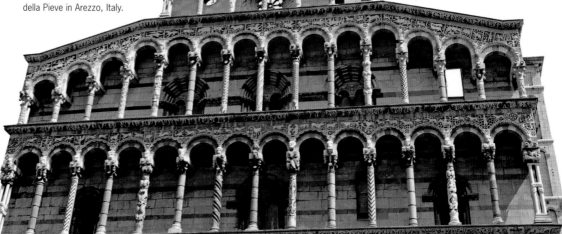

San Michele, a Catholic basilica church in Rome

### THE HALLOWED FOUNTAIN

Borrowing architectural influences and styles from many periods and places, this image is unified by the repetition of the curved Romanesque arch flanked by twin pillars.

### PLANNING AND CONCEPT

Such a large, complex image requires a lot of planning, and a strong concept to direct and unify it. The driving force became the figure in the center of the fountain, and everything was then designed to reinforce this. All the small figures in the image and all the statues are pointed toward the central figure.

The freestanding arch leads both figuratively and literally to the fountain, and the dark shapes on the left and right edges of the image bracket the fountain, keeping the viewer's eye moving around the composition, but never letting it out to the edge of the canvas.

The figure is also set off by the strong contrast of the dark figure against the lighter buildings behind it, and by the color and temperature differences between the cool water and figure and the warm areas behind it. Perhaps the strongest contrast and emphasis of the figure is the way the horizontal lines and emphasis of the architecture are cut by the vertical lines of the figure and the water streams, which all serve to lead the eye toward the central figure.

## COLOR VALUES

Conceptually and compositionally, the whole image can be reduced to a few basic values and shapes, which is vital to keeping the composition strong and focused. Squinting at the image reveals that the buildings and freestanding arch have essentially one value in the lights and one value in the shadows. The ground plane and fountain become a single, dark mass, and the foreground elements are reduced to another single, darker value. Looked at this way, the image reads clearly as a series of value changes or layers, starting dark in the foreground to set the stage, then getting progressively lighter as they recede. If you lay them out this way in the sketch, and sculpt the shadow shapes so

that they depict form and provide depth or contrast where needed, even large, complex compositions can be reduced to something easily manageable, and the initial sketch can help keep you from getting lost in the details or losing your value relationships as you work.

*Tall, stately, graceful, brooding, romantic, haunted—all these and more apply to Gothic architecture, a staple for the fantasy artist.*

# GOTHIC ARCHITECTURE

Gothic architecture is the quintessential fantasy architectural style. From majestic castles and graceful cathedrals to haunted ruins, its distinctive lines and clean, graceful forms are at once beautiful, evocative, dark, and moody, providing versatile building blocks for the fantasy artist. This means you can borrow heavily from Gothic architecture to create imagery that conveys a strong sense of being tall, graceful, airy, and delicate while also looking strong and solid.

### ESTABLISHING THE
### GOTHIC MOOD ▽

The strong Gothic lines and shapes of the background cathedral carry the entire image, and the height, grace, and openness of the interior space provide the perfect setting for telling the story of a long-abandoned shrine or temple. Even in a ruined state, the immense scale of the cathedral is apparent, and helps lend both a height and elegance to the otherwise squat, Romanesque-style architecture of the main buildings.

### USING LIGHT ▷

The warmth of skillfully added sunlight in this painting creates a peaceful focus to this vaulted space, and highlights the sleeping stone figures on the sarcophagus. Gothic architectural details—softened by climbing foliage—add to the ancient, undisturbed atmosphere.

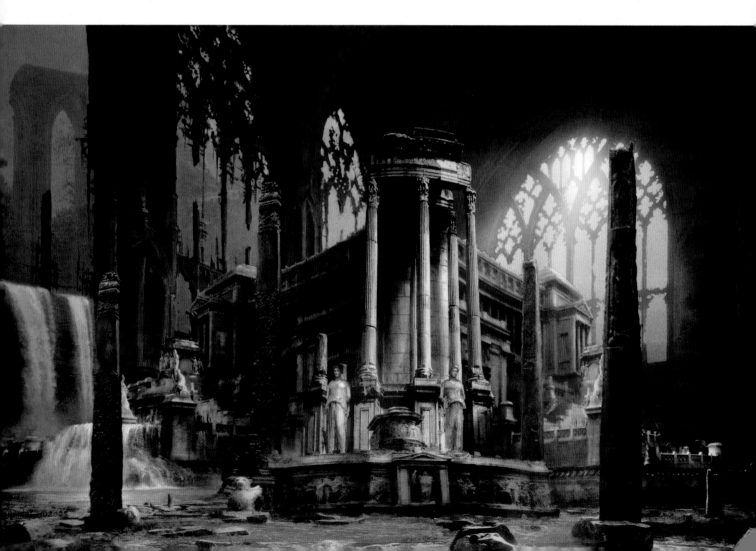

## HEAVENLY INSPIRATION

The foils (window tracery) reinforce a sense of height, and the sunlight streaming through the windows creates a sense of openness in what would otherwise be a very dark and oppressive interior.

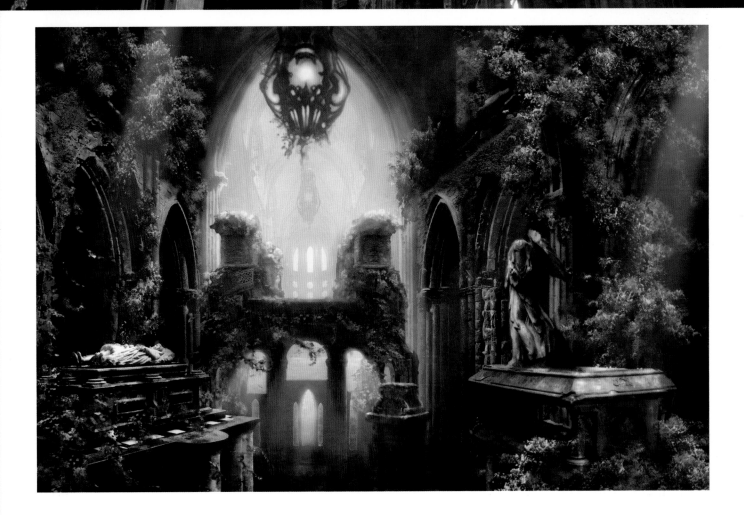

| Distinguishing characteristics | • Pointed arches— eliminating the keystone and using a pointed arch reduced the sideways thrust, and allowed for variation in the height to width ratio of the arch | • Flying buttresses—a system of external supports which transferred the weight of the ceiling outward and downward, allowing for thinner walls | • Ribbed vaults— provided additional strength, and channeled the weight of the roof to specific points along the wall and out to the buttresses | • Ornamental piers—often with grouped colonnettes or mini pillars, they helped support the lighter roofs, and became decorative as well as functional | • Multi-foil windows— window tracery became elaborate, reenforcing the sense of height and delicacy of the architecture |
|---|---|---|---|---|---|

# GOTHIC DETAILS

The primary characteristics of Gothic architecture are its height and delicacy. The use of flying and pier buttresses on the exterior walls allowed for the creation of taller structures with clearly defined interior spaces, while also reducing the overall mass of the buildings. A large portion of the structural weight was channeled through the arches and out into the buttresses, rather than being supported by thick walls and massive pillars. This allowed the arches and columns to be simultaneously taller and more delicate, and thinner walls meant windows—lots and lots of windows.

Arches became pointed rather than rounded, eliminating the keystone which reduced the outward thrust and allowed them to maintain a consistent height even if their width changed. Perhaps most importantly, the use of the buttresses also allowed the weight and thrust of the ceiling to be successfully funneled away from the arches to the walls at specific points via the ribbed vaults, allowing for tall, graceful, and well-lit upper stories.

**GOTHIC CAPITALS** ▷
Capitals are the decorated caps or tops of columns, and they were at their most varied during the height of Gothic architecture.

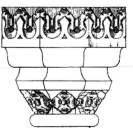

**PILLARS** ▽
Because they did not support as much weight as in earlier architecture styles, pillars were often compound, composed of many tall thin columns. These tall thin "ribs" were delicate in appearance and helped create a strong sense of verticality as they soared upward to the ceiling vaults.

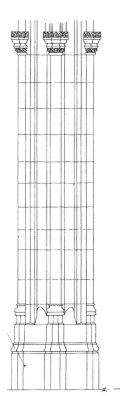

## RIBBED VAULTS

Both decorative and functional, the ribs transfer the ceiling's weight and thrust to specific points on the wall and out to the buttresses. This allows for thinner walls with windows and delicate features in the upper story. The ribs also created a very strong and stable building style that can be thought of as elastic or dynamic, able to adjust well to shifts due to settling or buckling of the masonry. Column capitals, like the piers, are multifaceted and echo the piers below as they lead the eye effortlessly up to the ribs above.

**PIERS** ▷
Because the weight on the pillars was less, the piers, while still strong supports, became more fanciful and decorative, their faces broken up with many facets and planes.

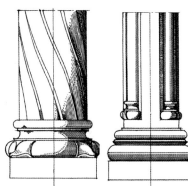

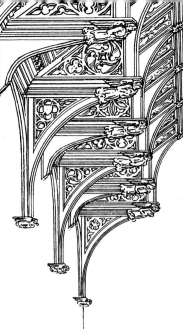

## WOODEN HAMMERBEAMS △

Hammerbeams consist of a series of trusses, repeated at intervals, to transmit the weight and thrust of the roof as low as possible in the supporting wall. Intricately carved, beautiful, and functional, they serve the same purpose as ribbed vaults, lending an elegance and beauty to the interior lines while at the same time directing the weight of the roof above and maintaining the sense of open space and light.

## BUTTRESSES ▽

The flying buttresses or arms (**A**) transfer the thrust outward and downward to the pier buttresses (**B**). Note how all the elements work together to reinforce the sense of the vertical, from the window foils and the lower arch to the buttress and pinnacles. The silhouette created is very evocative and unified. Emphasizing these features can give your image complexity, direction, and cohesion, whether you're painting romantic fantasy or haunted ruins. Remember, the spaces between the buttresses are often windows and the arms may be roofed over, creating alcoves and spaces (**C**), to allow you to play with light, shadow, and volume.

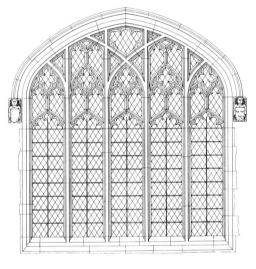

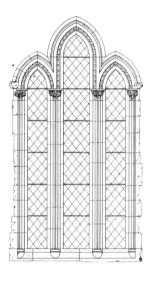

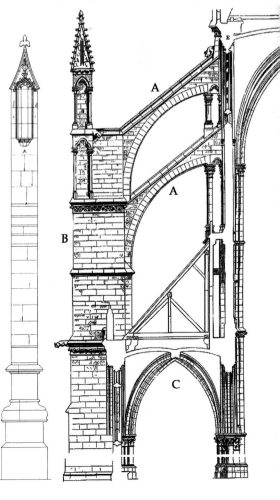

## WINDOW TRACERY △◁

Through the fourteenth century the tracery geometry became much more complicated and subtle; the complex patterns of the decorated style were created by combining parts of circles to form flowing designs. Types of tracery shown from top left to bottom right: early English, geometric, decorated, perpendicular.

## BASE MOLDINGS ▽

Moldings decorated the base of columns, ensuring that every available surface was beautiful and graceful.

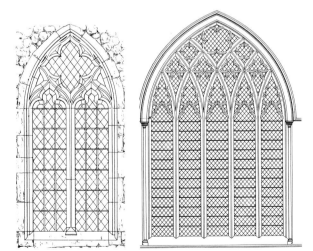

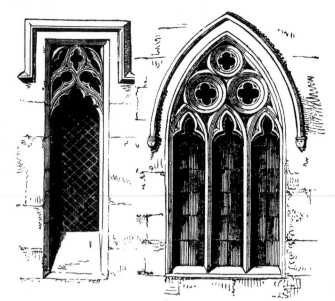

## HOODMOLDS ▽

The hood protected the area beneath it from rainwater, and the dripstones helped channel the rainwater down the columns.

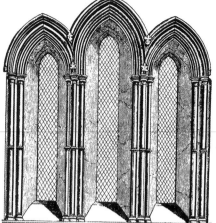

## GOTHIC DOORWAYS ▷

Unlike their squat, heavy Romanesque counterparts that had to support the considerable weight above and on either side of them, Gothic doorways could be taller, thinner, and more graceful, echoing the characteristics of the building itself. Deep hoods, called archivolts, were often highly decorated and carved, and the use of decorative colonettes, piers, and cable molding provides the fantasy artist a wealth of choices for making your world unique and expressive.

## GOTHIC BUILDINGS ▽

Although there was considerable variation in the structural forms, the pointed arch is so strongly associated with Gothic architecture as to be inseparable. Whether single or in multiples, plain, ornate, or enhanced with widow foils, the basic shape will instantly convey a Gothic sensibility to your image. Consider also adding Gothic touches to non-traditional Gothic forms, such as the rectangular window, in order to convey a sense of history and character to your image that might have resulted from renovations, rebuilding or a change in the ruling power of your world.

## DRIPSTONES ◁▷

Dripstones are the ornamental end caps to the hoodmold or drip mold, a lip which projects out over a window, door, or sill, acting very much like a combination umbrella and gutter. Water was funneled along and down the hoodmold to the dripstones, where it ran down the wall, pier, or buttress and away from the opening of the door or window. Dripstones were most often carved in decorative leaf and floral motifs, or else in grotesques or chimeras, similar to the gargoyle rainspouts. Rectangular hoodmolds, such as the one in the drawing of the rectangular window above, were called labels, and served the same function.

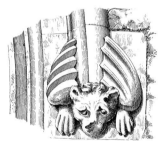

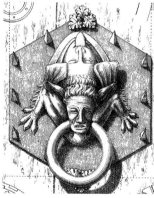

## GOTHIC DETAILS ▽

The qualities of Gothic architecture which allowed for its soaring heights, delicate stone work and well-lit interiors also opened the way for much more decorative treatments of the various features. Flying and pier buttresses, columns and supporting piers, and bases were carved and decorated, but so too were windows, doors, and walls. The pointed arch motif was prevalent, as were vertical lines and tapering forms, and in all things, there was a sense of the vertical, a lifting of the eye toward the heavens, as the drawing left clearly shows.

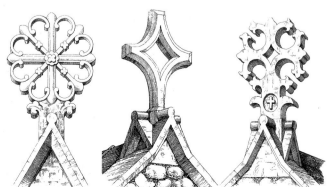

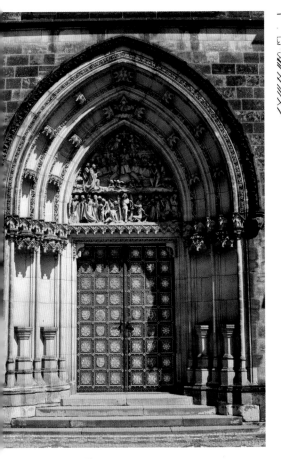

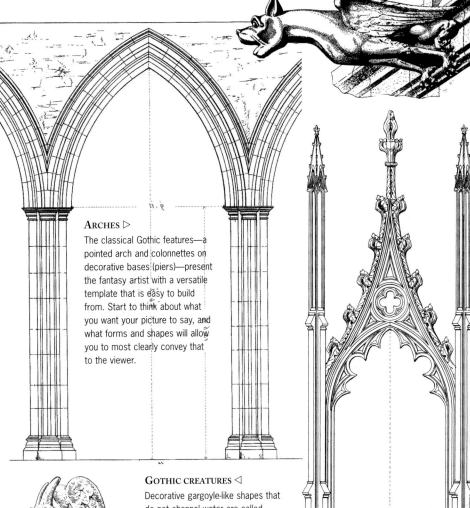

### ARCHES ▷

The classical Gothic features—a pointed arch and colonnettes on decorative bases (piers)—present the fantasy artist with a versatile template that is easy to build from. Start to think about what you want your picture to say, and what forms and shapes will allow you to most clearly convey that to the viewer.

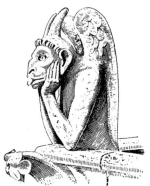

### GOTHIC CREATURES ◁

Decorative gargoyle-like shapes that do not channel water are called grotesques or chimeras. They may have partially served simply as decorative elements, to beautify the building exterior, to move the eye toward the heavens, and to call attention to the building itself, and for the fantasy artist, their variety presents unlimited opportunities for expressing the character and personality of your world.

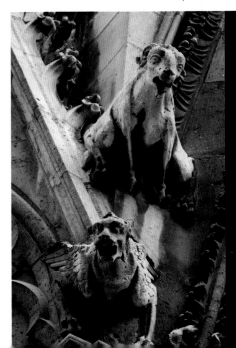

### GARGOYLES

A gargoyle is basically an elaborate waterspout or rain spout—a long, thin projecting sculptural element that overhangs the roof and directs water away from the building, preventing it from running down the walls and eroding the mortar that binds the masonry. Often carved in fantastical animal forms, they became very prevalent in Gothic architecture, as the presence of the flying buttress meant that water could be easily channeled from the roofs to the buttresses and then to the gargoyles and out over the clearstory and away from the building. Gargoyles are seldom used singularly, but are rather in rows or clusters.

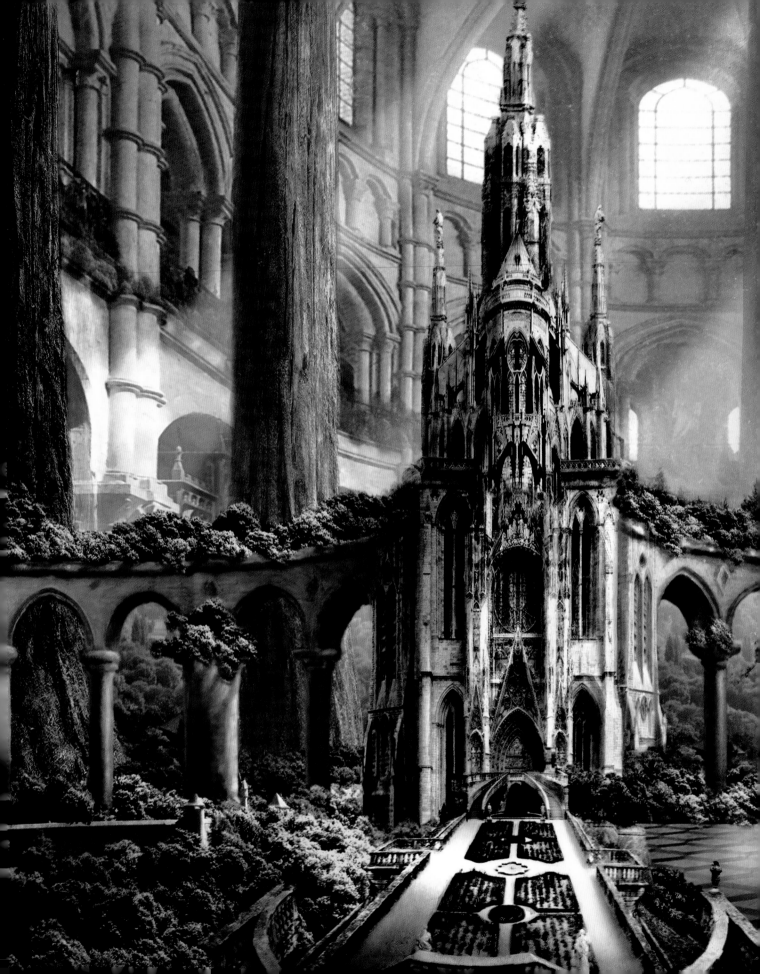

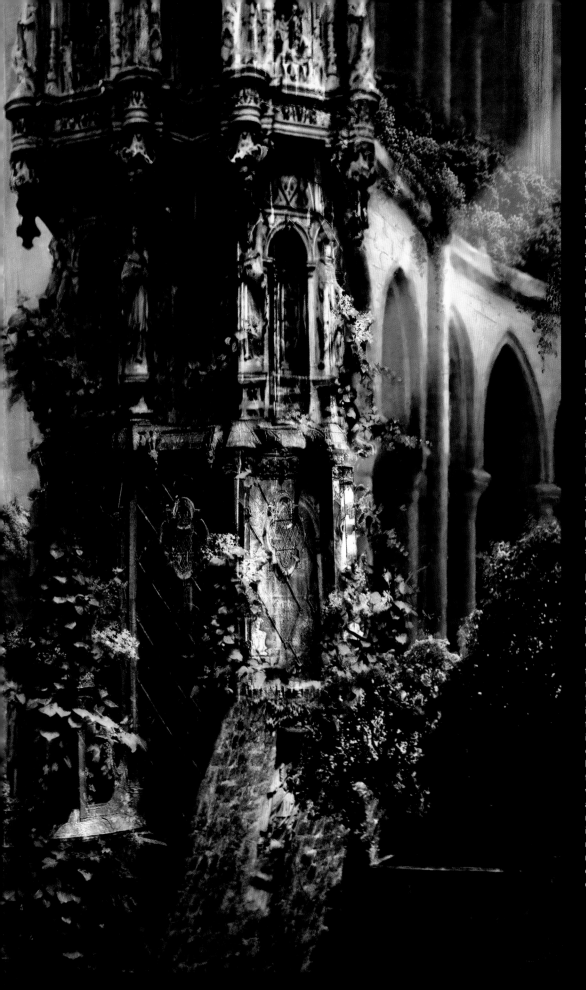

## TEMPLE GARDEN

The central tower incorporates many Gothic elements, and the overall design mimics the floor plan of a traditional cathedral, but it's all given a fantastical twist. The central tower dominates, flanked by the traditional two-tower arrangement. Pinnacles and window tracery—which is repeated in the external fluting and multi-storied windows—are all traditional Gothic elements, recognizable enough to make meaningful associations in our mind, but pushed into the fantasy realm by the setting and the scale.

## PAINTING TECHNIQUES

The initial concept was for a truly majestic cathedral, with natural and manmade elements in harmony, on an epic scale, and everything in the image was chosen to support that direction. Beginning by combining and overlaying numerous pencil sketches, the composition was refined and details added, balancing the many complex elements against a strong, simple composition.

Color was added in Photoshop, rough values established, then the image was archival printed, sealed, and mounted on Masonite before being finished with oil paints.

The sweeping curves of the walls are smooth, with the textures coming mainly from the foliage, integrating nature into the structure and allowing the eye to easily travel up and into the central tower. The curves of the ceiling gently bring the eye back down into the composition on the right, where the walkway leads us again into the center. The loop repeats, the eye keeps moving in and up, constantly reinforcing the sense of majesty that was the initial concept and driving force of the image.

*Perhaps it's the unusual shapes of the buildings, or the glyphlike writings in their distinctive square blocks, or the fact that so many of the remaining Mesoamerican cities, pyramids, and temples were nearly consumed by the lush, overgrown jungle, but whatever the root cause, there is a strong sense of the alien mystique to the ruins of Central and South America.*

# MESOAMERICAN ARCHITECTURE

For the fantasy artist, Mesoamerican architecture refers primarily to the complex cities, step pyramids, and great temples of the Central and South American peoples, most commonly the Aztecs, Incas, and Mayans. Unlike the Egyptian pyramids, which stand tall and proud in their desert environment, long explored and documented, the architecture of Mesoamerica, so recently rediscovered and so little understood, seems shrouded in mystery, a link to a past that is as remote and impenetrable as the jungle that hides it. A blend of the primitive and the sophisticated, where post-and-lintel construction dominated and neither the arch nor the wheel was known, and yet the stonework was so masterfully cut that it had no need of mortar to bind it together and holds together still, as tightly strong as the day it was built. The Mesoamericans had complex, fully developed systems of mathematics, medicine, astronomy, trade routes, and writing. Their decorative stone carving—sculptures and glyphlike writing—was crafted with such skill that much of it survives, despite centuries of weathering and erosion and the deliberate attempts of the Spanish conquistadores to destroy it.

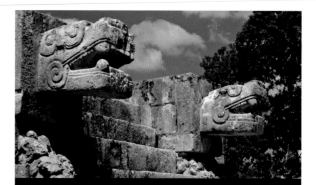

## GEOMETRICAL SYMBOLOGY AND STYLIZATION

Geometric stylization, circular designs, spiral motifs, and strong, clean lines are distinctively Mesoamerican. Note how in the painting below, the sphinx, an image firmly associated with Egypt, reads more as Mesoamerican because of the angular, stylized design and emphasis on the flat planes and horizontal axis, which echoes the design of the pyramid.

**MIXING REFERENCES • DON MAITZ** ◁ ▽

Combining characteristics of several different cultures, the design (shown in thumbnail format, left, and painted, below) holds together due to the strong, clean lines and bold shapes of the image. The steep, smooth-sided pyramid has definite Egyptian overtones, but the entrances on all four sides, the tablero style of cap, and figureheads lend a decidedly Mesoamerican flavor. An excellent example of borrowing from real-world sources, but use them as a starting point, not an end point for your design. Note also the way the drifting plumes of smoke break up what would otherwise be a very static composition.

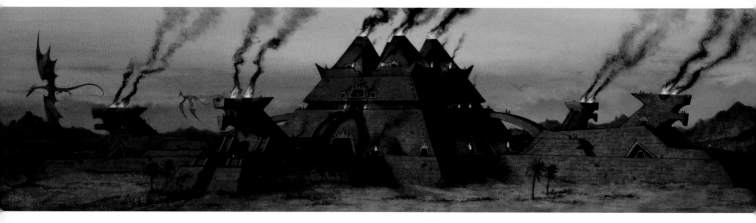

## PLACING A STRUCTURE IN AN ENVIRONMENT

Capitalizing on the overgrown jungle and warm tropical feel of the setting and color scheme, which echo our own world, the pyramid is styled along the lines of a traditional Mesoamerican structure and reads clearly in spite of the extra levels, the lack of a temple capping the pyramid, and the odd design. The strong, clean lines give a sense of strength, permanence, and solidity when juxtaposed against the lush jungle environment, as if the building has stood, somehow protected or safe from the ravages of nature. The steps are recognizable to the viewer, a known quantity, and therefore they establish a scale for the pyramid, giving a large, epic feel to the image.

Alexander © 2008

| Distinguishing characteristics | • Post and lintel construction—the keystone was unknown in pre-Columbian architecture, so there were no true arches, and hence buildings tended to be low and wide, rather than tall. | • Spiritual symbolism—the cities were laid out to reflect the heavens and the underworld with the temples, stelae, and ball court forming the axis mundi between the north and south halves. | • Step pyramids—constructed in the talud-tablero style of flat platforms on top of angled slopes or sides. | • Highly decorated—frequent use of carvings, inscriptions, and sculptural relief on lintels, friezes, doorways, and colonettes. |

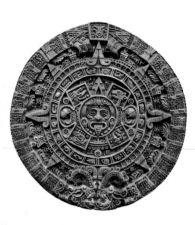

"Stone of the Sun," the Aztec calendar stone

# MESOAMERICAN DETAILS

## SPIRITUAL SYMBOLISM ▽

The pyramid with the temple on top was the axis mundi of the city, the spiritual center of the culture. Centrally located, the temple was the highest point, closest to the heavens and the gods. It was situated at the crossroads of the compass points and aligned to the position of the sun or stars on specific days of the year, often equinoxes, to capture or create certain lighting effects on certain days of the year.

There seems to have been very little significant change to the style of building, so even palaces or temples that took hundreds of years to complete have a harmonious and unified look. Cities that could have held 100 to 150 thousand inhabitants were laid out with a precision and order that bespoke of considerable skill and knowledge. For the fantasy artist, even the suggestion of a large, orderly city peeking through dense jungle growth can be a powerful visual, or the ruins of a simple post-and-lintel doorway, perhaps with painted runes or graffiti on them, telling a story within a story.

The large Mesoamerican cities were an attempt to create a tangible manifestation of the heavens and earth, and embody the

spiritual beliefs of the people. The northern parts of the city represented the underworld, and held tombs and other related structures, whereas the southern end represented life and held residences, markets, and monuments to the nobility. Between the two were likely to be the stelae, or standing stones, which represented the world tree that holds the heavens and connects them to the earth, pyramids topped by great temples, and the ball court, which may have represented the meeting point between heaven and the underworld, a place of crossing over. On the plains, the tops of temples were built with tall roof combs projecting upward to create a mountain, so that the ancestors' spirits, which lived in mountains, would have a place to reside within the city.

## ARTISTIC VARIATION

Use the variation in pyramid design to your advantage. The viewer will recognize the basic design of the step pyramid, even if you alter the shape, placement, spacing, or number of tableros. Create your own temple and pyramid shapes, play with complexity by drawing three-, four-, or even six-sided designs, or try curved rather than straight staircases. You will find you can easily create a unique world that will still echo ours but allow you to capitalize on viewers' knowledge of the Mesoamerican mystique.

## STEP PYRAMIDS ▽

Several variations of the step pyramid design were used, but all tended to follow a similar pattern. The variations, which may well have arisen through changes in leadership as one region conquered another, or through trade or other contact, give the fantasy artist considerable latitude in design. The basic structure or pattern is one of

steep sloping sides, called taluds, capped with flat, tablelike sections called tableros. There may have been multiple tableros breaking up the sloped side. Some were rectangular in profile, others were undercut or multilayered. Temples were situated on top of the pyramids, making them closer to heaven than any other point of the city, the axis mundi of the Mesoamerican city.

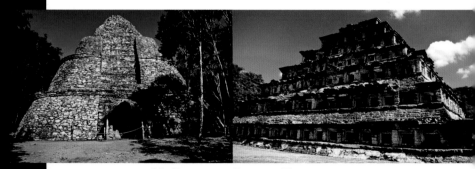

Xaibe Mayan pyramid in Coba, Mexico

Mayan pyramid in El Tajin, Mexico

## Masterful Stone Cutting ▽ ▷

Lacking wheels, pulleys, or metal tools but possessing a tremendous supply of manpower, the Mesoamerican peoples managed to cut, shape, move, and assemble intricate stonework and massive blocks of limestone. In part this was possible because limestone, when first cut from the quarry, is soft enough to work with stone tools. After time and exposure to the air, it hardens considerably. This allowed precise cutting and fitting of large blocks of stone, leaving gaps so small that a knife blade will scarcely slip through, to create walls and structures that retain their integrity after centuries of abandonment and exposure to the elements.

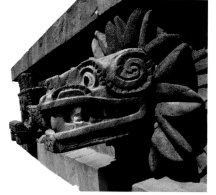

## Fantasy Languages

The best known of the Mesoamerican writing systems is the Mayan. Its distinctive square-cut blocks, into which the picture glyphs were carved, provide fantasy artists with a wealth of possibilities for creating cultures and landscapes that will nonetheless still resonate strongly with viewers. Look for ways to echo other cultures or their iconography in your work, in order to lend a complexity and sense of reality and history to it. One of fantasy's most influential stories, *The Lord of the Rings* trilogy, was often described by its author as a story loosely fitted around the languages he created. The more you can bring into your images from real-world sources, at least in spirit, the stronger your images are going to be.

A classic example of pre-Toltec style at Chichén Itzá

## Highly Decorated ▽ ▷

From numerous carvings of figures and deities to heavily inscribed and decorated friezes, lintels, columns, doors, and even steps, the Mesoamericans showed an incredible skill in carving and decorating their cities.

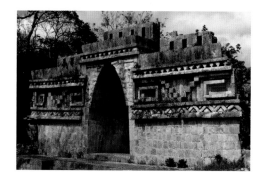

## Post-and-Lintel Construction ▷

Not having the keystone or rounded arch, the Mesoamericans were limited to the use of the corbeled arch, a simple staggering of bricks or blocks to create an opening in a wall or a doorway. These pseudo-arches are structurally much less strong than a true arch, and so many of the buildings were long and wide, or else relied on the massive limestone blocks for support.

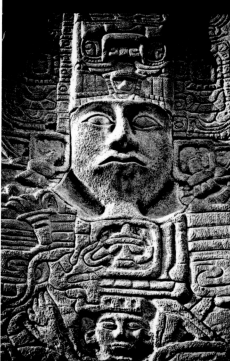

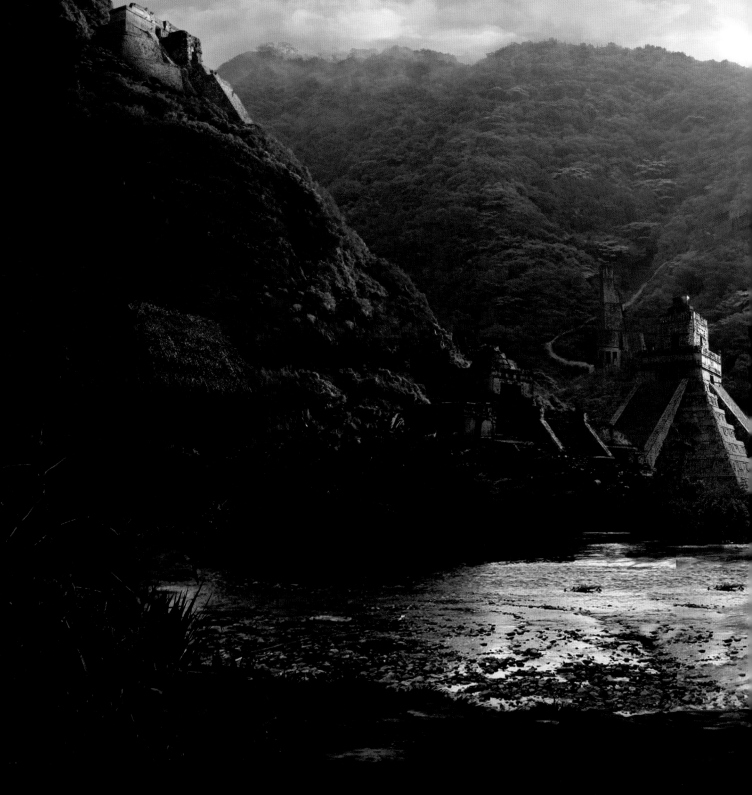

### MISTIKAN • JAIME JASSO

This digital painting uses familiar forms to create an entirely new world. The typical "talud tablero"-style pyramids, roof combs, and long flights of stairs are familiar—the flanking towers and walkways usher in the realm of fantasy.

### USE EXISTING STYLES TO CREATE UNIQUE WORLDS

Understanding architectural styles and forms, in this case Mesoamerican, allows you to create new forms, shapes, and structures that seamlessly build a unique world. Each new element should look as if it belongs to the same city, complex, or building, while at the same time, mixing elements gives you freedom to design the image and composition without constraint.

## TARGETING THE GAZE

The dark foreground and hills bracket the center of the image, focusing the eye on the middle pyramid first; the strong contrast and clean, straight lines separating it from the organic shapes that surround it. From there, the little spit of green land at the bottom right of the pyramid, the arc of the back hills, and the ribbon of water in the foreground all lead the eye to the right, and the true heart of the image: the multitiered temple, shrouded in mist and mystery. The careful use of line, value, and color within the composition are what allow this deliberate directing of the eye. There is relatively little contrast in the foreground elements, allowing them to become a large, dark, framing mass. The values of the mid-ground elements are very subtly rendered, with the warm lights of the central pyramid set against the cool darks of the hill, and the darks of the temple set against the lighter value of the sky. The touches of sunlight on both the hills and manmade structures add points of accent that help move the eye throughout the composition. The strong, repeating diagonals of the hills, pyramids, stones, water ripples, and tree branches echo and reinforce the shapes of the pyramids as well as the vertical nature of the roof combs and temples atop the right-hand pyramid. They break the vertical lines, making them appear taller and allowing them to become the natural focal point of the image.

*The Vikings exploded into the pages of European history in 793 when they sailed to Lindisfarne (Holy Island), burning and looting, but before writing them off as bloodthirsty barbarians, it is worth remembering that they were a sophisticated culture, highly skilled in many arts.*

# VIKING STRUCTURES

Courageous, fearless, strong, aggressive lovers of battle, adaptable, loyal, and noble—all these apply to the Vikings. The image of them as fearless, bloodthirsty warriors, demons from hell who had it in for the Christians, was painted by a people on the losing side, and is as one-sided as it is misguided.

The Vikings were raiders, to be sure, seeking treasure, livestock, and slaves, but they were also traders, adventurers, and explorers whose legacy is still with us today. They left their mark across Europe from Dublin and York to Paris, Kiev, and Constantinople. The Vikings lived, explored, and thrived in a variety of climates and locations that heavily influenced their building materials and methods, from the longhouses walled and roofed with sod in Iceland and Greenland to the wooden-framed wattle and daub houses of Ireland. Regardless of the materials used, however, there was a consistency to the designs and layout of Viking architecture.

**WOODWORKING SKILLS △ ▽**
The Viking tradition of artistry and functionality, shown in these carvings, provides the fantasy artist with a rich legacy, full of visuals that capture the imagination every bit as much as Celtic knot work or Gothic arches. In fact, without their famous wooden longships, which were strong, flexible, and durable in the extreme, the Vikings could not have traveled, traded, or expanded as they did.

◁ **AN ENDURING COMBINATION OF CULTURES**
Ranging in height from a few feet to over thirty, intricately carved circular cross-stones originally marked crossroads and boundary points, as well as being public monuments.

| Distinguishing characteristics | • Longhouse—communal family living, originally shaped to match an upturned longship. | • Stave church—displaying masterful woodworking prowess, these were as sturdy and beautiful, and as lovingly made and decorated as any longship. | • Woodworking skills—from longships and churches to sleds, wagons, and weathervanes, the Vikings' finesse with woodworking, joining, and carving was superb. | • Material variation—building with what they had at hand, and adapting to their environment. |

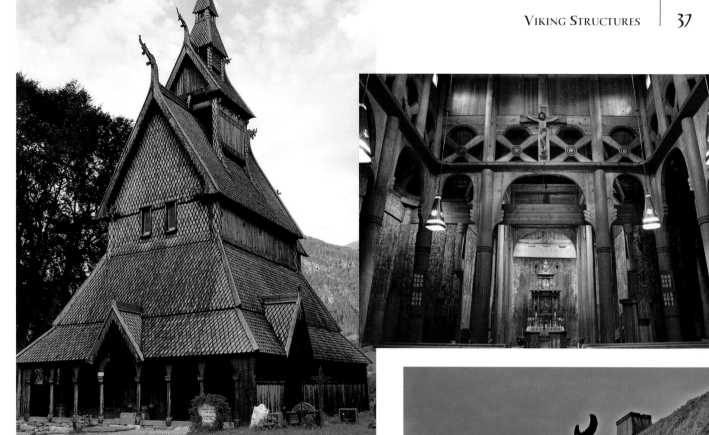

### △ STAVE CHURCH

Stave churches were elegant examples of a synthesis of the eastern European cog-jointed styles of building and western European stave-post styles. The churches were once a common sight all across northwest Europe. Church interior is shown above right.

### LONGHOUSE ▷

These long, low houses, built mainly of wood with thatch or sod for a roof, and, in some climates, sod for the north wall to create additional insulation, are the quintessential Viking architecture. A central hearth provided light and heat, as there were seldom windows, in order to conserve heat. Early versions of the longhouse were tapered at both ends. The lord's longship was wintered upside down on the roof, so the house was shaped to match. In later variations, high roofs with a steep pitch kept rain and snow from accumulating, and smoke vents at either end allowed the worst of the fire's smoke and ash to escape. Interiors were still somewhat smoky, especially the loft, and with the lack of window, often gloomy and dim—a perfect mood-setting condition for the fantasy artist, where shadows play tricks on the eyes and suggestions of form create mysteries.

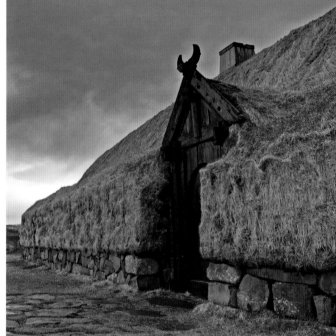

## MATERIAL VARIATION

The Vikings employed a wide range of materials, from wood to sod to thatch to wattle and daub, applying them to the construction methods and designs they had developed. There was very little in the way of transportation infrastructure on land, so moving materials any distance became very difficult, leading to a reliance on readily available materials, and, often, the need to build close to fjords and rivers.

*With their flaring, curved rooflines, low, wide expanses, and near seamless integration with nature, the temples, palaces, and pagodas of Asia encapsulate a look at once both alien and beautiful to Western eyes.*

# ASIAN ARCHITECTURE

Like the buildings of the Vikings, much of the architecture of Asia is constructed of wood, rather than stone. The unusual designs, superb craftsmanship, and distinctive shapes have influenced modern architects and fantasy artists alike. From their distinctive sloping roofs and ornate decoration to their harmonious relationship with the natural world, fantasy art borrows heavily from Asia to create worlds at once exotic, beautiful, alien, and remote. The cultural refinement and elegance of Asia is a world apart from the gritty, muddy, sweat-stained knights besieging European castles.

**DOMINATING ROOFLINES •**

**JON HODGSON** △ ▽

The central towers, above, are not Asian in style or shape, but the wide, low roofs with a curved flare convey the Asian sensibility. Remember that sometimes all you need is the suggestion of a style, or part of a recognizable type of architecture, to establish the look of the entire image. In the final painting, below, other Asian characteristics have been added—the castle and surrounding walls have a distinctly Asian feel, even in this fantastical setting.

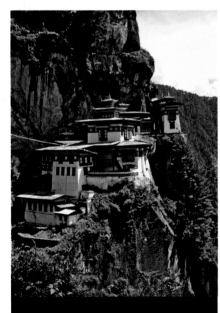

**CLIFFSIDE LIVING**

The gently sloping rooflines, slightly flared walls and tiered design of this monastery in Bhutan create an Asian style and integrate the building with its surroundings.

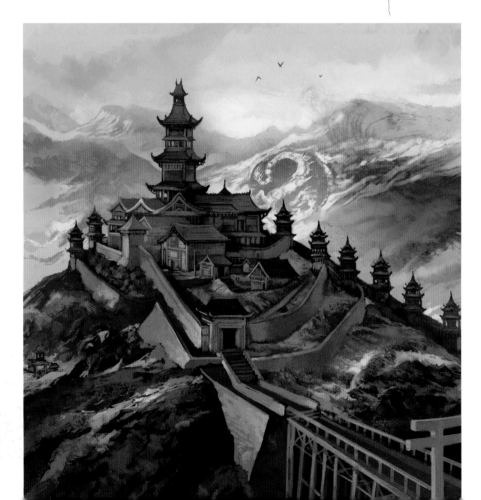

**THE OLD INFLUENCING THE MODERN • LORENZ HIDEYOSHI** ▷

Despite strong verticals—which should lead the viewer's eye up and off the page—the emphasis of the rooflines, echoed by the balconies, water puddles, and the wires connecting the two buildings all serve to emphasize the horizontal, boxing in the composition and creating a much more intimate setting. The traditional Asian features are introduced into a modern setting to create an image that is both very distinct and approachable.

**USING VISUAL SYMBOLS • ANTHONY WATERS** ▽

Sometimes, all that is needed are one or two visual characteristics to convey a style. In this example, the curved, hornlike projections that jut from the ends of the roofs and the large brick edge pattern of the right-hand building reference an Asian influence.

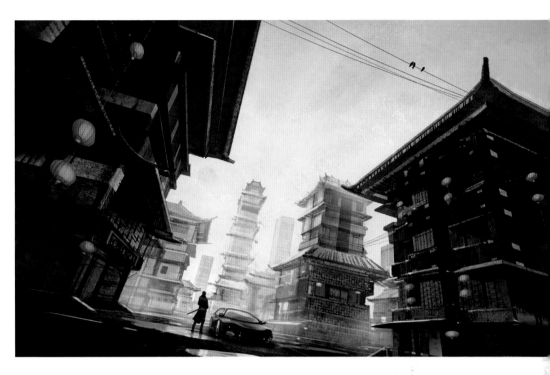

| Distinguishing characteristics | • Wooden construction—fine workmanship, detail, and decoration.<br><br>• Dominated by the roofs—distinctive, curved, sloping roof shape is both functional and sturdy, and common to all of Asia. | • Emphasis on the horizontal axis—the focus was on the width of buildings or complexes, as well as on symmetry and balance. | • Integration with the natural world—these structures did not squat in the landscape; they nestled gently into it, looking almost as if they grew there. | • Rounded, arched bridges—in a land with so many rivers and mountains, bridges are a must, and the rounded Asian bridge is as distinctive as the sloped, curved rooflines. |
| --- | --- | --- | --- | --- |

# Asian Details

Whether it be the typical long, low houses, palaces, and temples, or the tall, thin pagodas, there is a very strong visual unity, balance, and symmetry to the overall design and layout of Asian architecture. A reverence for the natural world is reflected in the way that structures are embedded in their environment so as to look natural themselves, a part of the wilderness. This is a stark contrast to the European style, where castles and fortresses sit like scars upon mountains, or on hastily erected earthen hills, dominating and overpowering the natural world. Even cathedrals were intended to show man's power over nature, a bending of the natural world to his will. Disturbing nature so strongly, according to Asian beliefs, would have dire consequences at both the spiritual and magical level.

A Chinese "pai-lou," a monumental arch or gateway

A Japanese pagoda, originally built in 730 A.D.

A traditional Chinese "moon gate" (a circular opening in a wall leading to a garden or courtyard)

**BALANCE AND SYMMETRY** △ ▷
Round doors are not just for hobbits. In keeping with the principles of balance, symmetry, order, and continuity that underlie Chinese architecture, rounded doors, called moon gates, were commonly built as entryways to the interior gardens and courtyards.

## Chinese Continuity

China is the world's oldest continuous civilization, thriving for thousands of years as essentially a single empire. (The Western Roman Empire, by contrast, lasted a mere 500 years.) Existing in isolation for the first few centuries, China developed a sophisticated, orderly, and functional style of architecture and city planning, which—from the fantasy artist's perspective—changed remarkably little over the centuries as it gradually spread across and influenced almost all of Asia.

One of the main reasons for this lack of change was the necessity of building with wood, whose inherent characteristics discourage significant changes or innovation in building styles. Also, the strongly held Confucian beliefs of the Chinese discouraged deviation from past traditions and styles, even down to the rules for the use of color, ornamentation, and decoration to declare the social status of a homeowner and the colors that could be used for the temple roofs. Rooms, buildings, and cities were symmetrical, orderly, and uniform.

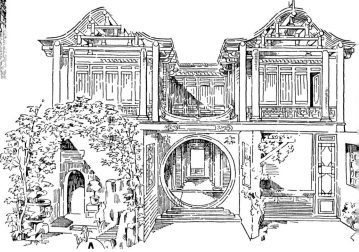

A Chinese Buddhist temple

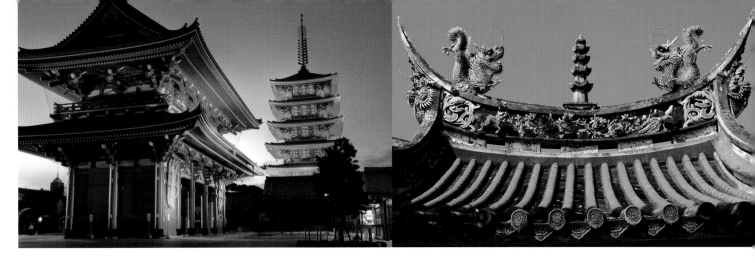

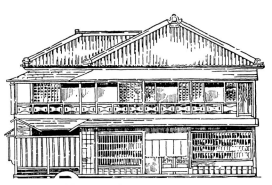

A traditional Japanese tea house

**WOODEN CONSTRUCTION** ▷
Workable stone was scarce across much of Asia, so wood was the natural choice of building material. The constant threat of fire, the frequent earthquakes of Japan, and the rapid deterioration of wood meant buildings frequently needed to be rebuilt or repaired. This was a much easier task with wooden structures. Even moving an entire building or city was possible if it was wood, rather than stone. In Japan, it was common to intentionally destroy a temple every twenty years and rebuild an exact replica.

Japanese compound brackets

Front view of the Grand Shrine of Izumo, Japan

# Japanese Refinement

The Japanese, while heavily influenced by Chinese styles and design, sought to refine their buildings, striving for a delicate, well-balanced symmetry, with a decorative beauty and workmanship akin to fine art. A good example of this is the Japanese system of compound brackets, which support the roofs. These intricate forms are as complex, beautiful, and structurally sound as any of the stone capitals in Europe. Like the roofs they support, the brackets have an almost indefinable "Japanese" character to them, as iconic as Doric capitals or the Gothic arch, and just as much of a staple for the fantasy artist in creating interesting, evocative worlds.

Matsumoto Castle, Japan

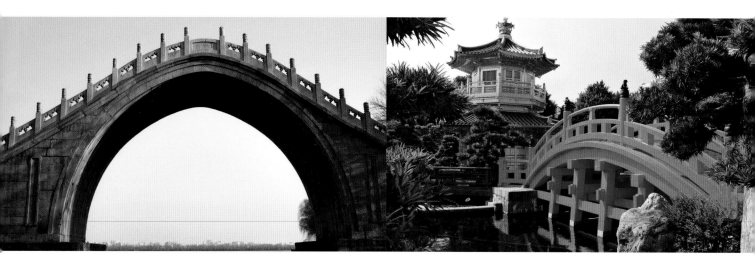

## ROUNDED, ARCHED BRIDGES △

Whereas bridges themselves are hardly unique to Asia, the distinctly arched, curving bridge, usually made of stone, is so strongly linked to Asia that, even with no other architecture evident in a painting, the viewer will automatically presume a cultural and aesthetic sensibility that mirrors or mimics the Asian. This effect can be particularly powerful when juxtaposed against other clearly non-Asian elements in a picture, or when a setting requires a sense of elegance, refinement, or sophistication.

A kondo (or "golden hall"), a sacred hall within a Buddhist temple

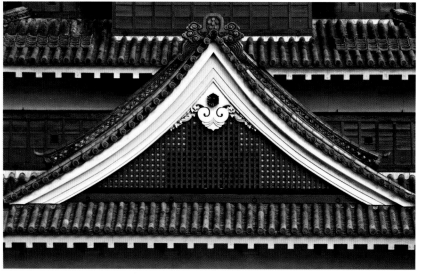

Detail of rooftop at Matsumoto Castle, Japan

## EMPHASIS ON THE HORIZONTAL AXIS △

Often there was no separation or distinction between sacred and secular architecture or between great and lesser houses. All tended to follow the same basic plan, and to express a similar emphasis on the horizontal, or width. The long, low styles, the flaring roofs, and the large compounds all reinforced the wide, spreading nature of the structures.

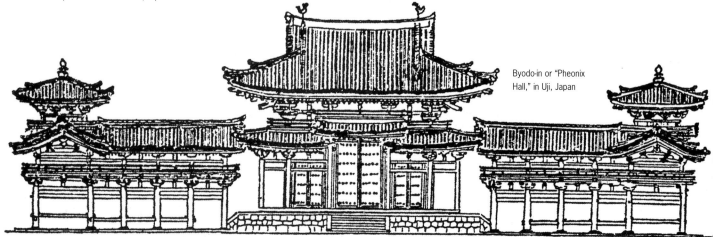

Byodo-in or "Pheonix Hall," in Uji, Japan

## INTEGRATION WITH THE NATURAL WORLD △▷

A key feature in all Asian architecture is a respect for, and integration with, the natural world. Where possible, structures are nestled carefully into the environment. Artificial lakes or woodlands in temple compounds and palace grounds are created with an artlessness that looks natural and unlabored. This is a feature perhaps as distinctive and defining as the shapes of the roofs for the fantasy artist, for it immediately marks the setting as distinct and different from the European norm, even if the castles are straight out of the Middle Ages or Gothic period.

Shibi, a type of architecural ornamentation in the shape of a dolphin's tail

## DOMINATED BY THE ROOFS ▽

The roof is the chief feature in almost all Asian structures, a dominating element that strongly dictates much of the layout of the house or temple, and which was emphasized, not downplayed as the Greeks or Romans did. Their method of construction was unique as well. Unlike their European counterparts, who raised a row of columns and then built the roof on top of them, resting it on the capitals, Asians built the framework for the roof first. From that, they determined the placement of the columns. The columns were then built under the roof framework, raising it up. The trusses that gave the roof its structural strength were formed of bamboo,

held together by wooden tenons in rigid rectangles, not triangles. This allowed the weight of the roof to be transmitted vertically, not outward, and necessitated the use of compound brackets, which attached the columns directly to the roof trusses without capitals. In this way, the roof was supported by rows of large, straight tree-trunk pillars of columns, not by the walls, which were thin, delicate, and entirely unsuited to bearing heavy loads. Imagine what your picture might convey if the walls became even more decorative, or lacelike, or incorporated visual elements from other architectural styles. Try creating a world with a hint of Asia and a hint of Gothic in the fjords of Norway.

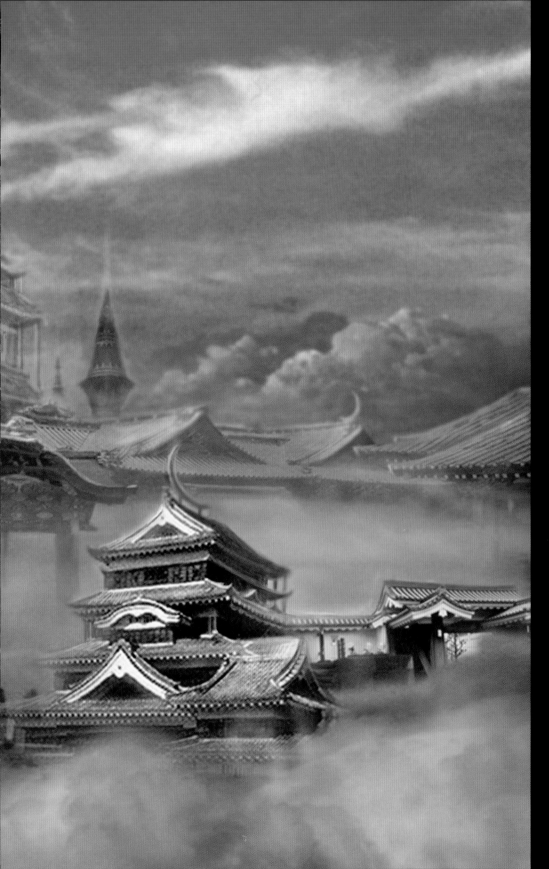

## PALACE IN THE CLOUDS

As was the case with the complex images on pages 16–17 and 20–21, this image combines elements from multiple styles, types, and time periods of Asian architecture as well as made-up elements. The need and challenge to create a detailed, "City of the Gods" illustration required an image that had the feel of a quintessential Asian structure, without looking like anything specifically Japanese, Chinese, or any other Asian culture.

### LIGHTING AND COMPOSITION

Backlighting was chosen to give a strong "divine light" feel to the image, and that naturally suggested roofs that were lighter on top, darker underneath in order to work with the lighting, rather than against it, and the use of the cool tones throughout meant that the warm colors of the central towers would clearly stand out as the focus of the image

Compositionally, the emphasis of the horizontal axis in the architecture is supported and echoed by the strong horizontal bands of clouds and the mists, maintaining the characteristics of Asian architecture and giving an innate credibility to the image. They read and define the image in spite of the many vertical pillars and towers, largely because of the strong use of the dark undersides of the rooflines to clearly create dark or shadow shapes, which will read well and establish the architectural forms while also creating depth and space in the image.

*Modern materials and construction allow for feats of design and construction that seem almost magical in their scope and execution. From gleaming glass and metal utopias to crowded, sooty metropolises, modern architecture presents the fantasy artist with a broad, unlimited canvas.*

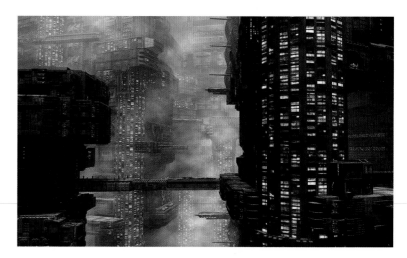

# MODERN AND FUTURIST ARCHITECTURE

Although there are limits to what modern architecture materials can do, or how tall buildings can be, or exactly what shapes can be created, for the fantasy artist, these limits become much less meaningful or confining, especially when creating images of the future. There is such an endless variety of building materials, styles, locations, and functions that limits become almost irrelevant. On the other hand, rules like perspective, lighting, mood, scale, depth, and proportion become even more crucial, as so many of the traditional visual clues are absent or distorted.

△ NOISY NEIGHBORS • PAUL BOURNE

Creating such a complex, futuristic environment requires an ability to capture mood, lighting, and texture, and to reduce the composition to fundamental, abstract shapes without losing the focus or story to the image. This wonderful example makes good use of atmospheric perspective, large simple shapes, and mood to focus our attention on the foreground towers, which are richly textured and detailed. Once the pattern has been established for them, the eye of the viewer will transfer that pattern to other objects in the image, allowing the creation of a complex image without the loss of clarity or focus on the central portion of the image.

DIFFERENT APPROACHES • FRANCO BAMBILLA (TOP) • PAUL BOURNE (BOTTOM) ▷

The top image suggests a densely populated utopian city bursting at the seams, built up over the years and complex in nature. The range of colors, shapes, and sizes indicate a place that has evolved. The lower image is mood driven, the buildings all painted in the same colors, textures, and materials, in order to create a sense of mass and uniformity. Atmospheric perspective is used to reduce the city elements to a large, solid shape. The city environment is a gritty, industrial, overcrowded metropolis of the future.

## NIGHT AND DAY

Noon on a clear, sunny day is not always the best choice of lighting, and with all the artificial lights of different colors, reflective surfaces and materials, and moods available in a painting of modern or futurist architecture, the choices of lighting, time of day, and mood are almost endless. Some images will naturally suggest a time of day, but if yours does not, don't hesitate to experiment and try multiple solutions to see what will best convey the mood, atmosphere, and quality of the image.

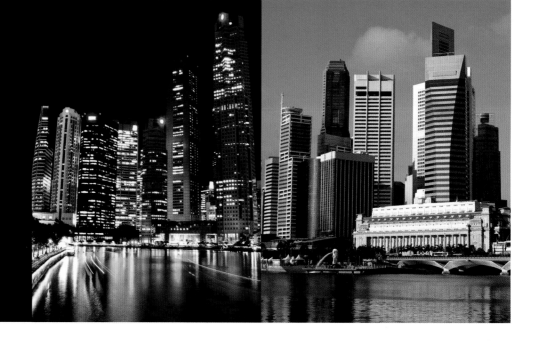

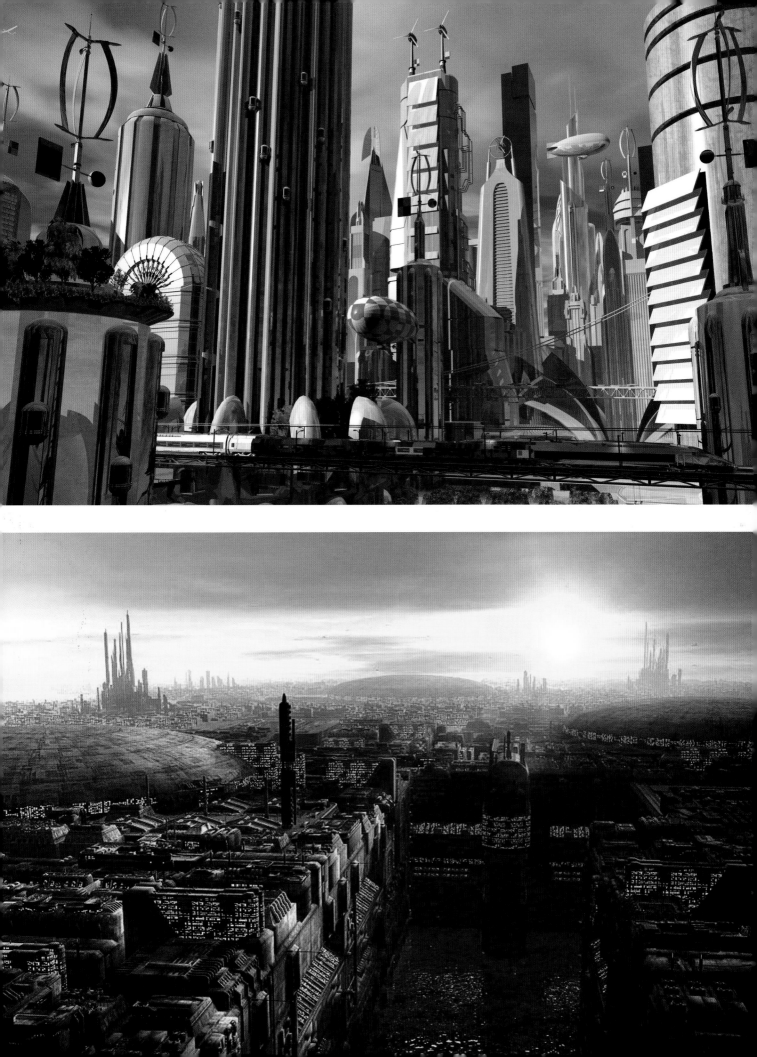

| Distinguishing characteristics | • Continuity without uniformity—cities do not spring up all at once, so don't make them look too uniform. | • Character —especially in future settings, look for ways to give your architecture visual character and identity. | • Form follows function—with such a variety of materials and styles possible, strive to let your design reflect something of | the nature and character of your architecture, the function of your building, and the materials it's made of. |
|---|---|---|---|---|

**LIGHTING ▷**
Modern and future cities can be lit from any angle, in any color, or combination of colors, which itself can create rich, complex atmospheres and moods. The exhausts, smoke, and steam from buildings can generate atmospheric perspective like haze and diffuse lights strongly and effectively.

# MODERN AND FUTURIST DETAILS

Modern architecture usually involves the creation of an entire city or complex, rather than an individual building, castle, or cathedral. Even if the focus of the image is a single building or small group of structures, it is most likely that other buildings will be visible in the mid- and background. This means that you must strive to find ways to simplify your image, to maintain the focus or concept, and to work with shape (both positive and negative) and value, as much as perspective or color. Start by creating a sense of space or depth, with mood, color, lighting, or perspective, even in your rough sketches as a way to establish the focus and emphasis

you want. Learn to think in terms of shape, perspective, atmosphere, light, and color, and remember that especially with modern or futuristic images, there are very few limits on shape or size of your structures. Your image may convey a shallow depth of field or it may encompass miles of space, in which case you must handle the elements with a strong use of picture-making fundamentals in order to maintain a sense of space, depth, scale, and proportion.

Look for ways to introduce variations of size, materials, colors, or textures in order to help break up the masses of your image or establish a focus or center of interest.

◁ **MATERIALS**

Most cities are built up over the centuries, with buildings being constantly added, removed, renovated, and updated. This means that there are a wide variety of surface materials and textures to choose from when you design your city, from stone and concrete to chrome, weathered metal, plastic, or glass. Learn to look at the world around you from the perspective of light and texture, and make a study of the way details, color, texture, and form are revealed by the different surfaces, as well as what intrinsic

mood, character, or story each has to tell, in order to create your own worlds and tell the stories you want to tell. For example, a gleaming tower of glass and chrome will look much different in the midst of a drab, industrial setting than it would rising from the lush green hills of an Asian harbor or the sands of an arid, rocky environment. As the context changes, so too does the story the building tells, the history of the setting, or the culture and mood of the people who populate your story.

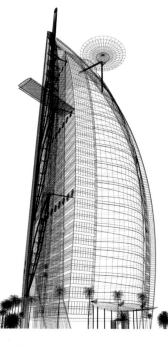

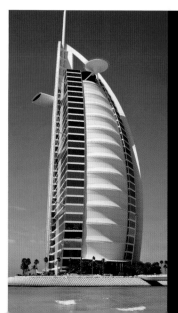

## BUILDING SHAPE AND STRUCTURE

Buildings shapes can range from rigid, linear designs to the abstract, sometimes combining both in a single structure. Proper use of perspective, scale, and proportion become crucial when dealing with buildings that are irregular in shape. Look for ways to simplify their shapes, or establish the perspective and depth with secondary structures, so that the viewers know what they are looking at, and to give yourself a guide for the design of your buildings or cityscape.

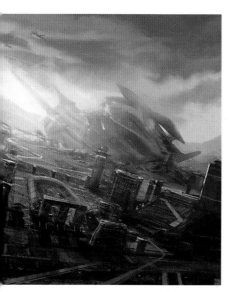

## ◁ CRASH SITE •
## LORENZ HIDEYOSHI

Sometimes it's the deliberate differences and dominating quality of the structure that tells your story or that conveys your idea. In this image, the crashed ship reads first as a building, its scale and location making it seem like a part of the city that dominates the other structures around it. What at first reads as a building deliberately designed to dominate its surroundings, proclaiming its mastery like Ozymandias's statue is then revealed to be the wreck of a crashed ship, creating a story within a story and engaging the viewer.

## ◁ ▷ INSPIRATIONAL BUILDINGS

Modern architecture is full of buildings that resemble space ships, giant sails, staircases, tubes, and tunnels—almost anything you can imagine. Modern construction material and techniques allow for such a wide variety of design and form that the fantasy artist is truly limited only by his or her imagination. Challenge the accepted ideas and conventions, let your mind go, and you will find there is little difference between creating a city of the far future, where impossible-seeming angles and shapes hold together almost in defiance of logic or physics, and creating a castle or cathedral held together and shaped by the forces of magic.

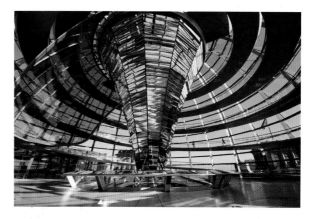

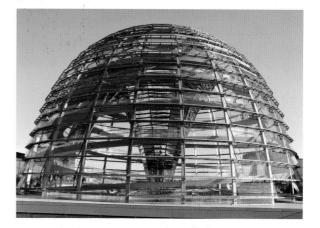

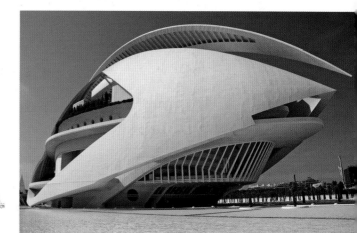

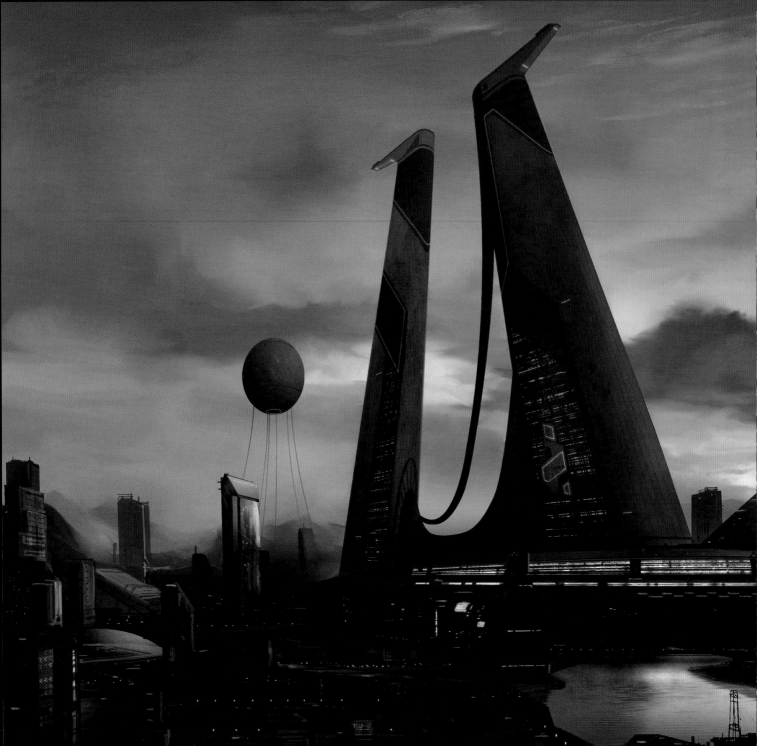

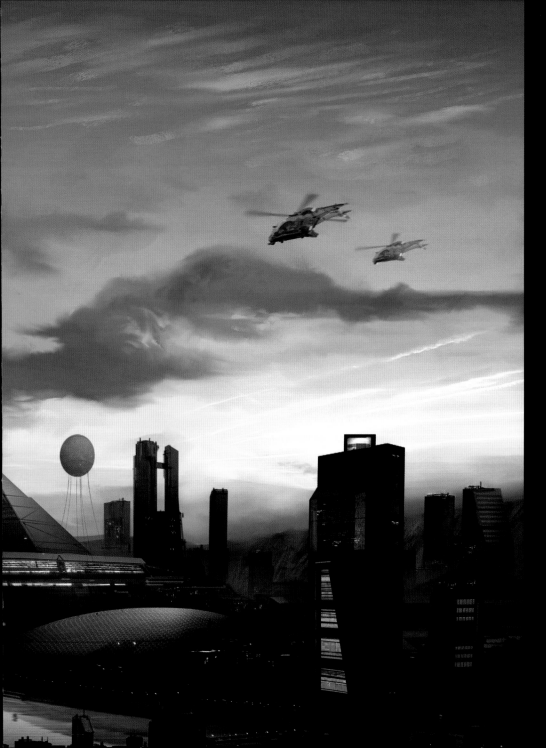

## MEGA-STRUCTURE •
## LORENZ HIDEYOSHI

Creating a complex, large cityscape can seem daunting at first, but by breaking down the process, working with value, shape, perspective, and keeping a central concept in mind, the process is made manageable.

### Focus

In this painting, the focus is on the large central tower structure, which dominates the center of the image. All the lines and shapes of perspective lead the eye toward the structure, as do the clouds, the water in the mid-ground, and the helicopters.

The city itself is organized into large shapes, separated by value, texture, and vertical points of emphasis, with the distant parts merging into a single mass. Selective details and buildings provide scale, depth, and form, and clearly establish the perspective.

The base of the mega-structure is the only strong horizontal band of light value, drawing the eye and anchoring the tower. The water in the middle of the image further isolates and emphasizes the structure, providing a light but cool passage that contrasts with the warm colors of the structure's lights. The foreground is similarly treated as a large mass, darker than the mid-ground, its contrast reduced so as not to compete with the central tower.

The details and buildings in the lower-right corner work to establish a pattern, scale, and perspective, and by setting them against the reflected light of the water and the misted background, they read clearly without dominating the image or detracting from the center of interest.

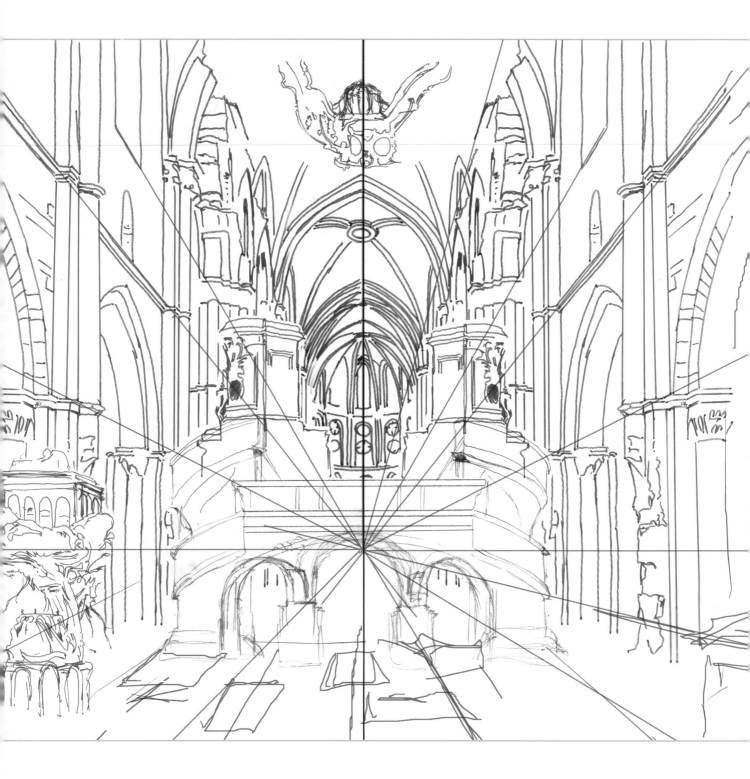

# PICTU KING
# TECHN

*A knowledge of arch requires an equally strong knowledge of art techniques to bring your imagination to life. This chapter covers the basics, with the emphasis on drawing and painting architecture and understanding lighting, perspective, mood, drama, and color theory as it specifically applies to drawing and painting architecture.*

# LIGHT, SHADOWS, VALUES, AND SHAPES

*Painting is all about light—you are never just painting a building, you are painting the effects of light on that building.*

Light reveals the nature of your buildings and gives a focus to your image, whereas shadows provide the three-dimensional structure and the framework. The center of interest in your image will always be in the light.

## Highlights

Look for highlights where a plane changes direction, or at the corners of objects. Remember that the highlight will usually be influenced more by the color of the light source than by the object being illuminated. Because you are striving to create the illusion of brightness, or its absence, always look for contrasts, for ways to strengthen the illusion you are crafting. To make the highlight you paint look as strong and bright as possible, place a cool highlight on a warm object, or a warm highlight on a cool object. This will create not only value contrast, but also color and temperature. Other ways to make your lights look brighter are to darken the areas around them, or to add more color in the transition zone between the light and shadow areas and reduce the amount of color in the highlight. The brighter a highlight, the less color you will see in it. In your light areas, strive to have only one dominating element—either the value or the color, but not both.

## Shadows

Keep the paint in your shadows thin and smooth, and avoid adding unnecessary details or information to them. Shadows should be sections of the painting that the viewer's eye flows past, with barely a pause, on the way to the next section of light, information, and interest. Most of the time, shadows will be warm colors, because most light sources are cool, and the warm tones will read as transparent, or as the absence of the cool light, and will recede in space. Even on cool-colored objects, such as blue tiles or a dark green material, you may need to make the shadows warm in order to create the illusion of depth and give them transparency and softness.

## Choose Your Lights

Your initial concept will strongly suggest or dictate the nature of your light—soft or harsh, low or bright, interior or exterior, even the time of day or season. Make the choice based on what will most strongly convey your idea, and work up numerous studies if you're unsure of the best solution. It will be time very well spent. Now is also the time to work out how the light will flow and move across your image, exactly what you want to reveal or conceal in your image, and how you want to lead the viewer's eye across the canvas. Think of your image like a song or dance, with rhythm, balance, flow, accents, pauses, and loud or fast sections, counterpointed by slow, graceful, and gentle areas. Think also of your lights as a hierarchy, a scale from the king and queen to the prince and on down to the farmers and peasants. You can have a lot of peasants, and more than one prince, but only one king or queen, who will be the primary focus of your painting.

| Key Points | | | | | |
|---|---|---|---|---|---|
| • Choose your lights—decide what type of lighting will best convey your idea, your initial concept. | • Be consistent—once you have decided on a type of light, be consistent with it throughout the image. | • Closer is always more—the closer an object is to the viewer, the more of everything it has: contrast, color, sharpness, and intensity. | • Look at the lights—the eye will always focus on the light areas of a painting, so make sure you place all your important information there. | • Shadows are the anchors—they must describe the forms, or the shapes of your objects. Keep them simple, thin, transparent, and "shadowy" in nature. | • Limit your values—this is true in almost all cases, and particularly if your picture is starting to get too complex and does not read well or clearly. This does not mean reducing the range of your values, just the number of different values you are using. |

## LEADING THE EYE WITH VALUE AND SHAPE

Even within the same general composition, the shapes, values, and break up of space will significantly affect your composition and the way the viewer's eye moves through the painting. These examples below show the effects of simplifying and massing the lights and darks within the same composition, studying how these changes alter the center of interest and rhythm of the painting. The simplification of values also affects the mood and composition of the painting, which allows you considerable control not only of how the viewer looks at your work, but also what he or she will focus on within the image.

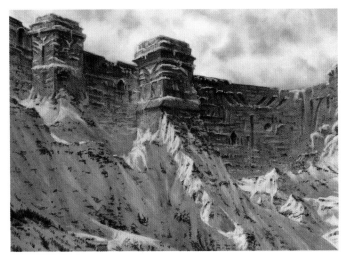

**Moving and trapping the eye** Use the light to control and move the viewer's eye: note how the high contrast between the lights and darks of the snow in the center of the image (**1**) work in conjunction with their shapes to march the eye up the image to the central tower and hold it there. Note how the change in value on the wall (**2 & 3**) echoes that of the mountain, despite their different base values, reinforcing the curved shape of the wall, and providing a dark base from which the central tower emerges.

**Breaking up shapes with values** Here, the focus is still on the central tower, but it is accomplished by leading the eye to it through the use of strong, dark, simple shapes, isolated by light values. The light beams breaking over the wall (**1**) provide backlighting, break up the shapes, and lead the eye downward to the curve of the mountain (**2**), which leads the eye back to the central tower. The faint light beam (**3**) keeps the eye traveling up to and over the tower, then back down the light beams.

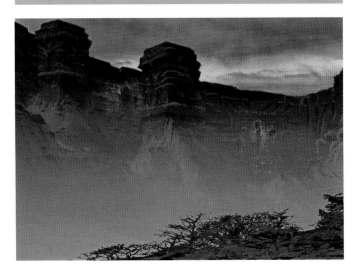

**Layering values to create depth** The wall has been reduced to a near solid dark mass, but the faint suggestions of form, and the shape of the wall itself keep it from reading as flat. Even though the sky is also dark, the light band (**1**) allows it to sit behind the wall, creating depth and space. Foreground elements have been introduced, but kept very dark against the lighter part of the wall (**2**) to further reinforce the depth. The focus has now become the small warm lights on the wall itself (**3**).

### CREATING A LIGHT PATH

It's not enough to have light and dark values in your painting—they must do more than be there, describe a form, or take up space. The eye will automatically move to areas of light, which means you, as the artist, have to work with and design the light, lead with the light, in order to move the eye of the viewer where and how you want. Use the rhythms of the lights and darks to guide the viewer toward the important elements in your image. Remember that the lights will automatically become places of interest in your image and areas with the most information, so they will also become the road map by which you guide your viewer.

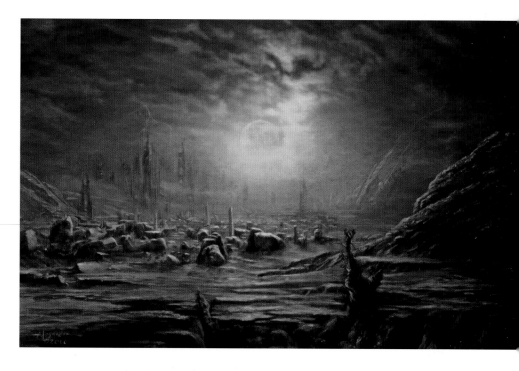

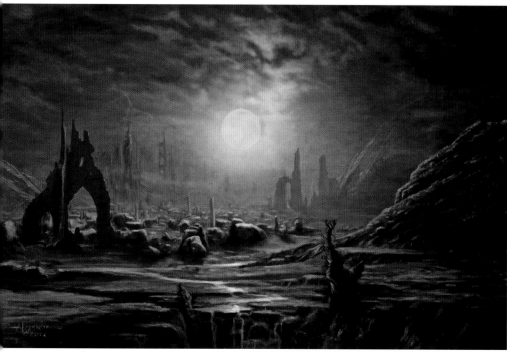

△ **Generalized lighting, lacking focus**
Here, a painting of ruins in the moonlight lacks a clear focus or rhythm—the ruins have been pushed into the background, subordinated to the stones of the mid-ground. And although there is light and dark contrast creating depth and volume, and describing surface textures, there is no path of light, no rhythm or dance or movement for the eye to latch onto and be guided by. In a very real sense, it is a painting lacking highlights, and so lacking focus, movement, or a center of interest.

◁ **Highlights provide a rhythm for the eye**
Here, the addition of the river, a brighter moon and clearer, darker shapes for the ruins give the eye a specific path and points of emphasis, and allow you to direct the viewer where you want them. The river flows toward the viewer, off the page, but the shape of it serves to lead you right back into the image, creating a movement and rhythm within the painting that begins at the edge of the canvas and leads the viewer instantly into the image, as well as clearly establishing space and depth.

## Be Consistent

Once you have decided on the lighting for your image, be consistent with it. This does not mean making everything equal, even, and uniform, as every picture needs variation, a gradation of light creating areas of stronger or lesser light. However, you must be true to your lights. Don't paint part of a bridge in strong, bright, noonday light and then paint the figure standing on it in soft, hazy lighting, or light the top of a tower from the left, but the bottom from in front or from the right. Keep the direction of your light in mind as well. If your light is striking the upward-facing planes most strongly, for example, then the left-facing planes, and then the right-facing planes maintain that relationship throughout the painting. Vary the light strength, working with shadows to sculpt and design the image, but maintain the basic direction of your light. Remember that if you have the strongest light striking a rock on the floor of a cathedral, for example, then the light that washes past the

TYPES OF LIGHT

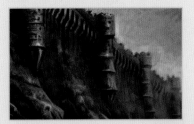

▽ **Top lighting** Upper planes are most strongly lit, and often reflect light back up into the side planes, most visible closer to the upper plane.

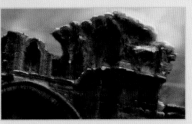

△ **Backlighting** Shape is reduced to a dark mass, detail is visible only where light strikes rounded edges or protruding forms from behind.

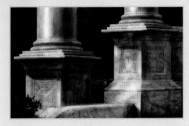

▽ **Classical lighting** Light strikes object from in front at a three-quarter angle, and above, as if coming over the shoulder of the viewer. Traditional lighting for indicating shape, mass, and texture all at once.

△ **Volumetric lighting** Lacks strong highlights or shadows, light seems to come from everywhere at once. The overall shapes read clearly as masses, with minimal details. Common on foggy days.

rock and touches the ground will also be strong, and the shadows created will be the strongest, darkest value shadows in your image. This contrast of strongest light and darkest dark will draw the eye to your center of interest.

## Closer is Always More

The closer something is to us, the more color, contrast, and intensity it will have—darker darks and brighter lights, with stronger colors and sharper edges. When your center of interest is the closest object to the viewers, it becomes easy to focus their attention on it. When that is not the case, you need to make sure your values and composition work together, maintaining the focus of your image without losing a sense of depth, or the illusion of space you've created.

## Look at the Lights

Our eyes are naturally drawn to the light areas of a painting. Not only will this determine what viewers will focus on in your image, it allows you to control how their eyes will flow across the canvas. A large part of creating a strong composition is not just in the placement of interesting shapes next to one another, but also in the careful arrangement of lights against darks. You want to lead viewers through the image like a skilled tour guide, pausing for emphasis or information only where you want to, telling the story as only you can. Learn to achieve this by picking and choosing where, how, and what you illuminate in your image.

## Shadows Are the Anchors

Shadows describe the overall shapes of your objects, providing a foundation for your image and a stage for all those wonderful lights. Keep them simple, think transparent, and avoid adding unnecessary details or information. Paint them from dark to light, and leave all details and reflected lights until your painting is almost finished—you will be surprised at how far even a few touches here and there in your shadows will go. Look for areas where your shadows will benefit from dark accents—they can be just as powerful as highlights in describing your subject, adding structure, points of interest, or clarity in small, select spots. Lastly, when painting outdoor scenes, remember that the shadows disappear sooner than the lights, and that they are more affected by the air between you and your subject. Under a blue sky, for example, shadows will take on a cooler, bluer cast as they recede.

## Limit Your Values

Imagine that you had to create your painting with only five different values, or four, or even three. You can still use the full range of values, from white to black, but you would find yourself grouping them together, or very carefully and selectively using them, setting them against one another for maximum effect, crafting the composition and the final image and thinking about each brushstroke before you put it down. It's a very powerful and effective way of creating a strong image, and if your painting is looking busy or lost, it's one of the first areas to examine, to make sure that you are not losing the focus by breaking up your values into too many pieces. Once you have your values worked out in your initial sketch and composition, don't change them over the course of the painting. If they were right in the first place, they don't need changing, and if they were not right, you should not be progressing to the final painting until they are.

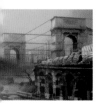

# PERSPECTIVE, DISTANCE, AND DEPTH

*Perspective is really just creating the illusion of depth, or space, on a flat page or canvas. Anyone painting architecture must be familiar with perspective, and comfortable applying it.*

## Definitions

The rules for perspective are fairly simple, and consistent, as the following definitions and illustrations show.

**Linear perspective** gets its name from the fact that it's based on lines—the edges of objects. The receding edges are projected into space and continued along until they meet at a point on the horizon line.

**Atmospheric perspective** is the effect the air has on light passing through it. The more air there is the more noticeable the effect will be. The most common example is the way the colors of objects in an outdoor scene shift toward blue as they get farther away, as well as losing contrast and sharpness.

**The horizon line,** in simple terms, is a horizontal line that represents the height from which the artist is viewing the scene. It can be high, low, near the ground, or the top of a cliff, or anyplace in between. Everything in the picture that is above this line is being looked up at, while everything below this line is looked down on. When the projected edges of an object converge at one or more points, these points will always be on the horizon line.

**The vanishing point** is a point on the horizon line at which the parallel lines from an object appear to converge. There can be one, two, or three vanishing points for each object in your painting, depending on whether it is in one-, two-, or three-point perspective.

**One-point perspective** occurs when you and all the objects in your scene are parallel to each other, for example, when looking straight down a city street or the aisle of a cathedral. In this case, lines extended from all the side planes will appear to converge at a single point along the horizon line, while all the front planes will be parallel to the horizon line.

**Two-point perspective** occurs when the objects you are viewing are at an angle to you, for example, when you are standing at a street corner and looking diagonally across the street. There will be an edge of the object that is closest to you, called the leading edge, and two side planes that face away from you. Lines extended from each of these side planes will recede to a vanishing point on the horizon line, so we call this two-point perspective. When all the objects in the scene are parallel, such as the city street, there will only be the two vanishing points, but if they are not parallel to each other, such as the furniture in a room, there may be multiple pairs of vanishing points.

**Three-point perspective** is very similar to two-point perspective, but with the addition of a third vanishing point above or below the horizon line at which all the vertical edges of your objects will converge. Three-point perspective is used most often when depicting very tall structures, or when looking down at a scene from a great height.

**The vanishing trace** is a point above or below the horizon line for vertical objects, or along the horizon line for horizontal ones, that is used to determine the correct, even spacing for objects, such as a row of pillars or wall piers, the tiles on a floor, or the slopes of rooflines in perspective.

| Key Points | • Basic rules—perspective is regular, predictable, and simple, once you understand the basic rules of it. | • Learn the principles—perspective will let you easily establish the heights of buildings, create space, or three-dimensional structure, or maintain consistency of scale within your image. | • Make your art credible—even in simple sketches or rough paintings, keeping the perspective accurate will give credibility and solidity to your structures. | • Apply the principles—perspective can be used to lay out not only the architecture you're painting, but also to determine the surrounding environment, the cast shadows, and the spacing between objects in your paintings. |
| --- | --- | --- | --- | --- |

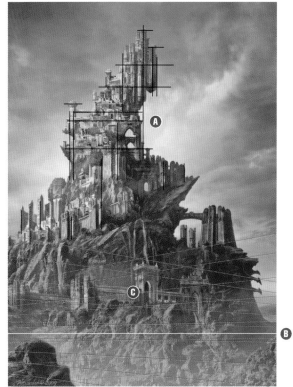

## △ CONTRASTING STRAIGHT LINES AND ANGLES TO CREATE DYNAMIC TENSION

In order to generate the sense of mass, of layering, and of the city marching its way up the cliff side in a zigzag pattern, it was painted in one-point perspective (the horizontal lines of the city (**A**) are paralell to the horizon line (**B**)). This kept the forms strong, straight, and clean. A sense of scale was established through the use of repeating shapes. The choice of one-point perspective in conjunction with the elevated eye level combines to give the viewer a sense of floating in the air, looking across at the city. The dynamic between the angles and organic shapes of the cliff itself (**C**) contrast with the straight lines of the castle (**A**) to create tension and movement within the painting.

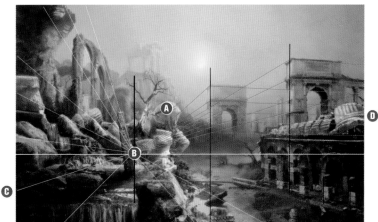

## USING PERSPECTIVE TO CREATE MOVEMENT IN A PAINTING ▷

Here, the left-side lines from the twin arches all pass through the middle of the seated figure (**A**) to converge at a point just in front of the leaning rectangular stone pillar (**B**). This is not accurate in terms of establishing the two arches as being the same size, but is done to create a series of lines that the eye of the viewer will naturally be drawn to (also see lines (**C**)). Viewers will follow those lines to the left, every bit as much as they will follow the gaze of the figure back out to the right (**D**). The lack of a head on the figure, or continuity of the perspective lines, does not impede the flow of the viewer's eye—the mind will fill in the missing information, engaging the viewer, and creating movement and complexity in your composition. The perspective also serves to create a strong sense of depth and space in the image, and allows the viewer to read one object as being in front of another.

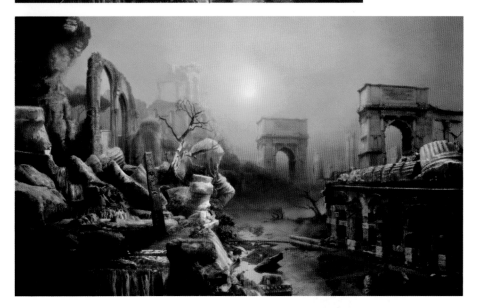

◁ **ESTABLISHING SCALE WITH THREE-POINT PERSPECTIVE**
Often, scale can be easily established by the use of a figure or other object that the viewer will easily recognize. In situations where those elements do not appear, three-point perspective (with three vanishing points, the extension the perspective lines (**A**, **B** & **C**)) can help create scale and proportion. In this image, the elongated composition and the use of three-point perspective, with all the structures leaning inward, lend both scale and movement to the painting. The viewer may well be accustomed to looking upward and seeing this type of perspective in their own experiences, perhaps looking at very tall skyscrapers or cliffs, so by treating the arch and spires in a similar fashion, it gives the sense that they are of equal or greater height to those immensely tall familiar objects.

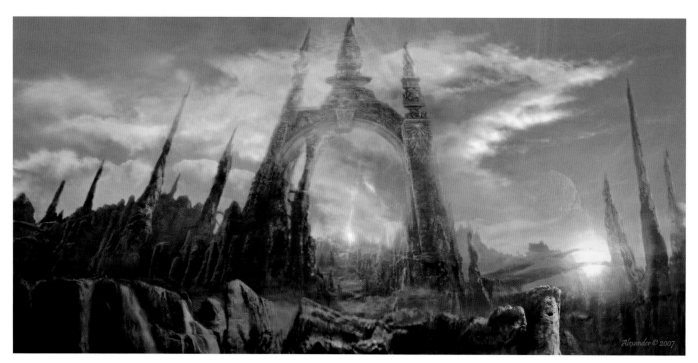

CONTROLLING THE SIZE, SPACING, AND ANGLES ▽

In this drawing, overlays clearly indicate how the spacing of the row of columns was determined. The first two columns were drawn freehand. Lines (**A** & **B**) are drawn for the horizon line and from the top of the first two columns to their vanishing point. Another line (**C**) is drawn from the midpoint of the first column to the vanishing point. A fourth line (**D**) is then drawn from the top of the first column, through the midpoint of the second column, to the horizon line. Where line (**D**) crosses the horizon line (**E**) is the vertical line for the center of the next column. This method of equal spacing works in one-, two-, and three-point perspective, on vertical, horizontal, or angled surfaces. The line representing the middle of the next object in perspective can even be shifted up or down for vertical shapes, or left to right for horizontal shapes.

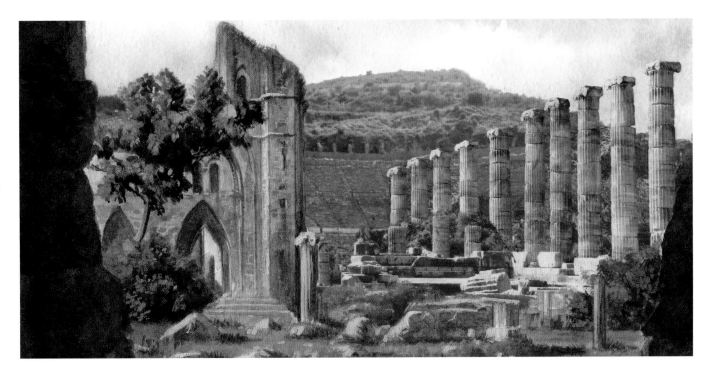

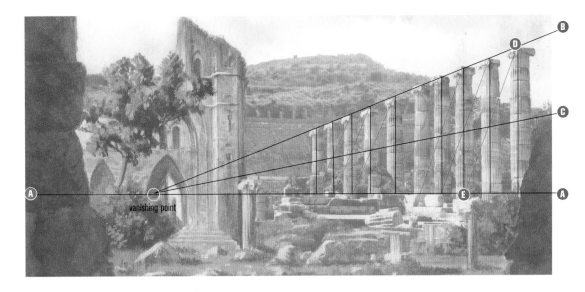

vanishing point

◁ THE COLOR OF AIR

Atmospheric perspective is all about creating depth and space in your images by painting air, or, more accurately, the effect of the air, on the light that passes through it as it travels from the objects in your image to your eye. However, it can also be an extremely powerful tool for creating mood, or a sense of lighting, for simplifying shapes or establishing a focal point in your image.

In this example, the sunset color dominates all the background elements, color and value are shifted toward that of the sky, and masses are simplified. As a result the focal point shifts quickly to the foreground, which reads clearly.

Atmospheric perspective can also be forced or exaggerated in order to create a very strong sense of depth or mood within a relatively flat picture plane. An example would be the interior of a room: if the effects of atmospheric perspective are pushed or exaggerated, a tremendous sense of depth can be created, focus established, and masses simplified with ease, allowing you to create a strong story or mood.

# COMPOSITION AND CONCEPT

*Composition is the arrangement of values, shapes, and colors, the rhythm of lights and darks, and the overall design of your painting. Concept is the driving force behind all the compositional choices; it's the underlying idea that holds your picture together, giving it life, unity, and energy.*

## Conceptualize First

The concept is the underlying idea that binds your whole image together and gives it direction and purpose. For example, if you want to paint the flooded ruins of an old city, where do you start? The idea is too vague. Even if you add a setting, such as a river, and an architectural style, such as Romanesque, there is not yet a clear idea of how to approach the painting. You must ask yourself what it is about the city ruins that you most want to explore and convey. It could be shape, color, value, texture, a play on intensity, or an exploration of bright or low lighting, for example. These are concepts.

Let's pick color as our concept, and let's refine it further. The painting will be about a splash of strong, warm color in a field of cool neutrals, perhaps the remnants of a dome or bit of paint against the dull color of the stone. Now you have a clear focus to begin defining, driving, and unifying your painting, and a gauge to constantly refer back to that will both keep you on track and tell you when you are finished.

**THUMBNAIL** ▽

In this thumbnail the overall concept of the warm area set in a field of cool colors has been defined. Now it's time to explore how best to compose and arrange the image. It's often helpful to begin with very loose thumbnails, drawings that can be made in fifteen seconds or less. Focus on the idea, and explore basic shapes and values. At this stage the drawings often look as much like abstract shapes as they do buildings.

◁ **INITIAL SKETCHES**

These two initial sketches explore more fully the ideas in the thumbnail above. Each has been sketched rapidly, and has focused on capturing a sense of depth, of shape variation, and working with shadow shapes. Here the initial concept, rather than the reference, is the guiding point, allowing the image to develop on its own, rather than being limited by the reference. Each sketch has a primary feature or section of the ruined city that is strongly silhouetted, reads clearly, and could be painted warm and made the focus of the image.

---

| Key Points | • **Conceptualize first**—you need a focus, a direction for your painting. | • **Explore your composition**—no great design ever happens by accident. Explore your options and strive to create the strongest composition you can. | • **Simplify**—focus first on the large masses, shapes, values, and colors. Details can come later. | • **Unity**—work the whole composition at once. | • **Tension**—look for areas of contrast within your picture design, such as lights against darks, large and small shapes, or dull colors against bright ones, in order to add tension, vitality, and complexity to your composition. |

◁ **FINAL SKETCH**
The final idea is now taken to a final sketch. At this point, reference material is gathered to add the necessary realism to the city. Even in a ruined state, there must be enough architecture to make it read clearly, and it must be drawn accurately.

**VALUE AND COLOR STUDIES ▷**
Now that the final drawing is complete, it's time to consider color and shape more thoroughly. Using flat colors at first, explore the large shapes. The emphasis is on establishing a basic palette, a warm to cool range that will allow you to maintain the focus of your initial concept, and to create shadow shapes and negative space that will strengthen your composition. Here, the studies progressed from flat fields of color that very clearly establish the shapes into a small watercolor study, which allows for more subtlety and variation although still allows you to work quickly. The watercolor study (**4**) was about 4 x 7 in on watercolor paper, and took about fifteen minutes; the flat color studies (**1–3**) were done in Photoshop, and took about seven minutes each. Again, the purpose here is not to paint details, but to work out how the large shapes, colors, and values will work together.

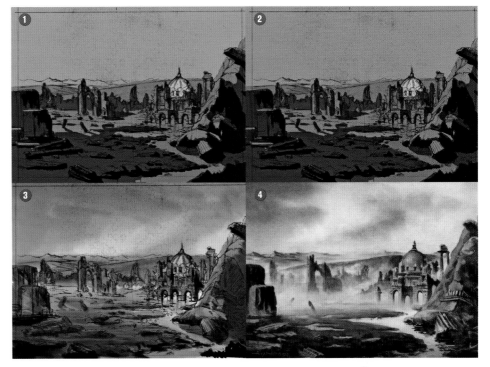

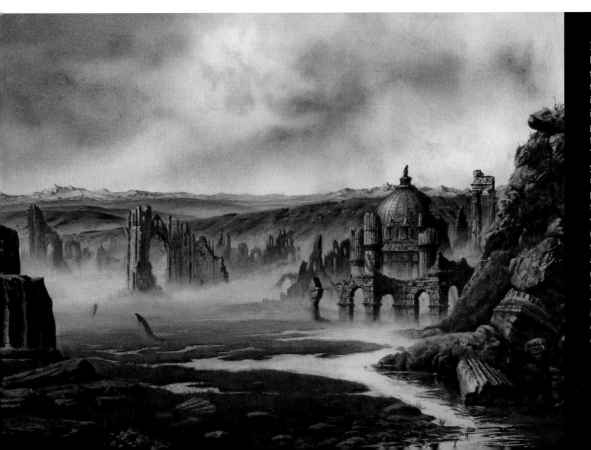

**FINAL IMAGE**
Building on all the steps that have come before, the image is painted in watercolor. However, it's not just a matter of painting what was done in the studies in more detail. You have to evaluate what you are doing at each stage of the creative process. Here, the right foreground hill structure was changed to create more of a stepped look to the shadow shapes and allow the ruins to read more clearly, whereas the grasses were painted with cooler, darker colors in order to more clearly emphasize the warm dome in the mid-ground.

The emphasis and focus of the painting developed on the previous page has shifted from the dome and pillars to the ruined arch in the mid-ground. By massing the right hill and domed ruins into essentially one large shape, and exaggerating the warm to cool contrasts of the mid-ground arch, the focus has shifted to the middle of the image. Cropping the image further simplifies and strengthens the massing.

Here, the focus remains on the dome and pillars on the right, but the visual solution is different. The colors of the scene have been desaturated, and a mist hides much of the background hills and city. This simplifies the image considerably, allowing the viewer's attention to be held by the dome itself, which is the section of strongest color and contrast. The waterway leads the eye into the image, and separates the fore- and mid-ground.

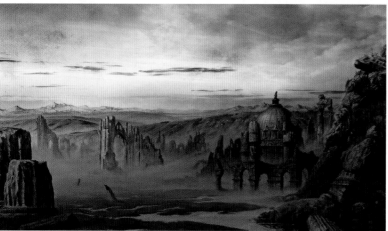

Rather than echo the warm colors of the dome with the reflections in the water, the foreground has been darkened and subdued, and the color is mainly in the sky and the dome, which remains the focus of the image. The sunset color scheme and brighter colors alter the mood of the image, and draw the viewer's eye upward. The result is a softer, more romantic version of the ruins.

## Explore Your Composition

Great design does not just happen by itself. Explore your idea fully as you compose, and be willing to make the changes necessary to improve the image, without getting precious about an element or detail.

## Simplify

As you compose, look for areas that you can simplify in your image. Can you express something with a fewer number of values, with larger or simplified shapes? Can objects be grouped into larger masses of dark or light? Do not worry at all about details at this stage, just about the overall design.

## Unity

It's easy to say, harder to do. Practice composing the whole canvas at once, keeping your brushstrokes loose and gestural.

Hold fast to your concept, and, at first, treat all the elements with a similar level of finish and finesse. Sometimes you will find that you're adding shapes and values with no clear idea of what they might represent in your image, only a knowledge that they are right for the composition. Don't worry about it—you can make the shapes into something specific later on, but for now, focus on working the whole canvas at once and making the design strong and clear.

## Tension

Learn to look for contrasts in your image, places where you can create tension, interest, or focus. A strong composition needs contrasts, whether it be large shapes set off by smaller ones, lights against darks, symmetry and asymmetry in opposition, or simply fields of complementary colors against one another.

## EXPLORING NON-COLOR SET AGAINST COLOR

The overall concept was one of colorlessness in the focal point being set off by stronger colors in the body of the image. Your eye tends to go toward areas of light and color, so the idea was to separate the two to create an image that succeeded, even though it went against the expected rules.

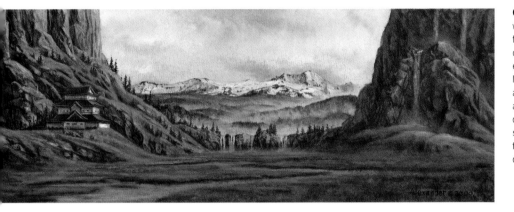

**Competing colors** The first solution was typical bright afternoon lighting, with fairly clean colors in the landscape and the castle painted primarily in whites. While this emphasized the castle against the hills, the light tones of the distant mountains, mist, and waterfalls competed with the castle for attention. A lack of clear warm and cool color relationships or of clearly massed, simple shapes also distracted the eye from the castle, as details in the hills and field competed with the details of the castle.

**Simplifying values** Hazy afternoon lighting was substituted for the brightly lit version, with more success. Values were simplified and grouped throughout the image, allowing the shapes to hold together more strongly, while the haze reduced the contrast and values of the mid and background sections. This allowed the colors of the foreground to appear more strongly saturated, emphasizing the castle's lack of color and making it much more of a focal point.

**Saturating the palette** The use of sunset lighting allowed the values of the foreground to be further simplified, massed together, and darkened, while at the same time the overall palette became more saturated. This allowed the castle to clearly become the dominant focus of the image. By eliminating the lighter values in the sky and foreground water, and introducing a light beam that cuts obliquely through the foreground field, the eye is drawn first to the castle, then to the cliff side, across the cloud, and down the hills on the right, moving in a continuous loop that always emphasizes the castle.

# COLOR THEORY AND USAGE

*Color is fairly meaningless on its own, and really only becomes relevant when in context with other colors. Don't think in terms of single colors, but rather in terms of color relationships.*

**COMPLEX RELATIONSHIPS** ▽
Color wheels seldom capture all the variables inherent in color, but they can provide a good starting point. Here, the differences in hue, value, and temperature become clear, as each color flows seamlessly into the next.

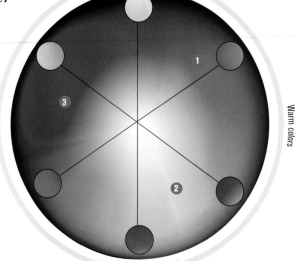

## Color Variables and Relationships

Color only has a few variables:
• Hue—the color itself; such as red, yellow, blue;
• Value—how light or dark a color appears;
• Intensity—how bright or dull a color appears;
• Temperature—how warm or cool a color appears.

Where it gets complicated is in the relationships between one area of your canvas and another. There are no absolutes in color. What appears warm and intense in one painting may look dull or cool in another. Our eyes perceive color relationships—we see a red against a blue, for example, and what we truly gauge is the difference between the two colors. The red may look warm next to the cool of the blue, but that same red next to a bright orange or yellow may look cool and dull. The red has not changed, its context has, and so it looks very different.

**Color Wheel**
**1** Red transitions in warm tones, becomes orange, then yellow.
**2** Yellow then transitions in cooler tones, becomes green, then blue.
**3** Blue transitions in cool tones, becomes violet, then as the blue fades, color returns to red.

**Complementary colors**
Complementary colors are the colors opposite each other on the color wheel: yellow with violet, blue with orange, and red with green. Mixing a color with its complement dulls it, or creates a subtle neutral, depending on the ratio of the two colors.

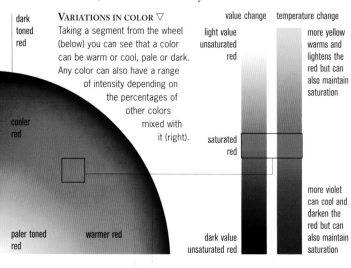

**VARIATIONS IN COLOR** ▽
Taking a segment from the wheel (below) you can see that a color can be warm or cool, pale or dark. Any color can also have a range of intensity depending on the percentages of other colors mixed with it (right).

dark toned red

cooler red

saturated red

paler toned red          warmer red

**value change**
light value unsaturated red

saturated red

dark value unsaturated red

**temperature change**
more yellow warms and lightens the red but can also maintain saturation

more violet can cool and darken the red but can also maintain saturation

▷ Generally the best way to modify a color is to use its complement color, which will give more interesting, lively color mixes. For example, to reduce the intensity of a particular red, mix in a green rather than straight black. Keep the value of the green and red the same if you only wish to adjust the intensity, but if you need to adjust the value of the red as well, lighter or darker values of green can be used.

lively mixes          dull modified red

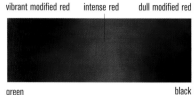

vibrant modified red     intense red     dull modified red

green                                    black

◁ Lightening or darkening a color with another color, such as yellow, creates temperature as well as value changes, and keeps the colors vibrant, whereas adjusting the value with white, gray, or black will dull the color. In this example, the red and yellow combine to create a range of pale, warm, lively colors, while the gray and red combine to form lifeless, washed-out looking colors, even though the gray and yellow are the same value.

| **Key Points** | • Stay true to your values—once you have established the values, don't lose those values and relationships when you apply color. | • Choose wisely—don't use a color because it's pretty, because you like it, or because it worked in your last painting. Use a color because it's the right color for the object you are painting. | • Tension creates interest—colors need contrasts, opposites, and tension, just as shapes and values do. | • Unity through light—the color of your light source will provide cohesiveness to your painting, tying everything together. | • Build on a strong foundation—lay in the shadows of an object first, then the local colors, allowing them to emerge from the shadows. In the same way, apply the brighter lights and highlights after the local colors and mid-tones have been laid in. |

## Stay True to Your Values

You carefully crafted and balanced your value relationships when you were laying in the composition, so be sure not to lose or change them when color is applied. Value change can modulate colors, but changes in temperature or intensity are just as effective. Utilize these options to model subtle changes in lighting or structure within a plane or area of your painting, or to push an object back into space or bring it forward, without altering the carefully crafted values or losing your overall concept. Edges are particularly important in creating the illusion of depth. Your primary tools are always value, color, focal point, and shape, with the end of one shape or stroke being the start of another. Lay in paint with care and deliberation, crafting your image. Colors need to accomplish two tasks in your painting—create the illusion of space and depth, as well as describe the form you are painting.

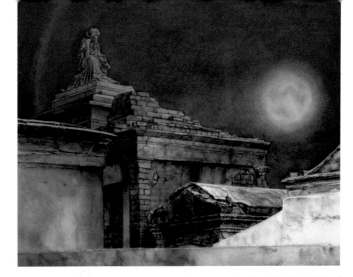

**CHANGE COLOR, NOT VALUE** △▽
The value relationships hold the image together, but color can play a large part in what the eye is drawn to. The black-and-white version of the image shows just the values, and the eye is drawn to the lightest area, the small geometric shape in the foreground. Without changing the values at all, the lighting is adjusted to an overall cool palette, and the eye can be directed to the middle of the image, and then into the figure in the background, by the use of a matching cool color on the crypt. In the warm palette version, the eye once again goes first to the foreground shape, then to the middle crypt secondarily, while the figure fades into the background.

Cool palette

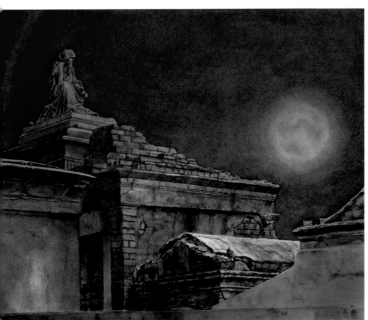

Warm palette

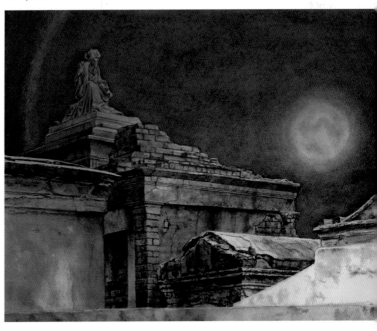

**COLOR TO CREATE DEPTH**
◁ In this image, the ledge is made to recede in space not by changes in value as it moves away from us, but simply by the use of color, maintaining the light, open airy feel of the image without sacrificing any sense of depth.

◁◁ Here, value changes have been used to create the same sense of depth, but it changes the overall look and feel of the image, which now becomes darker, moodier, and less open.

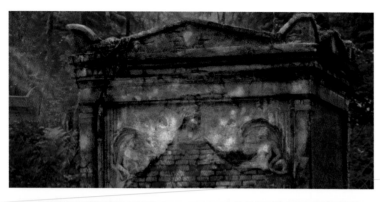

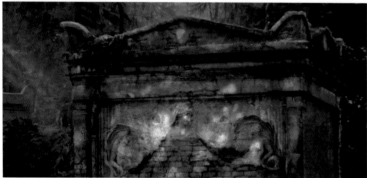

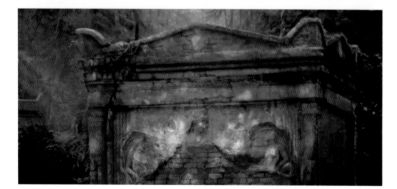

## Choose Wisely

You can paint a picture with only a few colors and make it look bright, intense, and colorful, and you can paint with lots of colors and end up with a muddy or chalky image. It's not the number of different colors you use, but how and where you use them that is most important. Allow a color family or strategy to dominate and carry the image. When all of your colors are equally important, they will compete for attention, and in the end, none of them can stand out.

## Tension Creates Interest

Colors need tension, contrast, and an attraction of opposites. Just as the surest way to make a light value look lighter is by darkening the areas around it, you can make a color of a light or highlight appear more intense by either infusing the area around it with the same color, as if the air itself were saturated with the color, or by setting the color against its complementary color. The same holds true for the other attributes of color. A warm color will appear all the warmer if it has a cool color next to it, or a color will look more intense if set against a muted, dull tone. In general, light sources will be cool, creating warm shadows, which by their nature tend to recede in space. That space, that background color, is, on one level, the color of your air, of your depth. Use that color in the mid-tones or at the edges of your objects, wherever they turn away from the viewer, to push the object back in space, or use its complement in a light area to bring an object forward in space.

**BE SELECTIVE AND HAVE A PURPOSE △**
**Oversaturation with no focus** The top image lacks focus, as all the colors are intense, and so compete with each other for attention, flattening the image and leaving the viewer with no clear center of interest or focus.

**Selective color** The middle image has very little color, but selective use of stronger colors in the highlight areas gives the image a clear focus, and prevents it from looking monochromatic. The viewer accepts the image as full color, even though most of the image has very low color intensity.

**Color family** Images may also be unified and given cohesion by allowing a color to predominate. Here, the warm purple—orange light that bathes the image holds the composition together. Note that the image does not look monochromatic, as there are still color variations within the range of purples, but the overall cast gives a pleasing harmony to the image.

**COLOR BARS**
Use colors with similar characteristics to create color harmony in your image, or colors with opposite characteristics to create subtle neutrals when mixed, or vibrancy when placed next to each other. Color bars, like the ones below, can be useful when matching colors to values in your work. Create one for each primary color, and hold them over your image, or next to a color on your palette, in order to match a color to a value while you work.

Light values ← Dark values → Light values
Cool bias | Warm bias

Blue with yellow transition | Blue with red transition

Yellow with blue transition | Yellow with red transition

Red with blue transition | Red with yellow transition

## Unity Through Light

Whatever you're painting, however varied the local colors of your objects, there will always be one powerful, unifying element to your color scheme and your image: the color of the light source itself. While it will be most noticeable right around the highlights, remember that every area that is not in shadow will, to some extent, be informed by the color of your light source. The shadows themselves will be similarly unified by a subtle absence of the light source color.

## Build On a Strong Foundation

Everything needs a strong beginning, a firm foundation. From your concept to your values to your colors, build and craft your image with care and deliberation. Lay in your colors all at once, so that you can see as soon as possible how they relate to each other on the canvas or page. Build the structures first, with the shadows, the values, and the masses, then add in color, and try at all times to make each stroke mean something. The painting is not the good bits you add at the end, it's the whole process, each part building on the preceding parts, and each stroke, each color, or value choice an integral part of the whole. You would not paint a house without doors, thinking "no one will notice." And by the same token, you should not put in a color—even in the background or a small area—without knowing it's the right color, or knowing it to be wrong but hoping no one will notice.

**USEFUL PALETTE** ▷
If you are building a basic palette, you could start with the colors shown here.

TITANIUM WHITE: cool, opaque. Dominates colors it's mixed with.

NAPLES YELLOW: opaque, soft and dull yellow, warm. Easily dominated by other colors.

CADMIUM YELLOW: very warm, very opaque, dominates colors it's mixed with.

INDIAN YELLOW: very warm, very transparent. Useful for changing the temperature of a light color without significantly altering the value of it. Easily dominated by other colors.

CADMIUM RED: very warm, very opaque. Dominates colors it's mixed with.

ALIZARIN CRIMSON: very cool and transparent. Strong staining color that dominates colors it's mixed with.

CERULEAN BLUE: opaque, warmish blue, easily dominated by other colors, which makes it very useful in cooling down or dulling stronger colors.

PHTHALO BLUE: very intense, transparent warm blue. Dominates colors it's mixed with.

ULTRAMARINE BLUE: very cool, somewhat opaque, very rich blue.

BURNT SIENNA: a deep, warm, burnt orange color. Strong on its own, but mixes well with many other colors without dominating them.

BURNT UMBER: a darker, deeper, richer version of burnt sienna. Can be dominated by other colors, used very extensively in under paintings due to its lack of intensity and its ability to create a full value range from white to black.

IVORY BLACK: a semi-opaque, cool black. Dominates colors it's mixed with, and appears flat if used on its own, but takes on tremendous depth when mixed with warm tones such as cadmium red or a warm green.

**COLOR IS ALL IN THE CONTEXT**
Note how different the same red swatch appears based on the color next to it. The light, dull background makes the red appear darker, but dull. The intense green background makes the red appear much less intense, and the intensity of the green draws the eye away from the red. The dark green background makes the red appear clean, bright, and intense.

# MOOD AND DRAMA

*Mood and drama are your "emotional palette," the intangible, intuitive, and evocative aspects of your image. Without them, your painting will lack the spark of life that fully engages the viewer.*

## Be Selective

Colors by their nature have an emotional element. Explore it, use it, have fun with it. Obvious examples are the energy and passion of reds, or the calm, serene aspects of blues. Look for ways to use these characteristics, especially in connection with the other elements of your image, to convey a mood. Can you contrast colors against one another, to create tension and drama? Constantly evaluate your painting, and be sure you are making the best choices you can at every step. Ask yourself how to make the most of your choices, and how to most strongly and clearly convey drama and mood through your use of shape, color, and value.

## Remember Your Concept

The underlying concept that began your piece will also drive the emotional mood and drama of the painting. Whatever your initial concept, it has within it a seed of drama. Let it out, and be sure that at all times you are reinforcing that initial concept, in order to keep the painting focused and on track.

## Less Can Be More

Often, mood and drama live at one end of a street, and photographic rendering at the other. As your image is progressing, make sure that it's not looking more realistic at the expense of the mood and drama. Should you find that to be the case, look for areas to simplify, be it eliminating unnecessary details, reducing the number of different values, or simplifying shapes in order to strengthen the area of main focus. Often the initial sketch or composition had an immediacy, a dynamic, and an emotional element that is sometimes lost as you labor on the final painting. Look at the initial sketch again and again. Chances are it was simple, bold, and direct, and focused on capturing the feeling of the concept. It's that initial concept and the solution for it that you loved in the first place, and that is what you must maintain throughout the execution of the final art.

## Don't Be Static

Mood and drama can come from the colors you use, or from well-juxtaposed values, but they can also come from the dance and rhythm of the lights across your image, or the way a piece reads, or even the integrity of the brushstrokes themselves. Don't feel that everything needs to be smooth, uniform, and blended. There is tremendous power in a single stroke of paint applied with deliberation, care, and confidence, and then left alone as you place another stroke on the page or canvas. This is especially true when painting the focus of your image, where you might want to emphasize not only the contrast or color, but also the strokes themselves, as a way to separate that element from the rest of the composition and draw the viewer's eye toward it.

| Key Points | • Be selective—try to use your colors efficiently and effectively, and be aware of their emotional connotations. A small amount of color in a largely neutral painting can be very powerful. | • Remember your concept—stay true to your underlying concept and always support and express it. | • Less can be more—if you're lost, look for ways to simplify the shapes, the range of colors, or the number of different values you are using, and allow the mood and drama to carry the painting. | • Don't be static—be sure you have enough rhythm and movement to create the mood you need, be it the flow of light, the interaction of shapes, or the movement of the brushstrokes themselves. | • Edit yourself—you're not a passive camera, but rather an editor of nature and the mind. Decide what it is about the subject you most like, are attracted to, or wish to express, and bring that forth. |

## CONCEPT THROUGH COLOR

These three images are a good example of expressing a concept through color. The values and composition have been kept fairly consistent from one image to the next, but the color palette has changed, and with it, the mood and drama of the image. The difference, then, is the color, or more specifically, it's the perception of color and its associated mood that distinguishes the images and gives each a specific mood and feeling. Learn to use the strengths and characteristics of color to your advantage, and at all times keep one eye on your initial concept to guide you. The three concepts explored were darkness as threatening, inviting, or adventurous, and these dictated the color choices for the three images.

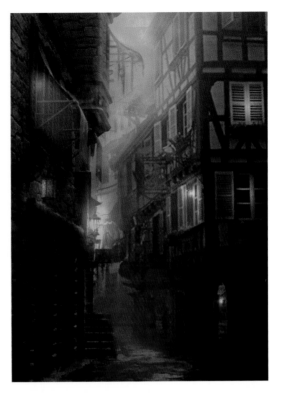

◁ **Warm sunset palette** With the whole image shifted to a warm palette, the mood becomes lighter, safer, more inviting. Warm lights, especially from manmade sources such as windows or campfires, instantly convey a sense of safety and security—they are human's way of keeping the dark and the night at bay.

▽ **Cool blue palette** The introduction of the clean, warm blues against the warm orange–yellow lights creates another mood altogether—one of an inviting, slightly adventurous place where nothing is very threatening. The blues both contrast against and harmonize with the warm lights. The effect of this is to make the lights appear brighter, cleaner, and stronger, leaning into the appealing and safe aspects of the warm manmade lights, whereas the warmer blue tones become inviting, rather than cold and distancing or threatening.

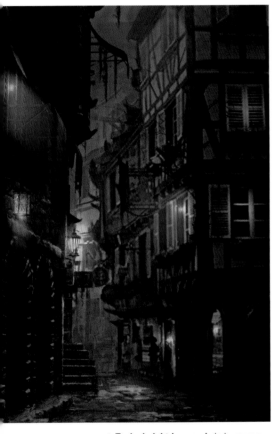

△ **Typical night image** A dark, narrow alley, with night coming on, buildings and darkness pressing in—in most fantasy imagery, this is the typical, and perfect, setting for a mugging, clandestine meeting, or other such dark and brooding event. The selective lights from the windows serve to emphasize the darkness of the alley rather than to provide the comfort and safety normally associated with warm yellow lights, and the muted color palette of the buildings themselves gives the image a dangerous and deserted feel.

# Edit Yourself

Your goal is not simply to copy nature or your reference, but to create the most realistic image you can. Think of yourself as a translator and conductor. Whatever you are painting, whatever the initial concept that drove you to want to create that specific image, there was and is a mood, a drama, a story to it, and the master and author of that story is you. That's all you can bring to the image that is different from anyone else's version of the subject—and that's all you need. Always analyze your canvas, your image, and be sure that what you're painting is what you most want to convey about your subject.

## STAY TRUE TO YOUR CONCEPT

A world where even the natural formations were made entirely of metal presented an opportunity to push and play with concepts in a very different way. Here, the metallic nature of the world was combined with the sense of mountain mass and the sooty quality of a furnace or smelter. The result was an image where towers the size of mountains squatted like hulks, dark and brooding in a hazy, polluted landscape. Atmospheric perspective would create a sense of depth, and reinforce the scale of the towers. The mood created would be dark, brooding, and haunted, and the masses of the towers would stand in near silhouette against the lighter sky.

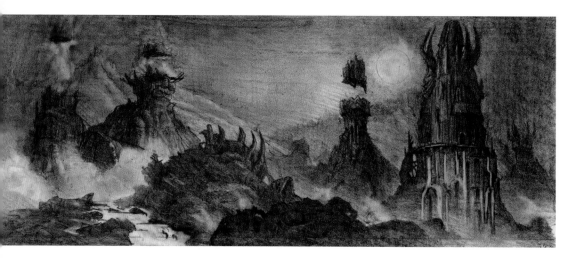

**Using simple shapes for form and structure** Maintaining the concept as the driving force behind the composition, the towers' details were kept to a minimum, the strong simple shapes giving them form and structure. Selective use of the haze and mist from the background would separate the forms and give depth to the image, while also serving to move the eye of the viewer through the image. The focus was on the alien, seminatural, semiconstructed nature of the towers, specifically the right-hand tower, which dominates by virtue of its shape, placement, and detail.

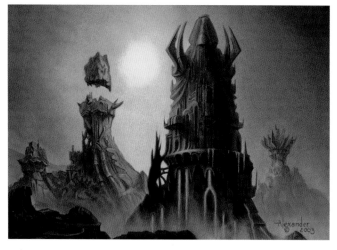

**Using light to unify an image** The soft, near monochromatic lighting served to unify the image, providing an overall mood, and generating the sooty, dark palette that was the defining mood of the image. The tower shapes were kept simple, with detail and structure being suggested and used very selectively to create the three-dimensional feel to the towers. The low vantage point thrusts the main tower upward into space, allowing it to dominate the composition, and allows the secondary towers to be painted smaller and recede without diminishing their scale or impact. The result is a painting that stays true to the original concept in the drawing, and conveys the haunting, brooding quality and mood that the sketch generated.

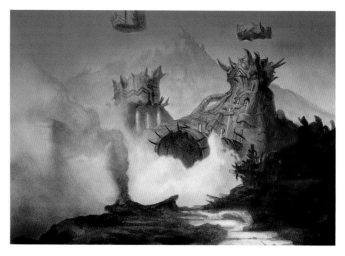

**Many changes fragment the image** Changes in the basic design, such as altering the lighting and a lack of massing in the two towers, have resulted in an image that is fragmented. Details on the towers compete with the shapes of the towers themselves, and the lighter background with its distant mountain competes with the mid-ground mist, halting the movement of the eye. In order to compensate for the additional detail of the middle towers, the foreground shapes have been flattened into large, simple shapes that fail to describe a three-dimensional form. The result is an image that has all the colors and concepts of the original sketch, but fails to succeed as an image.

## MOOD OF COLOR PALETTE

The moods in these images are created primarily by the choice of colors and the associations we make with them. Use these associations to your advantage; even a quick sketch can take on a strong emotional component that will help carry the image and give it strength.

**A good color scheme directs an image**
With the mood of alien adventure and hints of danger clearly established by the color scheme, a road map now exists to direct the changes necessary in the composition or shapes within the image. The tower becomes more of a citadel, rounded and extending off the picture plane, which both makes it look larger and downplays its spiky, clawlike nature. Brighter colors and values in the sky draw the eye of the viewer in, moving directly to the citadel, and then traveling down and outward to the right, before looping along the flat walls on the left of the maze itself, and so back into the distance and up into the sky.

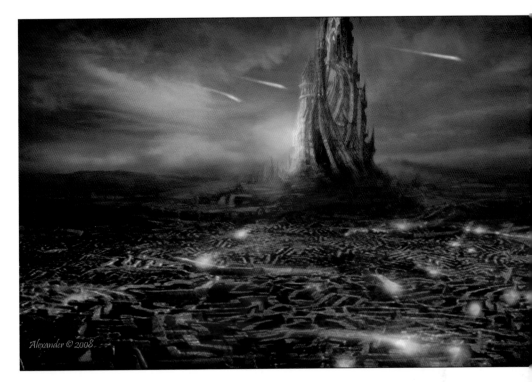

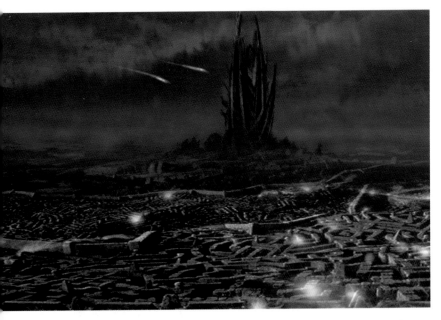

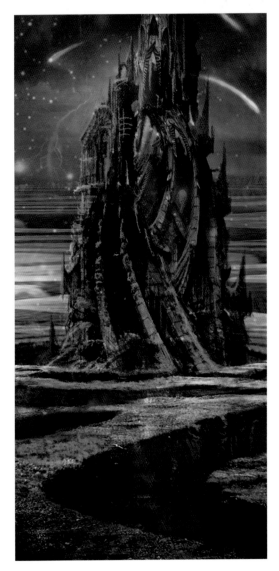

**Defining the mood** The tower sits in the background, all angles and spikes, whereas the lights in the foreground dominate the image, providing the only spots of bright color or contrast. The walls that bisect the image provide large, simple shapes for the eye to focus on and help to move the eye through the image. Because the mood has been so clearly established with the palette, and because the mood is such a unifying and defining element of the image, details in the landscape or the tower and maze can be suggested or hinted at, rather than clearly established.

**Keeping it simple** Cropping the image has allowed the tower to dominate the composition strongly, yet once again, the mood and color palette have determined that the tower will share the stage with the walls of the maze. By keeping the whole image in cool colors, the warm textures of the walls stand out strongly, drawing the eye and providing a natural focal point, as they are also areas of stronger light and brighter color. This is a situation where editing and not overdoing the detail results in a much stronger image.

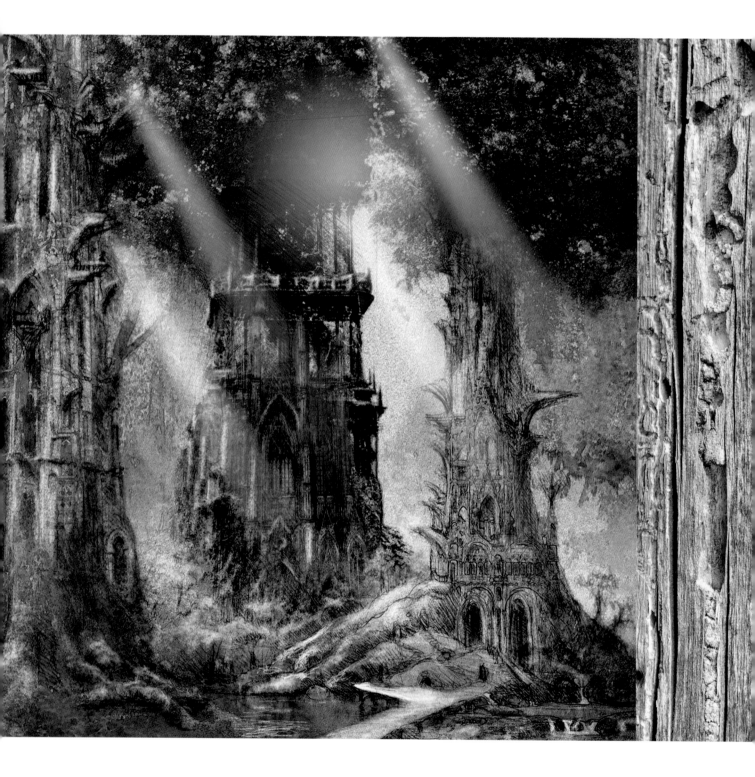

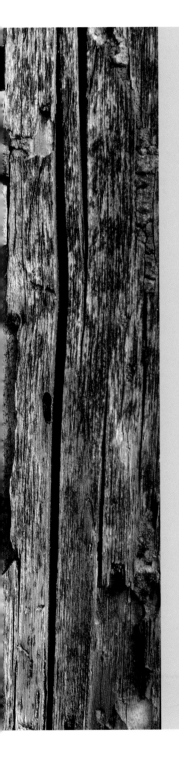

# DETAILS AND TEXTURES

*Putting knowledge into practice can be difficult, and requires time, effort, and dedication. The following step-by-step examples help break down many of the most common materials, details, and elements used in the creation of fantasy architecture, and walk you through the painting process in clear, easy-to-follow examples, which can also serve as reference for future paintings or a library of textures and materials.*

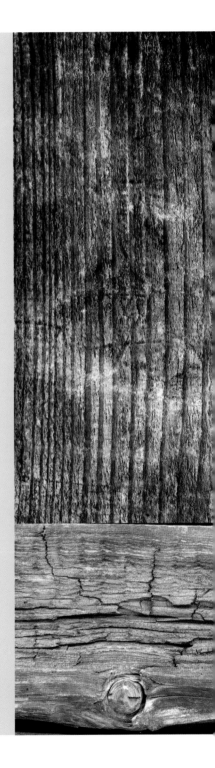

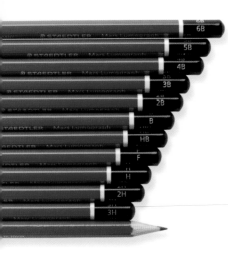

# TRADITIONAL ART MATERIALS

*Technology can be wonderful, but for capturing initial ideas and concepts, nothing works better than pencil or pen on paper, or a quick color study with paint. There is a tactility and immediacy to traditional media that digital art can't capture.*

**PENCILS**
Experimenting with a full set of pencils, from very faint hard (H up to 6H) pencils to soft black (B down to 6B) ones, will let you find the grade that suits you best, or you may find you prefer mechanical pencils, available with a variety of hard or soft leads.

**INKS AND PAINTS**
Buy professional quality, artist grade paints. Oils come in tubes and can be used thick or thin. Acrylics can be used similarly to oils and come in jars or tubes. Inks come in bottles. Gouache comes in tubes and watercolors in tubes or tablet form. Be aware that with water-based media, the color you see on your palette will appear differently once it has been applied to and dried on your paper.

## Initial Sketches

A good and affordable place to start is with some artist-quality pencils and a small sketchbook or two, as well as a small notebook. Sketchpads should be acid-free, archival artist-quality paper—notebooks can be as plain or fancy as you like.

Mechanical pencils are well suited to architecture drawings, as they maintain a thin and consistent line width and never need sharpening. You can carry them with you to make notes and scribbles whenever inspiration strikes. Taking a set of paints with you is a bit more difficult, but can easily be accomplished, and is quite rewarding, as it affords you the subtlety of painting from life. If you work in oils or acrylics, consider taking premixed containers of white, black, and two mid-tone values, one warm and one cool. Make sure containers are small, easily portable, and seal securely.

For quick sketches and capturing ideas, try not to erase—these drawings are not about creating a beautiful finished piece, but about capturing an initial spark of inspiration or design. For finished pieces, an eraser will prove invaluable and necessary, but leave it at home when you travel, and if you just can't stop yourself, do your initial sketches in pen instead.

## Final Linework

For finished drawings, you will need some large sheets of heavy paper, and for architectural drawings, a large drawing board or drafting table, T-square, and a set square are essential. Don't feel intimidated by them, and don't feel you need to spend a lot of money, but you really can't draw the straight lines and angles of your architecture without them.

Whenever possible, you should work as large as you can, within the bounds of comfort and the space you have available. This will give you the chance to add more detail and accurately work out your perspective. Buildings can be quite intricate, and to try and draw them too small will actually be harder than drawing them large. The drawing of the plans for Cologne Cathedral in Germany, for example, is over 13 ft. (4 m) in height.

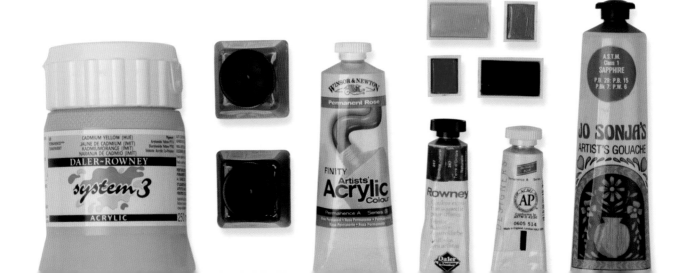

## The Science of Painting

At their core, paints are all composed of a pigment, a binder that will hold the paint to whatever you're painting on when the paint is dry, and a medium, which is what thins the paint out and makes it workable. In the case of watercolor, the medium is water, and the binder gum arabic, which is why it bonds well to paper but not to canvas or other sealed surfaces. With acrylic, the medium is water and the binder is a liquid polymer emulsion—a liquid plastic—which is why acrylic is so permanent and unworkable when dry. For oils, the oil itself is both the medium and the binder. Oil changes its chemical makeup as it dries, which is what allows it to work as a medium and then perform well as a binder.

## Choosing Products

There is no right or wrong medium to choose for architectural paintings, and all of them will serve you well, once you are comfortable with them. Regardless of your medium, you should always buy quality, artist-grade paints, brushes, paper, or canvas. One or two good brushes will last a long time and perform well, but a dozen cheap ones will do nothing but frustrate you and make the painting experience a miserable one.

Good brushes will hold their shape, hold a lot of paint, and respond well to your every touch. Quality paper or canvas will be consistent, last a long time, and be a joy to work on, while artist-grade paints will have a lot more pigment in them, be of a better grade, and contain a lot less fillers. When buying paint, take a moment to read the label and only buy colors that are lightfast, and avoid the use of dyes or fugitive colors, as they will fade or change color quickly, rather than maintaining the color and quality they had when you finished your painting. Remember, the pigment is the same in all paints, so don't think that if it's oil it must be permanent or if it's watercolor it won't last.

### BRUSHES

Fine sable brushes are fantastic for both watercolor and oil paint, but a good synthetic one will also hold up well, and it is recommended for acrylic, which tends to be thicker and more viscous. Other natural hair, such as mongoose, which is soft, or hog bristle, which is stiff, can also work for both oils and acrylics. The main criteria is quality. Cheap brushes will jettison bristles as you work, leaving you trying to pick them out of the wet paint, or else they will clump, fail to hold a point, or wear out quickly.

Brushes come in several shapes. Flats, brights, and filberts are all wide from side to side, but narrow from front to back, and are generally used for larger areas, or to work with thicker paint. Rounds come to a fine point at the end, and are generally used for fine detail work.

### PENS

Fiber-tip or ceramic-tipped pens are useful and well suited to quick drawings, as are roller-point, fine point, chisel tip, or even simple ballpoint. Whatever you choose, the important thing is that they are comfortable in your hand and suit your drawing style. Just as with paints, buy pens that contain permanent, preferably waterproof ink, rather than dyes.

### WORKSPACE

Whether working traditionally or digitally, you need to create a proper workspace for yourself. This means a desk with a decent chair, a good light source, both natural and artificial, a large drawing board or table, and storage space. A light box can be useful, too. Try to keep liquids, such as paints and inks, separate from your dry goods, such as paper, and even more important, your computer.

For architectural drawings, a very large piece of plywood or something similar, about 6 ft. x 2 ft. (1.8 m x 0.6 m), can be used for those times when the vanishing points are well outside the picture plane. Mount your paper on the plywood, find your vanishing points on the horizon line, and you can stop guessing where those vanishing points really are.

# DIGITAL ART MATERIALS

*Digital art is all about creating and manipulating images and information with a computer, and can range from importing a drawing and adding simple color to it to modeling a virtual building or city and generating the lights, textures, and atmosphere entirely with the computer.*

**COMPUTER**
The Apple iMac is an ideal computer for digital artists.

## Choosing a Computer

With the wide range of options and abilities the computer offers, it is important not to forget that the computer is really a "dumb box." It will do what you tell it to, and do it well, but if you don't know how to draw and paint, if you do not understand light and perspective and composition, then the computer will faithfully execute your poor ideas, and generate poor images—it cannot make your art "better."

Your choice of computer is your preference. Apple Macintosh (Mac) is the preferred system among digital-drawing professionals, but most industry-standard software is available for both Mac and PC. Most PC operating systems include a program that allows you to draw, paint, and edit images. Microsoft Paint, for example, is part of Windows, and although slightly primitive, it is a good place to start experimenting with digital drawing. You can draw freehand, create geometric shapes, pick colors from a palette or create new custom colors, and combine visual images with type. Sketchup is a free, basic 3D modeling program from Google, and Blender is a free modeling and animation program. Most scanners also include a basic photo editing and drawing package or a reduced version or trial version of a professional package.

## Buying New Software

Once you're ready to progress beyond a basic package, consider researching online tutorials to learn more about the various software programs and their capabilities, or go to a library or bookstore and look them up that way. Many programs are available in free trial versions, so you can evaluate it before you buy. The most important thing is to ask yourself what you would like to do with the software, and find the best match for your needs.

## Program Possibilities

As you begin to discover the possibilities of drawing on-screen, you will probably want to upgrade to more sophisticated software. A wide choice is available, although some programs can be expensive. However, as these are continually being revised and improved, it is often possible to pick up older versions quite cheaply.

Painter Classic 1 is easier to use than the more complex later versions and offers a wide range of drawing implements. Painter is the industry standard for digitally mimicking natural paint media, and offers a wide range of options and tools for freehand painting and creation.

Photoshop Elements, although basically a photo-editing program, also allows you to draw and paint images. Photoshop is the industry standard for image manipulation and control. It contains a powerful set of drawing and painting tools, and is unmatched in its ability to adjust and work with images or portions of images.

All graphics and modeling programs tend to be layer based, which simply means that you can create layers to work on, like transparent pieces of paper. Each layer is separate and independent from the others, and can be worked, adjusted, and manipulated without altering the information on other layers. You can add light, textures, and colors on separate layers in a modeling program. The options are endless, and the level of control provided is part of what makes digital art such a powerful medium.

## DIGITAL PAINT BRUSHES

When you are using a brush tool, you can set the type of brush head and size in the toolbox. To view this, click Brushes in Windows on the software's top toolbar. The green marks represent different airbrush sizes. The blue marks show a marker-pen-style brush. The pink marks show the more unusual brushes that produce a particular preset shape many times.

**Rectangular Marquee Tool** — M
**Elliptical Marquee Tool** — M
**Single Row Marquee Tool**
**Single Column Marquee Tool**

**Quick Selection Tool** — W
**Magic Wand Tool** — W

**Lasso Tool** — L
**Polygonal Lasso Tool** — L
**Magnetic Lasso Tool** — L

**Clone Stamp Tool** — S
**Pattern Stamp Tool** — S

**Eraser Tool** — E
**Background Eraser Tool** — E
**Magic Eraser Tool** — E

**Eyedropper Tool** — I
**Color Sampler Tool** — I
**Ruler Tool** — I
**Count Tool** — I

### SAMPLE OF DIGITAL TOOLS
These panels show a sample of the tools, layer, and brush options available in Photoshop.

### USING LAYERS
One of the most useful functions in digital painting programs is the ability to put different elements on different layers. The layers window (see above) allows you to turn the visibility of each layer on or off and to adjust transparency using the opacity percentage slider.

### TOOLS
Different tools allow you to select parts of the image. The marquee tool is useful for simple geometric shapes. The lasso tool is used for drawing around chosen areas. The magic wand can be used to select areas where the color or tone is distinct. The picker tool allows you to sample a color that is linked to a selection dialog box, which allows you to adjust the range of the selection through the fuzziness slider. The quick mask tool allows you to paint a selected area.

## STYLUS AND TABLET
Drawing with a mouse can be awkward and clumsy because it is held quite differently from a pencil or pen; a stylus replicates the natural drawing movement. Tablets come in a range of sizes, with commensurate differences in price, but smaller ones are well within the budget of most artists. Wacom tablets are the standard for artists, as they have the best pressure sensitivity and natural feeling response, allowing you to work more intuitively and transparently.

## SCANNER OR DIGITAL CAMERA
If you don't have a scanner, a digital camera will allow you to import photos and reference, and can double as a scanner. You do not need to spend a fortune, but it is wise to buy the best you can afford at the time. The increase in quality, longevity, and flexibility that a better model provides is worth the extra money, and it saves having to replace something in six months because you have run up against its limitations.

# 1. WOOD

*No matter the style of the fantasy architecture depicted, wood is likely to play a key role. Whether you're painting a weather-beaten clapboard siding, a time-darkened oak beam, or a polished pine floor, it is the grain of the wood that will give authenticity to your story. Exposure to the elements marks wood, creating a road map or journal of its history. Interior wood, spared this constant exposure, is often chosen for its color, grain, and beauty. These pages explore ways of depicting exterior and interior wood convincingly.*

## 1.1 Rough Exterior

Has your structure stood sentinel on a hilltop, bleached by the sun and frozen in winter? Or does its warm, humid setting mean that it has been subjected to constant moisture and insects? Once you know what sort of environment the building has been exposed to, and for how long, you will have a clear idea of how it will have been affected, and what aspect of that you want to focus on, and what details will best convey what you need for your final image. Ask yourself if the wood grain will be emphasized or minimized, is the wood strongly colored or faded, in good repair or splintery and broken? Has someone carved into it, driven a nail into it, or spilled something on it? These are the subtle nuances that really tell your story.

TEXTURE REFERENCE FILE

### Exterior Well Worn by Weather and Time

**1.** The cracks and gouges, the water damage, and the gaps created by the expansion and contraction of the wood over the years all tell the story that the image needs to convey. To emphasize the story further, these elements are contrasted against areas worn smooth and polished by the touch of many hands over a long period of time.

Begin by roughing in the basic shapes and values. The wood is very faded and bleached and the lighting is soft and indistinct, so the scene can be rendered in three basic values: one for the top or upper planes, one for the side planes, and one for the shadows and interior of the well itself.

**2.** Strengthen and reinforce the wood grain in the places where it will be prominent, leaving other areas smooth. Modulate the values and temperatures across the forms, in order to create depth and structure. Selectively add local colors in the middle-value areas. Using them sparingly will create the bleached look in the rest of your image.

• Remember, in a field of neutrals, a small amount of color will stand out strongly and carry the image.

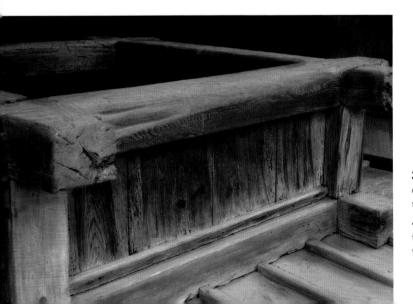

**3.** Pick elements to strengthen. Because the focus is on the aging and erosion, emphasize the areas where those features will be most prominent, still keeping in mind the overall value relationships.

• Notice that parts of the image have been left loose and suggested, with the underpainting still showing, whereas the side and upper beams of the well have been more carefully rendered, highlighting the texture and cracks.

## 1.2 **Interior Wood**

Load-bearing beams are often made from hard woods, while non-load-bearing beams may sometimes be softer woods, more suited to carving and decorative embellishments. To demonstrate the differences between similar exterior and interior woods of a similar age, the wood in this example is plain, unvarnished, and uncarved.

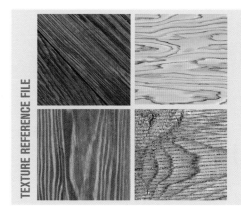

TEXTURE REFERENCE FILE

## Grain and Texture

**1.** The image is composed of strong, clean shapes and essentially has two values. Initially, focus on establishing the structure and the warmth of the shadows, allowing the brushstrokes to follow the direction of the different planes. Keep the paint thin, and look for ways to create variation, such as spreading the bristles, scumbling, or dry brushing.

• Do not overwork the paint. Allow the brushstrokes to suggest the wood grain as it describes the structure.

**2.** Strengthen the values and shapes, clean up edges where they have become too indistinct, and begin to add local color in the light areas. Continue to work with thin paint, adding more wood grain and texture to the light areas. Carefully work in opaque paints as necessary, but preserve your values. Add a thin glaze to the shadows to adjust the temperature, unify the shadow shapes, and provide a foundation for your image. Apply a similarly thin glaze to the metal plates to make them look cooler, darker, and different from the wood.

**3.** Continue to refine and define the shapes, being sure not to destroy the value relationships. For the lightest areas, you may find it helpful to apply a very thin glaze of your mid-tone color over the whole area and then work into it with the lighter-value paint. This keeps the light from getting too strong, and allows you to blend colors on the canvas, creating lots of subtlety and value variations. When the painting is dry, if necessary, apply another transparent glaze to give the light areas more color and intensity, or to unify the shapes and control the values.

• Strive to find a balance between regular grain and the randomness of organic forms and textures, using small brushes if necessary, and keeping the paint layers thin.

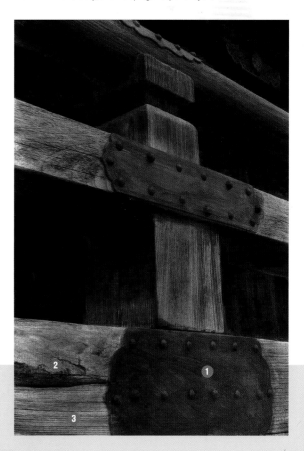

Since the image was reduced to two basic values, careful handling of the textures and wood grain were very necessary. The addition of the large dark mass of the metal plate ① helps bring out the darks of the wood grain details, ② and ③, creating the necessary texture without destroying the value relationships.

## 1.3 Exterior Carving

Because wood is so versatile and can be worked in so many ways, carvings can be simple reliefs, layered, more complex three-dimensional forms, or even freestanding separate pieces. This example explores simple beveling, a decorative layer over a base layer, an intricate but weathered form, and an intricate but sheltered form. Note the differences caused by weathering and exposure on the planks versus the freestanding forms, and how much older and more worn the exposed freestanding form looks.

**TEXTURE REFERENCE FILE**

## Painting Carved Wood

**1.** The focus of this piece is texture and movement. Strong horizontal and vertical bands are contrasted against the swirling shapes, creating movement, tension, and action. Although the range of values is considerable, they essentially form three groups: the top, side, and shadow planes.

Paint the initial layer with very gestural strokes that follow and describe the different forms and their actions. Your focus is on establishing the movements of the different shapes and their rough value relationships.

• At this stage, only loosely suggest the edges, small details, and colors.

**2.** The various shapes are more clearly defined, but still with very gestural strokes, creating a sense of swirling movement in the curves. Rendering of the forms is subordinated, secondary to capturing the sense of movement and texture, especially in the upper swirl, which is left very rough and suggestive. The exact form is less important at this point than the textures and large planes. Glaze over the darkest areas with neutral darks, both to unify them and knock them back in the picture.

**3.** Add details in color and form and define edges, cracks, gaps, and highlights more strongly to make the forms look three-dimensional and real, but be careful not to detract from the overall gestural and textural qualities of the image. Use the preliminary steps as your guide to help you know when to stop painting, and to make sure that the initial concept is not lost in the rendering of detail for detail's sake.

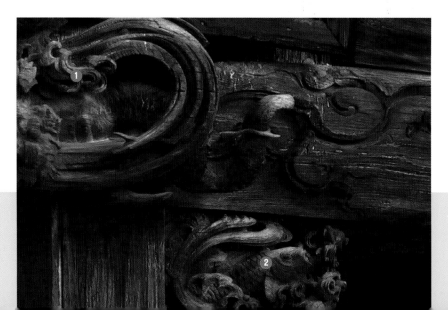

In keeping with the overall concept of movement, the animal motifs of dragons ① and fish ② were chosen, as their swirling shapes and flowing lines capture and move the eye continuously.

## 1.4 Painted Wood

Unlike stained or polished wood, painted wood often has little or no visible grain. Its color is determined by the paint, so it may appear more as a mass of shapes rather than individual parts or beams. The colors of the light source or reflected lights will be more clearly visible, as they will be illuminating what is essentially a field of flat color on the wood. In this example, the wood is bright red, and the setting was deliberately chosen to showcase the multiple colors of light and shadow that occur—even in natural light.

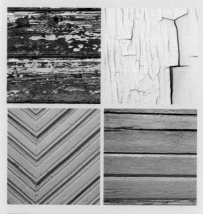

**TEXTURE REFERENCE FILE**

## Light and Shadow on Painted Wood

**1.** The painting is Asian-inspired and very linear, composed of strong, clean horizontals and verticals. Prepare a neat, accurate drawing and rough in the values, using local color—in this case, red. Pay close attention to values and value relationships. Once again, there are three basic values: the bright highlights on the upper planes, the mid-values on the floor shadows and secondary highlights of the wood, and the side or shadow planes of the wood.

• Focus on the value relationships, and make sure they are accurate and read clearly before going on to the next step, as you will build on them and use them as a guide all through the image.

**2.** The prime concern is the edges, values, and, above all, the temperature relationships. Notice that the secondary lights on the upper planes are warmish, as the sun lights them, though not directly. The side planes of the wood and the shadows on the floor are all cool, as they are lit by the indirect light, which comes mainly from the blue of the sky. The strongest highlights on the wood are also cool, as the sunlight in its strongest form is often cool. The reflected lights on the vertical planes of wood near the floor are very warm yellow-orange, as they are lit by light bouncing off the warm-colored floor.

• As a general rule, keep the paint thin in areas of shadow, cooling them with glazes, and thicker in the areas of light, warming them up with opaque paint.

**3.** Add details such as the lights and shadows between the floor tiles or slats of wood, as well as minor, subtle modulations of value or temperature within a light or shadow plane, to create emphasis or a smoother transition from one form to another. Glaze over colors that have become too strong or dull, to bring them up or knock them back. Adjust edges that need strengthening or softening and render subtle lights and reflections. If the focus of the image needs reinforcing, use opaque paint to build up the sense of light. When the paint is dry, you can wash a color glaze over the area, if necessary, to restore vibrancy and intensity.

• Remember, a brushstroke can be used to convey color or value, but not both at once.

① Warm tones
② Cool tones

# 2·WOOD JOINERY

*Joinery is a fascinating and complex aspect of architecture and construction that reveals as much about the mindset of the architect as it does about the material itself. Wood is so versatile, and can be worked in so many different ways, that there are many different options for creating joints. For the fantasy artist, the focus is often on showing the level of craftsmanship in the culture you are painting and the aesthetic it prefers, as well as the purpose of the structure.*

Is your building lovingly crafted to last the ages, or hastily erected in a time of need or hardship? Is it defensive in nature or more domestic? Is it a common dwelling or a palace? Was it built of large, long, old-growth timbers, flexible young materials like bamboo, or smaller pieces spliced together, perhaps because no larger materials were available? Is the material new or aged, raw or well cured and shaped?

Has it been exposed to the elements warping and twisting it? Are all the sections worked in the same manner, indicating a continuity of style, or perhaps a short building time? Or does the style of construction change, indicating possibly a lengthy construction, or a renovation to an old building? Attention to detail when depicting the wood joinery will largely answer these questions and add realism and character to your image.

## Supporting Joinery

This example examines the underside of a porch or floor, showing a variety of different joinery cuts and types. Just as importantly, it shows what was cut with great precision and what was less precise, how the wood has warped, shrunk, or moved with time and exposure, and the care lavished on the supporting cross beam, which will likely never be seen, but was decoratively carved nonetheless.

IN CONTEXT *"Oboro, Palace in the Clouds"* page 44

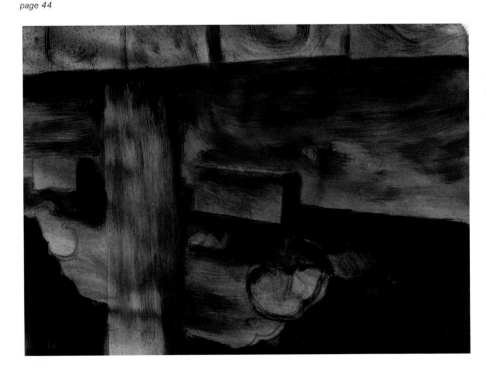

## Underneath the Floor

**1.** Rough in the basic shapes, ensuring that the brushstrokes follow the directions of the wood grain and the shapes themselves. Notice how the strokes are describing the form's essence: rounded curves for the exposed ends of the floor beams because the cuts from the saw are the dominant feature that has dictated the pattern of erosion; long, gentle arcs for the horizontal beams, which have been cut from a very large tree; and the cleaner, straighter grain of the support pole, which comes from a smaller, younger tree.

Pay attention to the basic values and relationships as you begin to rough in the image, leaving the darkest areas relatively flat and unworked. Add information to the deepest shadows near the end of the painting, when you are more certain what and how much is needed.

• By describing the forms in as many ways as you can, right from the outset, you will find that you are not fighting your image later on as you work, and that whatever shows through to the final image will help it along, rather than detract from it.

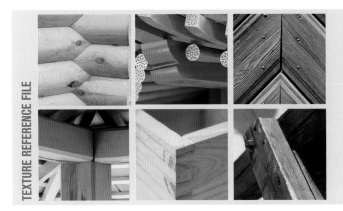

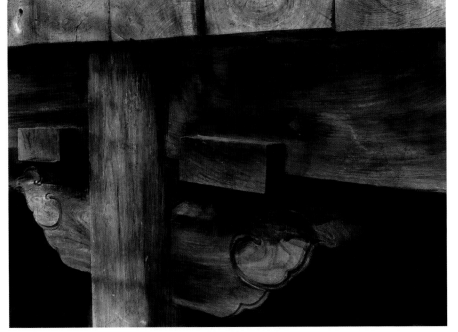

**2.** Keeping to the underpainting as your guide, begin to build up the basic colors and textures. Stay within the value ranges you established in step 1, and continue to keep the shapes clean and clear. Exaggerate the colors and textures of the wood, as they will be painted over with semiopaque paint and softened later on. Do not paint the shadow or dark areas too dark at this point, as they will automatically look darker once the wood is lightened. Painting the shadows dark now will likely result in them being too dark once the lighter values are put in, creating a loss of transparency in the shadows and a dull, lifeless look in your final image.

Notice how the edges between the ends of the floor beams and the deep shadows beneath them are kept crisp to cause the lighter values of the floor beams to come forward and separate from the shadows, while the edge of the support beam blends in with the shadows underneath the support bracket, creating a sense of depth and pushing back the support pole.

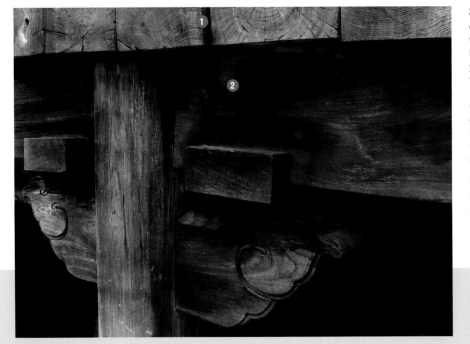

**3.** Having crafted the shapes and values so carefully in steps 1 and 2, you can now add color without having to guess at the values you need. Describe the values first, and add the colors once you know that the values are correct. In this case, the wood is a cool, neutral gray.

The emphasis is on the textures and details. Cracks, pits, and gouges are added, or the wood grain is extruded or emphasized in spots. Notice how the shadows have largely been left as they were in steps 1 and 2, with little or no information added to them.

• The more transparent, simple, and uniform shadows are, the more "shadowy" they will look. The eye should pass over shadows with barely a pause, moving from one area of light to the next. Shadows are the stage and light is the main attraction, so be sure to keep a separation between them.

Notice that the strongest discoloration of the wood is on the right of the support pole, because there is more of a gap between the planks above ①, allowing more moisture to affect the wood at several points ②.

# 3· STONE AND BRICKWORK

*Whether you're painting smooth, precise marble, soft, hard, or natural stone, cobblestones, or crumbling ruins, there is a uniqueness to stonework that must be captured in your artwork. Surface details, tool marks, weathering, vegetation and aging are all details that add character and history. This section explores the many styles and types of natural and manmade brick and stonework, which are integral to architecture painting, and that will allow you to create your own distinct images.*

## 3.1 Natural Stone Structures

Mass, volume, and a sense of three-dimensional form must be established before surface details are added. Color, surface details, and textures must all be balanced within the value ranges set up by your initial form or they will flatten out your image. Look for striations in the rock, veins of color, clearly defined plane shifts, or layers to help define its structure. Details such as grasses, moss, and lichen, stains, or weathering can help add character to your painting and define the setting more clearly, creating a complex, subtle, and interesting story for the viewer.

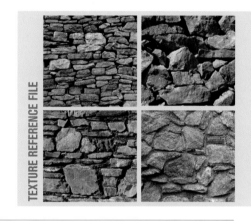

TEXTURE REFERENCE FILE

### Painting a Natural Stone Wall

**1.** Begin by laying in rough values and colors. Keep the values limited to two or three, thinking always of clearly defining the basic shapes and planes of your rocks. Your lighter values will be added over the top of this first layer of paint, so keep the middle values darker than they will be in the final painting. Don't overwork the brushstrokes.

**2.** Once dry, begin to reinforce the structure and add surface details. First establish the values of the lightest planes, then, using your underlayer as a guide, add the darker shades, keeping the values within the ranges you have already established. Here, the strongest light is on the upper planes, so the same value cannot be used on the side planes.

**3.** Add final details such as vegetation, cracks, and chips. Keep in mind what the stone needs to say in your painting. Has it sat in a field, undisturbed for years? Did someone recently disturb it? Perhaps part of it is covered in fresh dirt, recently exposed, or moss has been partially scraped off the surface.

① Grasses and lichens cover a portion of the rocks.

② Edges, color variations, and broken brushstrokes add natural, subtle variations.

③ Cracks, chips, and pockmarks have an edge or side that is dark and casts a small shadow, as well as a highlight edge or shadow.

## 3.2 Worked Stone: Soft

Soft stone refers to the softer, interior stone used mainly for decoration and detailing, rather than structural support. Often carved and shaped separately and then fitted to the interior structure, these forms were a chance for stonemasons to showcase their skills. Not able to hold a polish or crisp edge the way marble or other hard stones could, they were often left with more of a rough, natural appearance, their edges more rounded and uneven. Tool marks from the masons will often be visible, as are irregularities in patterns and joinings fitted.

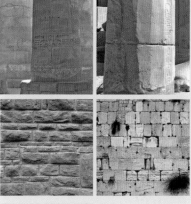

**TEXTURE REFERENCE FILE**

**IN CONTEXT** *"City of the Dead",* Page 23

## Stone-carved Pillar

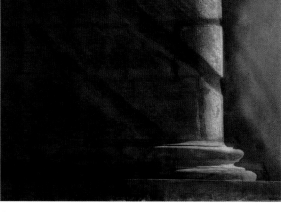

**1.** This stone tends toward a fairly strong uniformity of color. Begin by laying in related base colors, keeping some variation, within a fairly narrow band. Don't overwork the paint or overblend the colors, and concentrate on capturing the overall structure solidly.

**2.** Once dry, continue to define and refine the shapes and edges with a dry brush or broken strokes, creating subtle textures and variations.

**3.** Add or emphasize specific surface textures and features, such as chips, cracks, and worn edges. While you may not have the weathering and erosion typical of exterior stone, there may be areas that have been polished smooth by the repeated touch of hands, or darkened from proximity to torches, areas of discolored stone where a section was replaced, or even tool marks that are still visible. Look for details to add realism, subtlety, and sophistication to your painting.

① Texture will be most visible in the mid-values, or where a form turns away from us.

② Use the background color to help the stone turn away and recede.

③ Lit from above, all the upper planes have the strongest light.

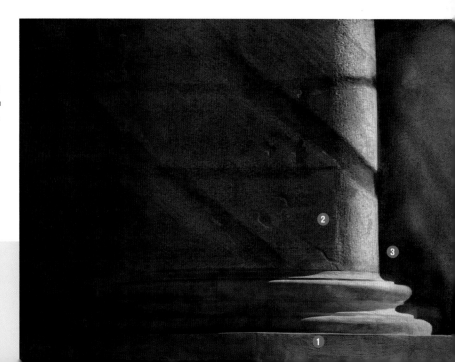

## 3.3 Brickwork and Mortar

Bricks are manufactured, rather than being cut from existing stone, which both homogenizes the overall color range and results in each brick being a slightly different color. Mortar is clean and white when first applied, small fingers of it spreading into gaps and cracks in the bricks. As it ages, these fingers are the first areas to weather and fall off. Cracks are more likely to appear in the mortar than in the bricks themselves. Aged bricks are worn smooth, and will have duller colors, chips, pits, and missing chunks. Missing areas of mortar between bricks may have been taken over by moss or grasses. If there is mortar or plaster covering the bricks, look for a smoother, whiter surface in new plaster, often with trowel marks; pits and cracks in mid-aged coverings, and missing chunks, large cracks, and extreme weathering in very aged coverings.

**IN CONTEXT**
*"After the Fall"*
*page 17*

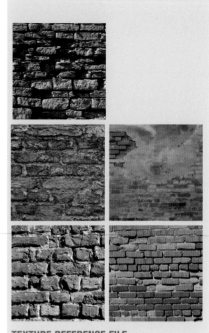

**TEXTURE REFERENCE FILE**

## Aged Red Brick Wall With Mossy Infills and Broken Mortar

**1.** Start with fairly flat, uniform colors, laid in loosely. Allow brushstrokes to overlap, keeping color variations subtle. The concern here is mass, establishing a sense of volume and structure through value, not color. Suggest color, but create a definite sense of form.

**2.** Once dry, strengthen colors and values to define individual bricks—some lighter, some darker. If you have weathering or staining, which will affect more than one brick, begin to add that in. Loosely suggest base colors for any vegetation or other surface irregularities you may have. Strive for a balance between loose and expressive, and subtle and controlled as you reinforce the structure. Keep the paint thin, allowing the first layer to show through as much as possible—you are refining the initial layer, not hiding it.

**3.** With opaque paint, lay in the lighter values for the mortar. Add chips or cracks as needed, finish the details in the vegetation, and strengthen the surface texture of the brickwork. Add spots of color for texture and to tie the wall in with the rest of your painting, according to the specific building you are creating.

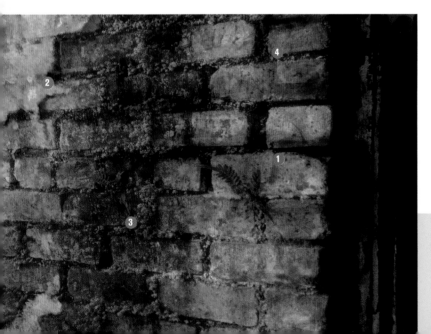

① Lay in shadows from bricks that stick out farther than the rest.

② Use clean, white opaque paint on fresh mortar, grayer and duller on older mortar.

③ Add highlights and underhang shadows to mossy growths.

④ Vary the amount of definition between bricks.

## 3.4 **Weathered Stone and Crumbling Masonry**

Crumbled masonry typically has faded colors and softened edges. It's weathered, exposed, and eroded. It is both the chaos of ruins and the clean structure of architecture. Sharp edges occur mainly in areas that have recently broken or chipped. Stronger colors often result from stains, lichen, and so on, and tend to span multiple bricks or stones. Suggestions of the detail and structure that was once intact can help place and define your ruins, creating both your current story and backstory at the same time. If the stones were well shaped and fitted at first, the overall structure will be apparent, even after it ages and the mortar crumbles. Splits, gaps, and cracks will help further define and add character and realism to your structure.

**TEXTURE REFERENCE FILE**

### Stone Arch Ruin With Encroaching Vegetation

**1.** Begin by laying in middle and dark tones, effectively creating a silhouette of your shape. Keep in mind the value and temperature of your shadows, and make the edges ragged and broken, not clean and crisp. Having some stones or blocks that are not crumbled allows you to establish scale, perspective, and mass or volume early in your painting. Keep the paint thin, do not overblend, and allow the brushstrokes to remain a part of the surface description.

**In Context** *"Karak, the lost fort"* page 17 top

**3.** Once the main layer is dry, strengthen, clarify or reinforce the overall structure, and add details such as runes or carvings, vegetation, highlights, and shadows between stones, in large holes or cracks, and so on. Look for areas where you can describe what the structure originally looked like, as well as its current condition. Be careful not to destroy the structure by adding too much detail. Remember, a little goes a long way when it comes to highlights, cracks, and so on, and often, less is more.

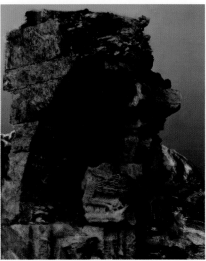

**2.** Once the underlayer is dry, lay in colors and lighter values to define your structure with thicker paint and broad brushstrokes, or a palette knife; let the paint layer break, leaving some spots and areas where the underlayer shows through. In the shadow areas, lay in colors similar in value but different in temperature and hue to your underpainting to create surface irregularities without flattening the structure. Strive to create structure and chaos in the same space through careful control of the paint layers, particularly in areas of strong light or broken, worn, or pitted stone.

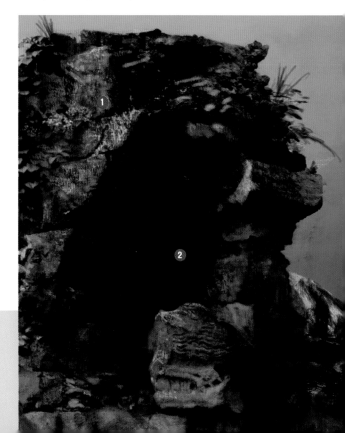

① Allow dabs and splotches of color to sit next to one another, rather than blending them.

② Rely on value to create a strong sense of structure and solidity in your rocks.

# 4·THATCHING

*With subjects like thatching, hair, or grass, look for visual clues to the structure that will allow you to indicate clearly the shapes and volume in your painting, without getting lost in the individual details. For thatching, these clues may include the fact that the upper planes, which are exposed to the elements, are often lighter in value, taking on a bleached, weathered look, or that the thatch may be bundled into larger shapes or layers, which become more structured and easier to paint.*

## Thatch: Volume and Structure

Your painting will look much more convincing if you avoid painting each individual stalk; instead paint an impression of the thatch, creating the volume, structure, and feel, and then selectively add details where they are needed and will be the most descriptive. Try to work also with variations of warm to cool, or faded against strong colors, or light against dark values in order to give structure to your image.

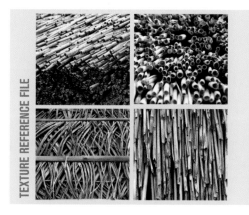

TEXTURE REFERENCE FILE

## Painting a Thatched Roof

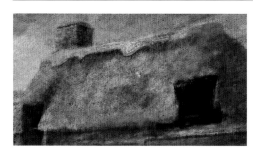

**1.** Begin by laying in the basic tones or values and the rough colors. Keep the palette limited and the brushstrokes loose, suggestive, and moving in the direction of your forms—running along the length of the straw, or scumbled and indistinct for the exposed ends. Pay attention to establishing volume and structure, to give you a foundation on which to build your details.

• Remember to work with negative space—the areas around or behind the subject—to help define its shape and generate value contrasts.

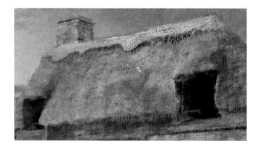

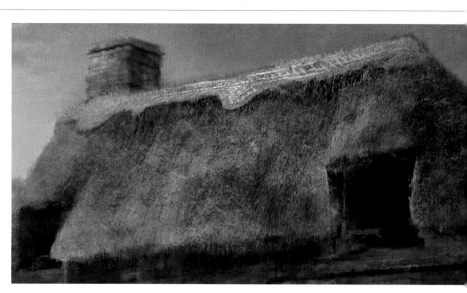

**2.** Define and refine your shapes and textures, and begin to look for areas of emphasis, whether it be spots of light on the roof, areas of color, or other details that will help you add interest to the broad planes of the thatch.

**3.** Add the small details. Is there netting over the thatch, or leaves and debris caught between the stalks and bundles, random splotches and spots of color, or perhaps moss growing on part of the thatch? In this example, there are spots of color, small areas of moss, and in the light areas, stalks are picked out to establish a visual pattern.

• Once the pattern or texture is established in part of the image, the viewer will extend it to the rest of the image.

# 5· PLASTER

*Plaster is one of the oldest, most durable, and most versatile of building materials. The limestone in lime plaster changes chemically as it cures, the carbon dioxide in the air transforming the calcium hydroxide into calcium carbonate. This is the same transformation that allowed the Mesoamericans to work limestone with only simple tools, carving and shaping the soft stone, which then hardened with exposure to the air into something much more durable.*

## A Versatile Material

Plaster can be molded, painted onto, used to strengthen walls and ceilings, to cover bricks or marble, to decorate both the interior and exterior of buildings, and even to make replicas of anything from tombs to statues.

As a result of its widespread uses, plaster can be helpful in showing the age, condition, or construction of your architecture, allowing you to tell the story you want with your image, from crumbling walls discolored with age to bright new detailing on the ceiling of a manor house, or from the distinctive look of a fresco painting to primitive stick-and-plaster huts.

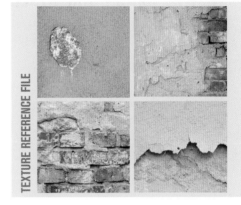

TEXTURE REFERENCE FILE

## Plaster Applied Over an Exterior Brick Wall

**1.** Establish the values and rough color palette. Here, the light plaster is set against the darker values of the bricks. Dappled light allows you to focus on part of the image, showing the weathered but still visible surface details and creating a center of interest.

Begin by laying in the rough shapes, allowing some of the colors from the bricks to bleed into the area of plaster and keeping the shapes and edges rough and loose. Keep the values limited at first, creating two or three basic values: for the bricks, for the plaster, and for the shadows. Keep the brushstrokes loose and rough to help establish the rough, weathered textures.

**2.** Establish more surface details and textures, working with the rough underpainting as your guide. Refine your colors and allow some edges to become crisp. Look for areas where details like cracks, chips, and pits will help describe your surface. Use your initial painting to keep the value relationships accurate, and continue to paint loosely in order to avoid having your image overrun with details.

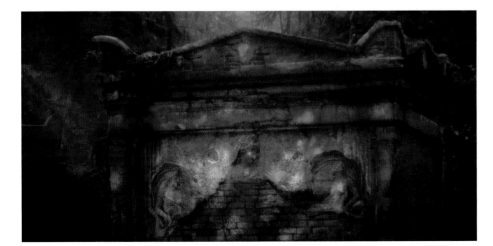

**3.** Refine and define your surface details. Balance the warm and cool aspects of the image, and add details where they are needed. Warm the edges of the shadows cast in the dappled lighting, glaze a cool color over the shadows, and build up the light areas with stronger, opaque paint in the center of interest.

• Light equals information, and the stronger, more opaque paint will draw the viewer's eyes.

# 6. MARBLE

*Prized for its beauty and elegance, its purity, and its distinctive, translucent sheen, marble has been the stone of choice for centuries to create sculptures, palaces, temples, mausoleums, and more. Marble's ability to be worked with great precision and to resist shattering makes it ideal for architectural uses. Its very low index of refraction allows light to penetrate several millimeters before scattering, resulting in the characteristic shine or luminescence of marble and giving marble sculptures their lifelike appearance.*

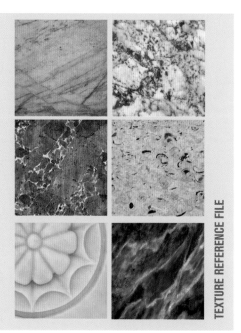

TEXTURE REFERENCE FILE

## Grandeur and Sophistication

Marble is available in a range of colors, and the veining or streaking varies from minimal to heavy. Pure white or light gray marble is often prized for use in sculptures, whereas the more varied types are often used in architecture to provide color, contrast, and detail.

Because of its inherent beauty, its versatility, durability, and historical associations, marble instantly lends a sense of legitimacy or refinement to a place or scene. For fantasy artists, this association works especially well, allowing you to generate a sense of cultural sophistication, wealth, or history in any setting you can imagine. In ruins or decay, use it to create a sense of loss, of greatness fallen and faded, or, just as easily, use it newly crafted to create the story of a young culture seeking to establish itself by mimicking the styles of those who came before. It was common for cultures to use pieces of older buildings in the construction of new architecture, giving artists yet another way to add complexity, history, or story to their images.

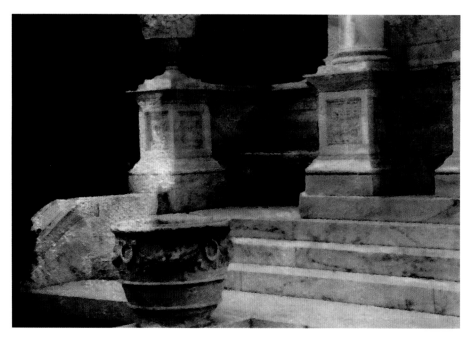

## Outdoor Marble

**1.** Lay in your basic shapes and values, intentionally painting them darker and more saturated than they will appear in your final image. This is because semiopaque paint will likely be used to refine the marble and create the translucence, lightening your values as you progress. As this is an outdoor scene with dappled lighting, the shadows will be illuminated primarily by the blues of the sky, so they should be painted slightly warmer initially, as they will be cooled with glazes as you progress.

• In many ways, marble is a study of opposites, requiring an almost counterintuitive approach to painting. Its milky translucency—the fact that light penetrates into it rather than reflecting off the surface—requires a different approach than most surfaces or textures you will paint.

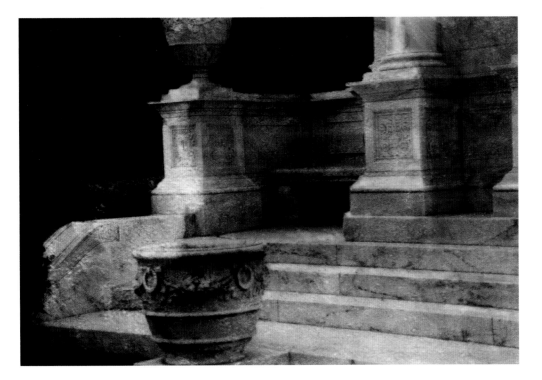

**2.** Using thin layers of semiopaque paint, refine your value relationships. Introduce cooler colors into all but the deepest shadows, allowing the brushstrokes to break up. This will generate a stipple or pointillism effect, creating the necessary neutral tones without homogenizing the colors. The temperature and the vibrancy of each color are therefore retained, and the colors are mixed by the eye of the viewer rather than

on the canvas or paper, giving your image a stronger luminescence.

Warm the upper planes of the marble, laying the foundation for the dappled light, and add the discoloration that occurs at the joints and cracks in the stone once the paint is dry.

• Be sure that as you introduce paint into the midtones, you do not alter the value relationships too strongly, and be sure to craft and refine the shapes

and structures—you may be suggesting shapes in a near-abstract manner at times, such as here in the carvings on the bases of the pillars or the urn, or carefully rendering something, but strive to be clear and deliberate with your strokes. Make each stroke count for something, give each one a purpose, and craft your image deliberately.

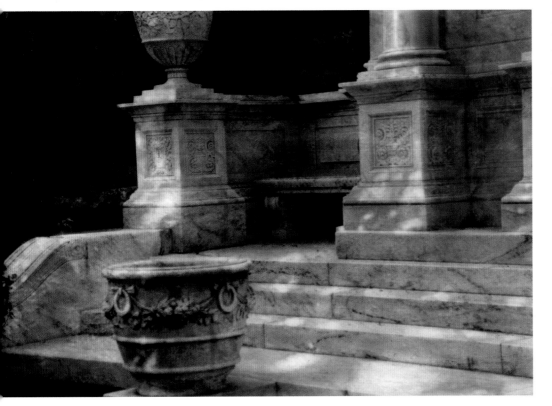

**3.** Continue to refine the shapes, values, and colors. A loose suggestion of vegetation can be added to the background, and highlights added to the marble, most notably the shine on the round pillar. The dappled light effect is created by glazing semiopaque cool colors over the areas of shadow to lighten and smoothen them as you cool them, and then building up the areas of bright light with stronger, thicker, more opaque paint. The transition between the two is glazed with a warm earth tone because cast shadows tend to warm up at the edges.

Continue building up the dappled effects with several layers of paint, in order to keep the values and color effects separate and to maintain the intensity of the colors as you build up the values and balance the warm and cool effects. Finally, glaze in the discoloration effects around the cracks and between the slabs of marble, and add any staining or weathering effects.

# 7·WEATHERING AND AGING

*While weathering and aging are, in some ways, two words for the same thing, for the fantasy artist a distinction can be applied that may prove helpful and give you a focus or concept for your image. Weathering refers to surface effects, which usually do not change the shape or structure as much as its surface appearance and texture, whereas aging primarily refers to the effects of time on the shape and structure of something, causing breaks and cracks, and similar damage.*

## 7.1 Weathering

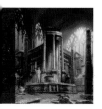

**IN CONTEXT**
*"Abandoned Temple"*
*page 22*

Surface stains and blemishes, the patina or pitting on metal, the bleaching of wood, or small expansion cracks in wood joints and beams are all good examples of effects that do not significantly alter the shape of your subject, but do alter its color, texture, or appearance. A careful study of the effects of weathering on stone, metal, wood, or any other common architectural material will help you add considerable realism to your image.

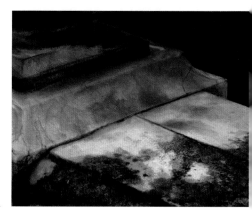

### Stained and Weathered Marble

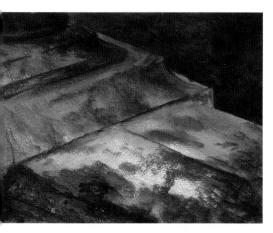

**1.** The overall concepts for this piece are color against neutrals and shape. Because the surface weathering effects will alter the local values in the image, darkening the white marble while lightening the dark metal, shape becomes very important. Rough in the composition with a minimum number of values—in this case three: the upper marble planes, the side or beveled planes, and the dark metal and shadow shapes.

• Note how the brushstrokes within an area are kept loose and gestural, but the shapes themselves are clearly defined.

**2.** Keeping to the underpainting as your guide, begin to build up the basic colors and textures. Stay within the value ranges you established in step 1, and continue to keep the shapes clean and clear. Exaggerate the colors and textures of the marble, as they will be painted over with semiopaque paint and softened later on. Do not paint the shadow or dark areas too dark at this point, as they will automatically look darker once the marble is lightened.

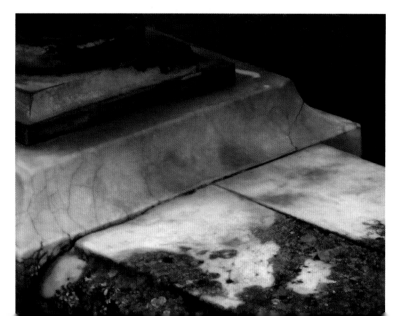

**3.** Using very small amounts of thicker, opaque paint (dry brush for watercolor, gouache, and acrylic, dry brush or scumbling for oils) begin to build up the lights of the marble. Allow the underlayers to show through the paint, creating the milky, translucent look of marble.

Work the green stains into this upper layer of paint where you need to, so that they appear to be on the surface of the marble. Darken and simplify the shapes of the metal and background, defining the patina by painting the darks around it. Once the paint is dry, build up the colors and textures of the splotchy growth on the marble, paying particular attention to the edges of your shapes to make sure that they sit on top of the marble plane. Build up the green stains further with glazes if needed, warm up the shadows, and add highlights and dark accents.

• Marble has a very low index of refraction, which means that light passes several millimeters into it before being scattered. This is what creates its beautiful, translucent qualities and gives a sense of being able to see into the marble to the colors within.

## 7.2 Aging

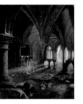

IN CONTEXT
*"Abandoned Temple"* page 18

Aging for the fantasy artist is all about making something look old. Worn, faded, crumbled—you need to study the how and why of things getting old before you can paint them. Under normal circumstances, for example, stone ledges, protrusions, or the limbs of statues will age, crumble, crack, break off, and deteriorate first. Areas protected by an overhang will show their age the least, but may provide shelter for moss and lichen to take hold. An arch, or even a partial arch, will tend to support itself well, and shelter the things below it, until the keystone or other integral support degrades, at which point it will rapidly begin to crumble and fall. Open, exposed faces of a building will be pockmarked, cracked, chipped, or missing pieces, whereas nooks and corners will have an accumulation of soils in crevasses that will support some degree of vegetation. Look also for areas where water might have collected and remained, or pooled and frozen, causing expansion or cracking. All these details will help you determine how and where your structures have aged, and allow you to paint them with as much or little detail as you need.

## Stone Column in Shadow

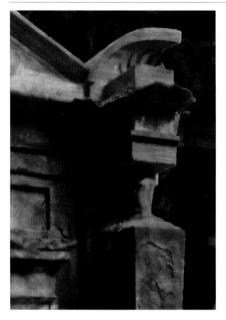

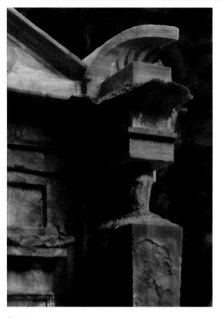

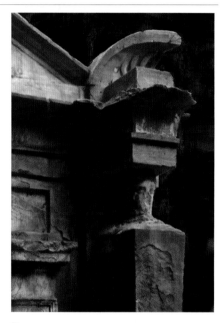

**1.** Establish the large, basic forms and values. For this image, three layers of paint were needed to get in all the basic information, each kept thin, loose, and transparent. There are three basic values—side planes, top planes, and shadows. The protruding square column casts a very soft, indistinct shadow across the face of the structure. In order to capture the sense of darkness enveloping the structure, allow the initial rough to dry before you add the shadow gradation.

Additional darks were painted into the shadows and some areas of the lights were pulled out while the paint was still wet, using a clean brush and, if necessary, some medium (water for watercolors or acrylics, thinner for oils). Keep the paint layers thin, especially in the shadows. The shadows are where the underpainting will most likely show in the final image, and it's important not to lose the sense of transparency in them.

• Painting everything in one layer makes it more difficult to maintain the structure and an even shadow gradation. Two or more separate layers will give you much more control over your paint.

**2.** Keeping the paint thin, begin to work details into the mid-tone areas, adding color and building up textures. Add surface details like chips, cracks, gouges, or breaks that will give your image character. Look for areas that will show discoloration or stains, or places where vegetation is taking root. Leave the shadows alone at this point, in order to preserve their transparency, until you know what, if anything, they might need.

• Ask yourself if any of the damage to the surface might have been recent, showing sharper edges or exposing a clean stone face. These are the types of details you need to truly convey the history and story of your structure, of your painting, and they are what you must strive for every time.

**3.** Continue to add details and refine the mid-tones. Begin to selectively add brighter values to the upper planes, such as the top of the right pillar or the upper planes of the ledges on the left. Because the light is coming from above and right, the lower-left edges of the pits, pockmarks, and cracks will have a subtle highlight to them, whereas the upper-right lip or edge will cast a subtle shadow, making the surface details look convincingly real and three-dimensional. Add touches of vegetation and stains of stronger colors, and carefully add reflected lights or dark accents into the shadows.

**TEXTURE REFERENCE FILE**

# 8. MOSAICS AND PAINTED TILES

*Mosaics, painted or ceramic tiles, cut stone, or glass can be used to create patterns, images, and designs within your artwork. Unlike painted designs, which are continuous color or line on a canvas or plaster wall, or the solid, unbroken threads and yarns of a tapestry, mosaics and tiles are separate, hand-cut pieces, the designs and shapes fitted together like a jigsaw puzzle. In the case of mosaics, the colors are inherent in the stone itself, and the artist creates the image from these preexisting colors, and in the case of painted tiles, the artist is using the painted design almost as a brush, using a number of tiles to create a larger pattern.*

## 8.1 Mosaic Pattern

The pieces may be roughly cut and fit loosely, with gaps between them, or cut with a near perfect precision so that they align with almost no gap at all. You can either work out the design of your mosaic on the fly, allowing it to develop as you work, or you can work it out beforehand in your drawing.

### Planning and Painting

**1.** For this study, the design was worked out beforehand and transferred to the board prior to starting the painting. Light, quick washes were brushed over the board with thin paint, then the darker passages and details were roughed in, with special care given to the gaps between the pieces. Very rough suggestions of color were scrubbed in as well, so that the painting was not monochromatic.

**2.** Still working entirely with transparent paint, the colors were refined and strengthened, as was the pattern and the darks between the shapes. There will be a slight dappled light effect in the final image, so some initial work is done on that, beginning to break up the otherwise uniform values of the flat plane.

**3.** Switching to opaque paint, the colors and values are strengthened considerably, and the full value range is clearly painted. Once these have been established, the textures can be strengthened, using the values as a guide, so that the texture does not overwhelm the value relationships. The darks between the stones are also strengthened, as are the shapes of the stones themselves, softening the edges of some, while making others crisp or ragged.

## 8.2 Painted Tiles

For painted tiles and mosaics the images created can be representational or abstract, floral, animalistic, or figurative, which means that the fantasy artist needs to be aware of what cultures created what types of designs, and make use of that knowledge to his or her best advantage.

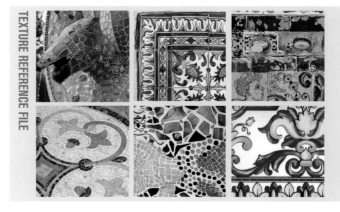

TEXTURE REFERENCE FILE

## Distressed Tile

**1.** Painted tiles start out as a flat tile with a uniform color and minimal texture. In most painting situations, you will likely paint in a light value for the area to be decorated, then paint in the designs on top, but, for this example, the tiles are aged, cracked, worn and damaged, adding another dimension to them. Since the tile will be worn, it's necessary to create the different surface textures and variations before adding in the actual glazed colors or patterns. Working very loosely, the beginnings of the tile are laid in, with light, dull oranges and earth tones for the exposed wall, and paler, smoother tones for the tile itself.

**2.** The tile textures and shapes are refined further, the colors glazed, or scumbled over with thicker paint to create the base for the tile design. Cooler whites are painted over the areas that will be the smooth ceramic of the tile, to further separate them from the warmer tones of the exposed wall beneath. The edges of the cracks and pits or areas of missing ceramic are brought out with highlights and shadows, as are the spaces between the tiles.

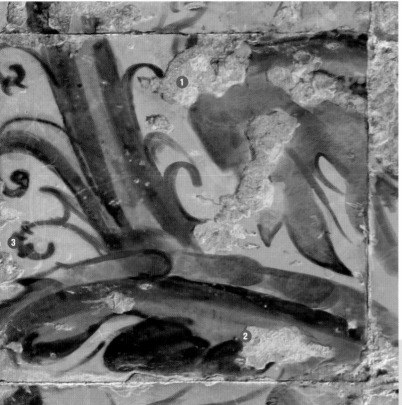

**3.** Glazes of color are added on the ceramic portion of the tile. These would have been hand painted in real life, with variations in paint opacity and consistency, in stroke pressure and width, and with a transparent feel that can only be achieved by hand painting. The colors used were almost invariably transparent, so that where strokes overlapped the paint became noticeably darker.

• Tiles were painted quickly, so that occasionally colors would mix or blend on the tile, and these are the qualities you need to impart in your own painting.

The textures ①, edges ②, and shapes ③ established in the earlier steps are the most important detail for conveying the distressed character of the tile. The colors and glazes are what the viewer's eye will focus on, but the underlying shapes, values, and textures are what will hold your image together.

# 9· FIRE AND SMOKE DAMAGE

*Unlike the slow erosion and damage caused by natural, long–term exposure to the elements, such as decay, swelling, cracking, or bleaching, the rapid destruction caused by fire, by the heat and the smoke, is intense, sudden, and violent. While smoke damage is primarily external, from an architectural standpoint, fire is both internal and external, causing wood to burn and disintegrate, as well as causing cracking and structural damage to stone, destroying supports, swelling, peeling, and cracking paint, and melting metals.*

## 9.1 **Fire Damage**

Where destruction by fire in the natural world is a necessary part of the life cycle, resulting in rich regrowth or the chance for new species to gain a foothold in a new environment, fire and destruction from an architectural point of view is all about endings. The building may be rebuilt but it cannot grow back. Visually, this presents a fantastic opportunity for the artist to show the slow decay of wooden support beams or the rusting of metals or the crumbling of stone foundations, or the gradual reclamation of structures by the environment.

### Damage to Wood

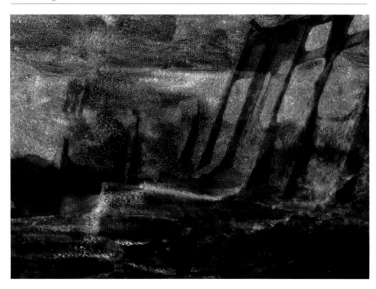

**1.** This image shows the damage sometime after it has happened, the wood being gradually reclaimed by the elements and breaking down. Moss, lichen, and other organic materials have begun to grow on the remains. The image needs to convey a bleak, abandoned, and forgotten mood, so a muted palette, desaturated colors, and low-level lighting were chosen. The concept is one of areas of color against colorlessness, with rich dark tones.

Begin by establishing the dark overall tones of the image and creating the foreground shapes. Texture and suggestion are far more important at this stage than detail. Try to capture the large overall shapes of the composition, the repetition of the dark, angled shapes on the right, and the mass of the foreground.

**2.** It's time to begin adding colors and textures, and reinforcing the sense of depth in the mid-ground shapes. Notice that the values have remained very close to what they were in step 1. The background haze has been used to lighten some of the angled shapes and push them back in space as they recede, to unify and separate some of them from the foreground elements„ and to lighten the background enough to establish a clear separation between it and the ruins.

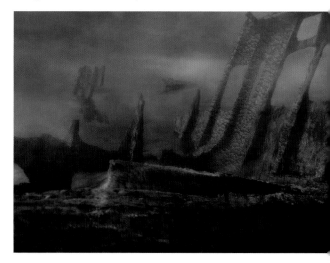

**3.** Balance the lights and darks, and make adjustments for the temperature of the colors. For example, the large beam in the foreground needed to be cooler to balance against the spots of brighter color, and in the detail (bottom left) the combination of light and dark and warm and cool colors create texture and tie the picture together. Rather than lightening the values of the foreground beams, which would have detracted from the burnt, blackened look and mood, the background was darkened.

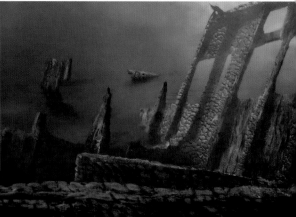

## 9.2 **Smoke Damage**

The soot and smoke damage will reduce the value contrasts and clarity of your forms, since they will reduce objects to large, dark masses. Therefore, it is very important that the basic shapes read clearly. When composing this kind of image, it may be helpful to envision it at first in only two values—the stone and the smoke. In this case, there are three values, one for the base value of the stone, one for the stone that has been covered in soot, as well as the darks of the background, and one for the highlight of the stone and smoke where a shaft of light breaks through, suggesting perhaps a collapsed roof.

**TEXTURE REFERENCE FILE**

## **Damage to an Interior**

**1.** This image shows the damage as it happens, with the embers of the fire still warm and smoldering, the discoloration fresh and the archway blackened but still standing.

Begin by roughing in the basic shapes and values you will need, loosely at first, and darker than you will need them in the end, as the lighter values of the smoke will be painted on top and the stone itself has become blackened. Rough in the values and shapes quickly, allowing the textures of the brushstrokes to remain, and keep all detail to a bare minimum of suggestion.

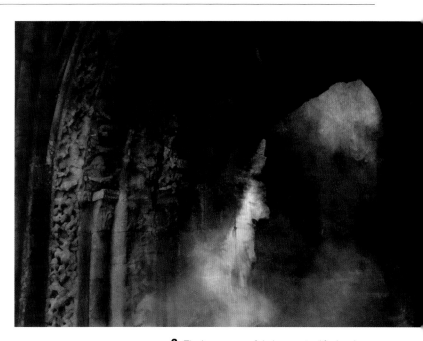

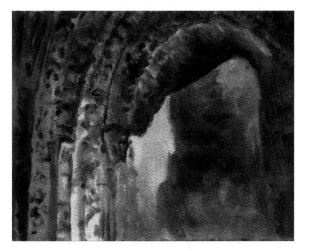

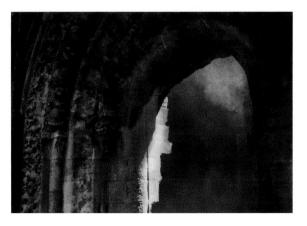

**2.** Details in the darks are added and refined, so that when they are glazed over and the values darkened and simplified, they will not become simple, flat shapes. The focus here is on establishing structure, in the concentric rings of the arch, the cylindrical shapes of the poles, and the cast shadow, all of which are necessary to allow the large shapes to read clearly and still establish a sense of depth and space.

**3.** The large areas of darks are simplified and glazed over, but because of the details from step 2, they do not become a flat mass, but have depth and structure to them. Details and textures are added in the lights and the smoke is painted, now that we have a gauge for them against the darks. The whole image is worked at once, balancing the value relationships, balancing detail against shape, and looking for areas that need to be simplified, smoke damaged, and soot covered. In many ways, the smoke acts like a very thick, localized atmospheric perspective, but one that can be placed anywhere it is needed for best effect.

• Don't forget, glazes can be painted with transparent paint, such as the shadows, or opaque paint such as the smoke and haze.

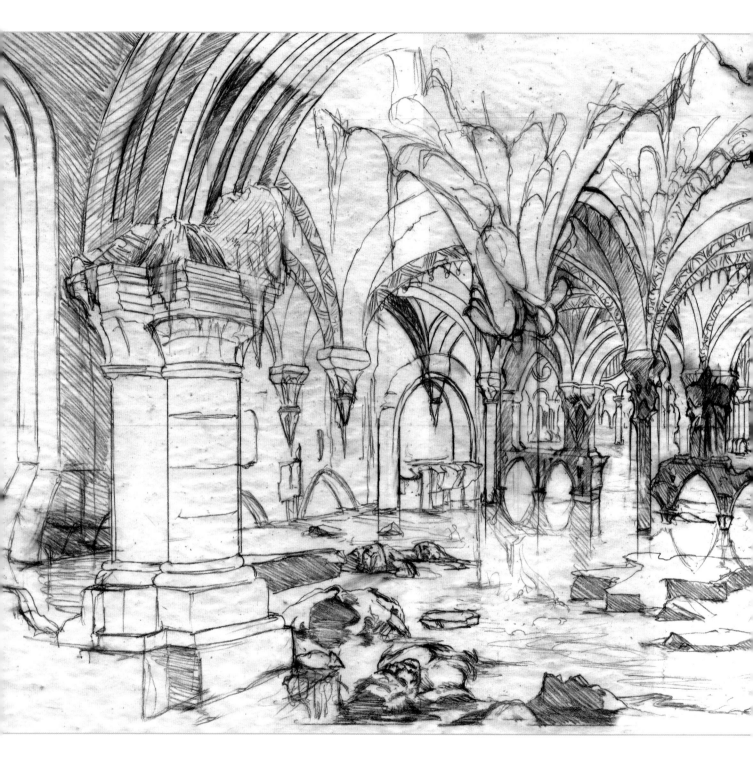

# CHAPTER 4

# CREATING YOUR OWN WORLDS

*Now it's time to put everything you've learned into practice. Building on a strong foundation of technical knowledge, painting skills, and a solid understanding of architecture, these artists combine history and inspiration to create unique fantasy worlds. Step-by-step examples and insightful accompanying text will give you a look behind the eye and into the mind of these artists as they design, paint, evaluate, and complete their images, both traditional and digital, bringing their imagination to life.*

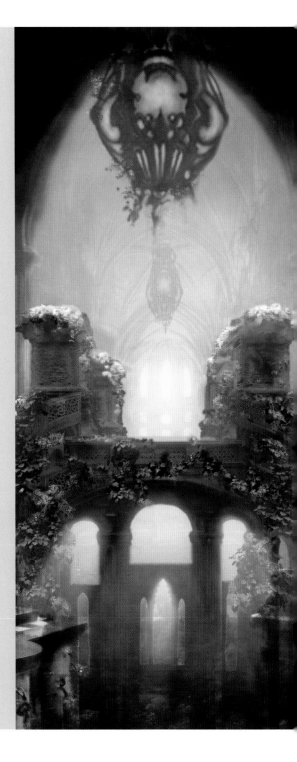

*Painted as a cover for an instrumental Halloween soundtrack, the image needed to capture the haunted, Victorian atmosphere of a derelict asylum.*

**1. FIRST THUMBNAIL: STONE ENTRYWAY AND GATE**
The assignment required depicting a long abandoned, derelict asylum, and the initial sketches explored what, and how much of the building to show in order to best capture that sense of desertion and decay. The first sketch was of the exterior of the grounds, the stonework damaged and overrun with vegetation, the gates still barred, and a shadow of a figure suggested.

## ROB ALEXANDER
# LAYERING VALUES

The choice to use low lighting and muted colors meant paying careful attention to the balance between massing shapes to convey mood, and rendering details to add realism, structure, and depth. The image keys off the moon and skull as the lightest points, and the darks to lights are conceived as alternating planes to help establish depth.

The initial thumbnail sketches were done on toned paper with pencil and white chalk, in order to quickly work out the masses and values. Shapes were kept intentionally large, simple, and suggestive. The sky and ground planes will have text over them when printed, so value contrasts within those areas would need to be minimal in order for the text to be easily legible. Additional space at the top and bottom of the image allowed for flexibility when laying out the cover.

In the final painting, the gates, statue, and light beam serve to enclose the middle of the image, focusing the eye of the viewer on the derelict asylum while also keeping the eye moving around the image, and the mist creeping into the foreground both opens up the mid-ground, and provides the viewer with a visual path or entry into the image.

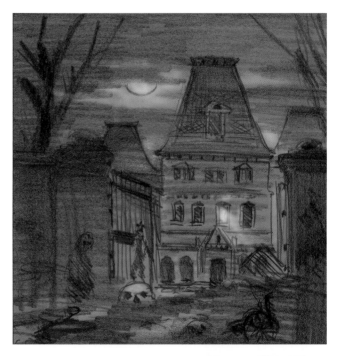

**2. SECOND THUMBNAIL: CLOSEUP OF ASYLUM**
As the sketches developed, the use of the skull as a counterpoint to the moon quickly emerged and was explored, as was the use of the ruined gate and a path directing the eye. In this sketch, the lights and darks in the foreground plane are in one-point perspective, and lead the eye into the image and to the front of the asylum. The asylum was enlarged and allowed to merge with the shapes of the walls, creating a strong silhouette, but the compression of space that resulted from making the asylum so large flattened out the image too much.

**3. THIRD THUMBNAIL: ASYLUM AND TREE**
The asylum was pushed back into the distance, and the use of layered values emerged as a method of creating depth. The foreground elements are massed into a single dark shape; the mid-ground is a light misty plane with subtle horizontal banding that echoes the shapes of the asylum. However, the tree in the foreground competed too much with the asylum and began to dominate the image, and the framing of the mid-ground elements looked too static.

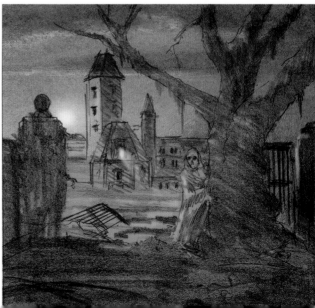

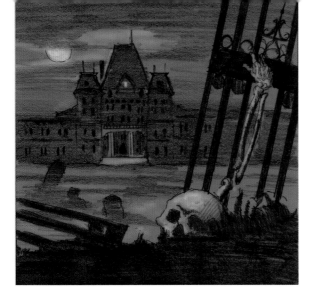

**4. FINAL DRAWING: VALUES**
Several elements and ideas from earlier sketches were combined, and the final design now has clear light and dark values establishing depth and mood, strong shapes which read well and move the eye about the image, and a balance between the size and values of the skull and moon, which anchor the image while laying the foundation of a good story within the image.

**6. ESTABLISH BASIC VALUES**
The basic values and masses are established. Although the palette is limited, color is necessary for establishing the depth and mood, so the background is kept predominantly cool, while the foreground is composed of warm greens and browns. The skull has been left as a large light shape to provide a counterpoint to the moon even in the early stages.

**5. FINAL DRAWING: LINEAR**
A final drawing is prepared prior to the start of the painting and transferred to the working surface. Details in the architecture of the asylum and the design of the gate are worked out fully, so that when they are painted with decay and damage, they will still have an accurate underlying sense of structure to them and be convincing. This also allows more freedom when painting the decay and dilapidation, and ensures details like the symmetrical panel in the gate will actually be symmetrical and in proper perspective.

**7. MID-GROUND AND FOREGROUND VALUES**
The asylum has been finished, the textures and additional details brought out with a pale blue gray that was also used in the sky, in order to create uniformity in the lighting, and allow the structure to sit back in space. Mid-ground elements have now been suggested, and the tombstones in the sketch replaced by the statue in order to break up the horizontals of the mid-ground and help establish depth. Additional textures and colors have been added to the foreground, but within a very narrow range of values, in order to maintain the sense of mass. The skull is roughed in.

**8. WORKING ON DETAILS**

Additional color and detail are added to the foreground foliage and skull, and the gate is roughed in with thin paint so that the shapes can be controlled more precisely. The stronger greens of the foreground now looked isolated and out of place in the painting, so a muted version of them was used to add more vegetation to the asylum and background elements, bringing the colors back into balance. The mist in the mid-ground is lightened slightly, and allowed to begin flowing over the foreground grasses.

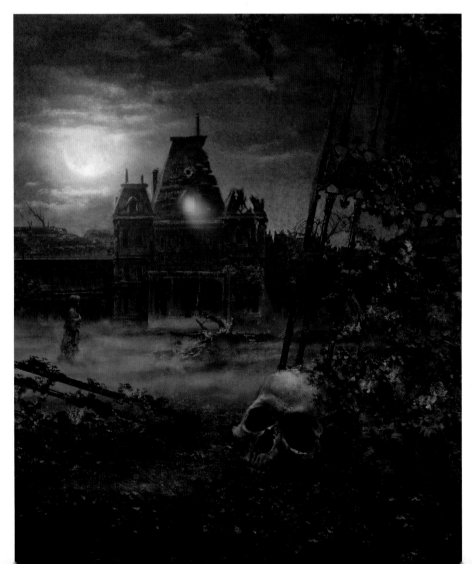

**9. FINALIZING THE PAINTING**

The gate is painted over with thicker, darker paint in areas, and rusty colors and textures are added in spots for accents. The warm orange browns of the rust bring out the warm colors of the asylum, and the effect is balanced to ensure that the asylum does not come too far forward in space or look out of place against the cooler lights of the sky. Climbing vegetation is added to the gate and allowed to partially cover the skull, in order to keep the skull from dominating the image too much or detracting from the asylum. A single shaft of light is added, shining out of the asylum, to help move the eye through the image and create a more complex mood and story. The mist is brought into the foreground, leading the eye into the image.

**10. FINAL PIECE: GATES OF DELIRIUM**

Small but crucial adjustments are made to the entire image, using color and value primarily to enhance the mood and atmosphere of the painting. The top of the statue's head is lightened in order to separate it from the asylum behind it, while the base of the statue is lightened, in order to separate it from the foreground gate. The fallen tree is further simplified and massed, and the lights on the asylum and skull brightened in spots for accents and emphasis, making the structures look more three-dimensional The whole image is then glazed over with a pale blue, unifying all the colors and enhancing the moonlit atmosphere.

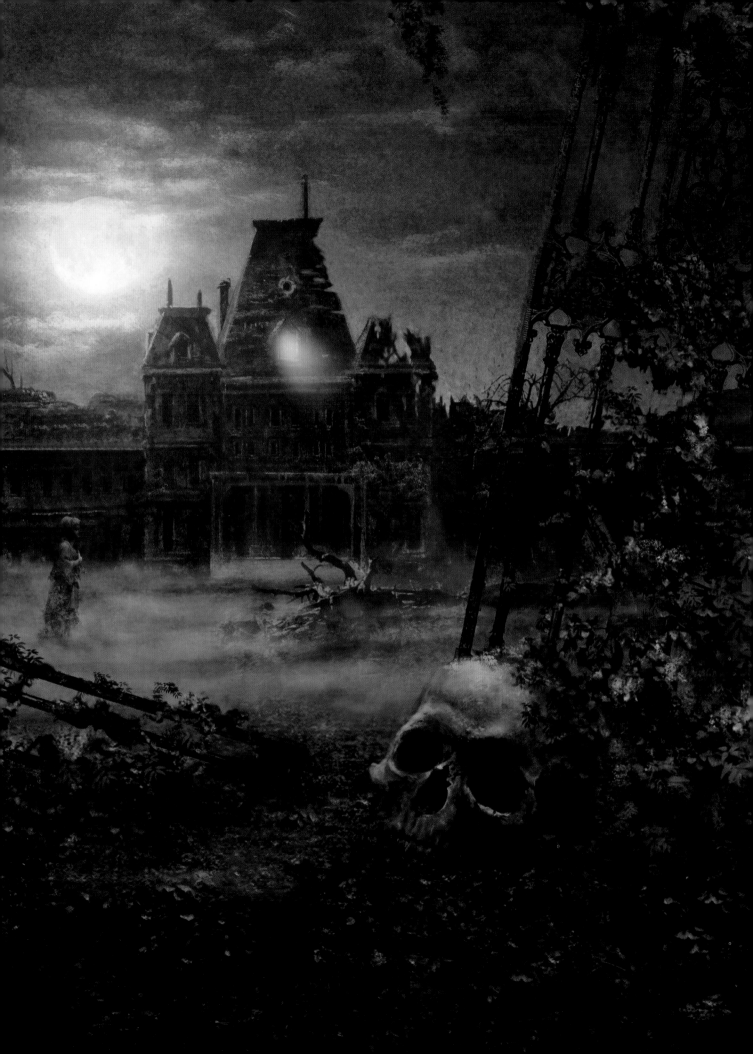

*Getting the light and color right involves a lot more than simply matching your reference. Time of day affects the mood of a piece, as does your choice of color.*

## ANTHONY SCOTT WATERS
# EVOKING MOOD

The classic approach to rendering such a setting could be to use golden shafts of pure sunlight over this strange crystalline city. The artist, however, deliberately chose to take a less comfortable direction. Ravnica isn't all pomp and circumstance. It's also dark and seedy, decayed, frightening. The artist wanted the viewer to feel those frayed edges around the perimeter of a predawn sky, and managed this primarily through his use of color and light.

△ **1. CONCEPT ROUGH**
Ravnica is divided vertically, with the forces of Law and Order getting the top bunk. It makes sense as the most likely place to situate big open spaces. Farther down in Ravnica's strata you'd find forests in the form of huge hydroponic gardens and at the very bottom would lie the sewer systems, the swamps. For this commission the artist was asked to portray this topmost layer of civilization, a place of broad open spaces dominated by crystalline cathedrals. This was his first pass.

◁ **2. PLANNING THE COMPOSITION**
The artist drops the horizon line to provide the viewer with a tiny slice of sky. He uses the two enormous towers to frame the view, forming a gateway onto the rarified world of Ravnica's "Plains" that stretch out beyond them. This has the same effect on the viewer as peering through an open door but on a grander scale: here he or she gets a peek into the realm of Ravnica's crowning layer, home to this world's elite.

**3. CLEANED-UP SKETCH ▽**
The artist begins to refine the "roughness" of his previous sketches to make them more presentable. For the first time the shapes and perspectives of Ravnica really take form. This is a sketch comp for the final composition, cleaned up for presentation.

**4. UNDERDRAWING ▽**
This is where the hard work starts—you don't get to "cheat" your way to a subject as complex as this— get ready for many hours of sketching.

This is the completed underdrawing for Ravnica Plains. You can still see parts of the artist's perspective grid showing through on the left-hand foreground building. The artist has corrected the perspective of the composition using a 2B pencil on a surface of frosted mylar (a durable surface that will take anything from pencil to paint, with a ton of scrubbing inbetween).

◁ **5. FIRST COLOR PASS**

The artist's first color pass. He chose a typical morning-light palette with a warm sky and raking shadows. The view is dramatic and at the same time familiar. Nothing has yet been lit directly by the sun. This makes the sky itself the main light source. You can imagine the first sounds of activity coming up from the open fields below. The color choices here are safe bets for suggesting a tranquil setting. Pastel colors tend to make the viewer feel everything is all right with the world. This palette didn't feel like it made the most of such a strange scene.

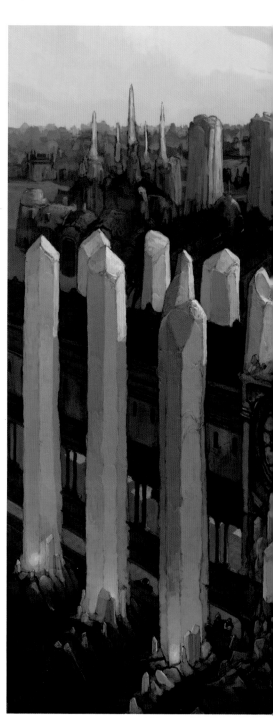

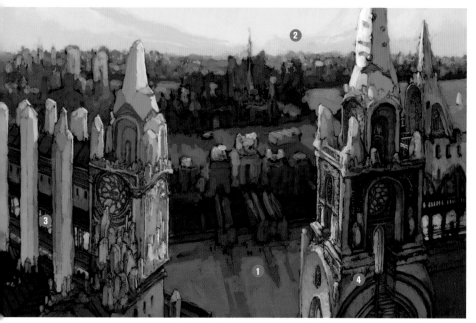

△ **6. SECOND COLOR PASS**

The artist drew inspiration for his Ravnica designs from Zladislaw Beksinski, the Polish surrealist artist, and Jean "Moebius" Giraud, the comic-book illustrator. The eerie yellow sky is very reminiscent of Beksinski's cityscapes and the strange buildings clearly reference the futuristic worlds created by Moebius.

Ravnica is supposed to have a strong Beksinski aesthetic and the artist has played upon this connection to create a strange, moody palette. The acid-yellow sky emphasizes the division between the natural and built world. This palette (yellow dominant, cool blues and lavenders for the subordinate) is known as a "split complement." It splits the difference between a direct complement (violet) and a triad (red and blue). Split complements have a subtler impact on the eye; they aren't quite complementary so can add a stronger note of the exotic to a piece.

① The cast shadows are a design element that establish depth, perspective, and structure.

② Clouds are curved, creating a "fishbowl" perspective, and the impression of a vast expanse.

③ The brighter, stronger sky colors allow for the use of lighter, more saturated colors in the shadows as well.

④ The lighter sky introduces more ambient light, so the towers are painted lighter and brighter, with more details.

▽ **7. THE FINAL PIECE: RAVNICA**

The artist has taken the main buildings as far as he
intended. There's a sleepy guard in the arcade, in the right-
hand building, and two figures are vying for the viewer's
attention between the tower and the first crystal pylon on the
left-hand building. These details barely show on the final card
but that didn't matter to the artist. He put them there for his
own pleasure. Commissions generally involve making
someone else's ideas pretty. Remember to reserve a portion
of every painting for you, no matter how small it may be.
That little hunk of territory can sometimes spell the difference
between a good painting and a bad one. It's breathing room
for your imagination.

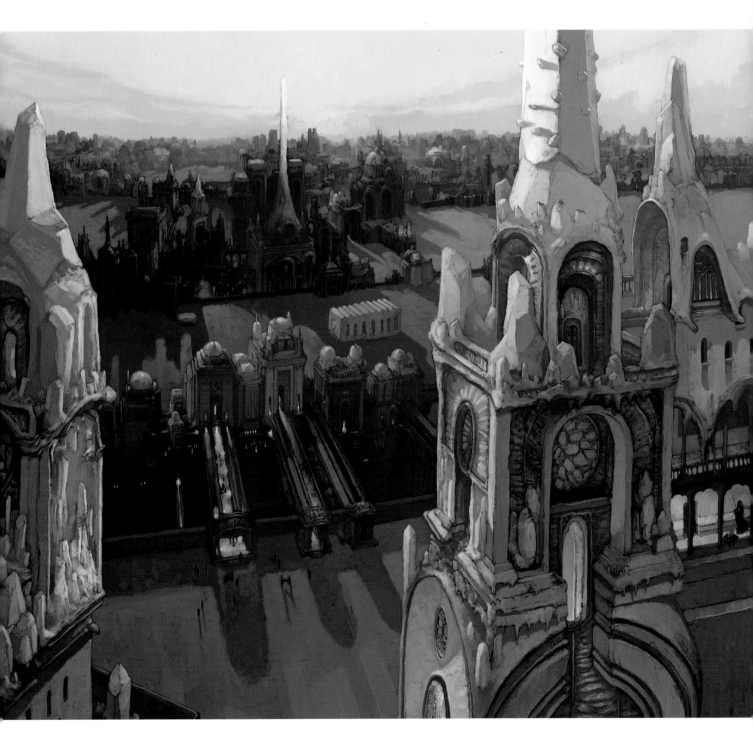

*This sequence focuses on how to artificially light a sci-fi environment using Photoshop and how to combine foliage and architecture harmoniously to create an otherworldly atmosphere.*

LORENZ HIDEYOSHI RUWWE

# PAINTING LIGHT

Before starting a painting, first consider the subject matter and how it is best presented. Here, the artist wanted to create a serene scene set in an alien world where architecture and nature combined harmoniously. The focus of the painting is on the unique building design built from geometric shapes in an organic way, so it ties in with the surrounding greenery. The twilight-like lighting was enhanced by accents of artificial light, illuminating the environment and creating vibrant color mixing. The overall green tone with complementing hues and slight color shifts added to the inviting mood.

**1. CONCEPT SKETCHES**
Inspiration came from a handful of sketches that had been done previously. The artist was drawn to the organically shaped buildings and smooth curves in the scenery and used them as the basis for his concept. Sketches like these will help you formulate compositional ideas early on.

**2. MONOCHROME SKETCH**
Starting with monochrome tones helped establish value relationships within the painting. These were kept vague and unrefined since there would be time to tweak them later. Bold strokes helped define the main masses and structures in the painting, and establish a basic composition.

**3. LAYING DOWN INITIAL COLORS**
On a new layer set to the "color blending" mode, the artist filled in colors with big brushstrokes. This dictated the general color palette while leaving opportunities for color changes later on.

### 4. DEFINING SHAPES

The process of defining the shapes in the building and surrounding structures was begun. A faint orange tone in the sky was introduced to suggest a setting sun. Yellow was used as the predominant light source coming from the building. Adding colors with an overlay or color dodge tool and then blending resulted in vibrant color mixing.

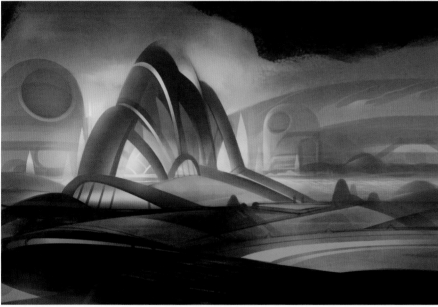

### 5. ADDING TEXTURE OVERLAYS

A textured brush was used to break up the overhanging rock formation so it looked more natural. The more geometric shapes in the buildings and landscape keep the eye interested while the background is left open to interpretation. The artist started to add texture overlays to describe the materials. Blue was introduced in various areas to add variation. To achieve clean lines and curves the artist used the path tool and converted it to a lassoed selection within which he painted with a soft brush, resulting in smooth gradients and value changes.

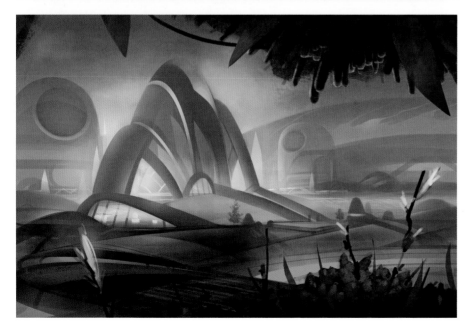

### 6. LIGHTING THE SCENE

Plants and foliage were introduced in the foreground to create more depth and scale. Similar or complementary colors maintained the overall tone. The building was hazed to push it back a little more into the distance. A lot of illumination was coming from various light sources spilling into the environment. Airbrushing with a soft brush over bright areas helped to create a soft, hazy atmosphere, as if particles in the air are affected by the light.

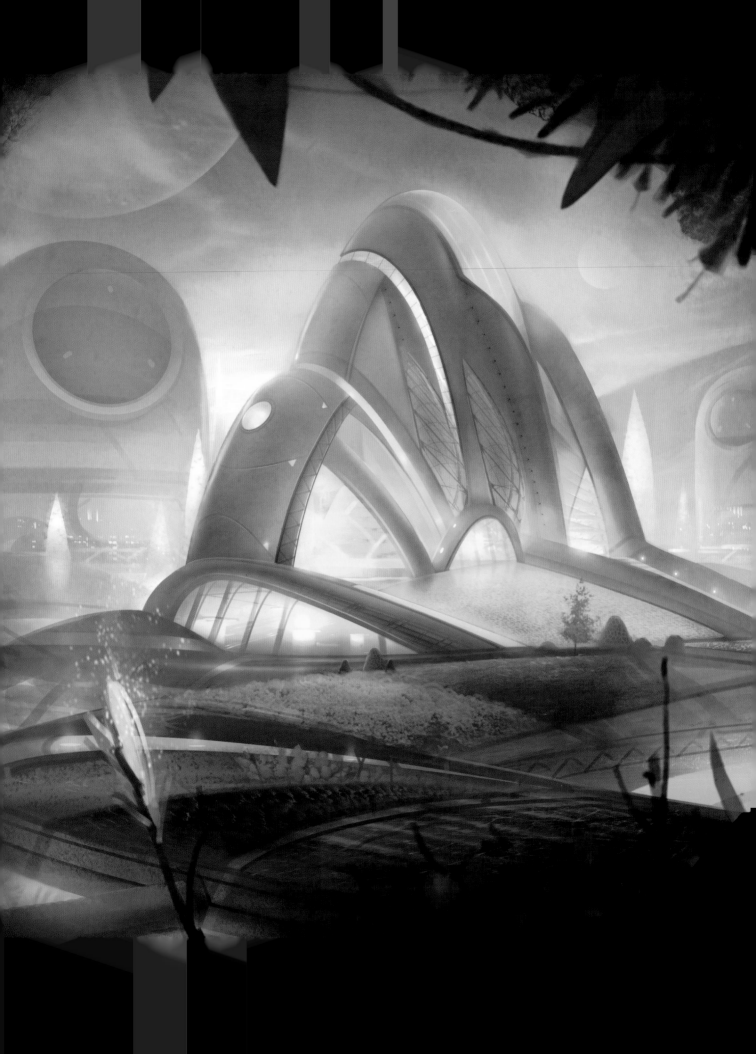

## 7. FINISHING TOUCHES: LIGHT MANSION

In order to enhance the illusion of depth, the foreground elements were darkened and blurred, and the image borders vignetted with a dark gradient. Details were added with overlaid textures to distinguish the materials and surfaces, which are made to look reflective and shiny in certain areas. The sky was broken up with wispy clouds and a planet in the top-left corner. The background was kept very bold and far less detailed than the main building, which is meant to be the focus of the painting. Adding fountains and little background light sources using photo textures, further helped with scale and realism.

## PHOTOGRAPHIC TEXTURES

Photographic textures were used by overlaying them on separate layers, which could be tweaked in order to blend them realistically with the painting.

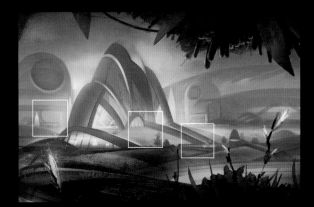

Overlaying photo textures to show tiny lights in the distance gave the impression of a populated area. Note the simplified brushstrokes for the background building to push it into the background.

Trees and foliage can make good reference points for scale and also add realism to a scene. Overlaid textures as well as reflections outlined the materials used.

Fountains in a pond surrounded with flowers were added to create areas of interest and character to the concept.

*Stephen Hickman's work combines classical forms, media and aesthetics, a powerful and distinct imagination, and superb drawing skills, melding them into beautiful, evocative images.*

## STEPHEN HICKMAN
# EXPLORING IDEAS

When Stephen Hickman was commissioned to illustrate a scene from *Nine Princes in Amber,* the first volume in the Amber series by Roger Zelazny, he had to interpret the author's descriptions of the city of Amber in a way that would please his client, depict the scene for the reader, and fit the available space.

### 1. CONCEPT SKETCHES
After settling on the subject, the artist made an initial sketch (left) and sent it to the client. The reaction was positive, but the client then specified two different formats and sizes, which represented the available display space for the painting. The artist reconfigured the composition and added several characters that the client wanted to include in the painting (above). While he waited for a reaction, he decided to go for the larger of the two sizes, but then felt that it called for a more epic treatment.

### 2. REFINING THE CONCEPT
The client liked the sketch, but felt that it distanced the viewer from the characters he wanted to see, so the artist decided to focus on the grand stairway leading into the city as his stage for the characters he had selected as the most visually interesting from the possible candidates. The concept and composition were then approved, but the artist felt that the scene was rather prosaic and static. He decided to use the figures to add a bit of excitement, and create a counter-diagonal to the angle of the city.

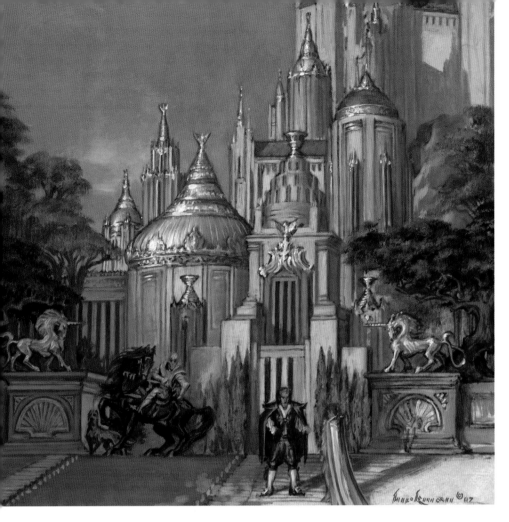

**3. COLOR SKETCH**
When undertaking a project of this size, you can avoid a great deal of toil and grief by first making a color sketch. You do not have to follow this slavishly—compare the shadows in the foreground in this sketch with those in the finished painting overleaf.

**4. FINAL CHARCOAL DRAWING**
This is how the charcoal drawing looked just before the artist started the monochrome underpainting. After the sketch in step 2 was approved, the number, placement, and treatment of the figures was reworked and refined to give the image a much stronger, more dynamic composition, and lead the eye from the foreground into the zigzag lines of the composition, breaking the strong horizontals of the steps. A final sketch was prepared at that point. Unlike the sketches for the client, which showed value, structure, and detail, this drawing is concerned primarily with the outer shapes. It's a line drawing, transferring the carefully worked out composition and key shapes to the final painting surface. The steps have been carefully lined in, keeping the correct perspective in mind. They turned out to be the most time-consuming part of the painting to do.

## 5. BLOCKING IN COLOR

The artist began with a monochrome underpainting in Mars violet, and then used a glaze of raw sienna to establish the predominant yellow mood of the picture. While this glaze was still wet, he started to work in the colors, beginning at the lower left-hand corner of the painting. Compare this very meticulous approach to drawing, underpainting, and initial color lay in with that of Tom Kidd (page 122). Both artists are establishing colors, shapes, and values in a warm palette, but Stephen's block-in, like his preliminary drawings, is clean and precise, whereas Tom's block-in follows in the spirit of his sketches, exploring and making decisions on the fly as he paints. Despite the different approaches, both artists are constantly evaluating and crafting their image, always willing to edit and change in order to make the image as strong as it can be.

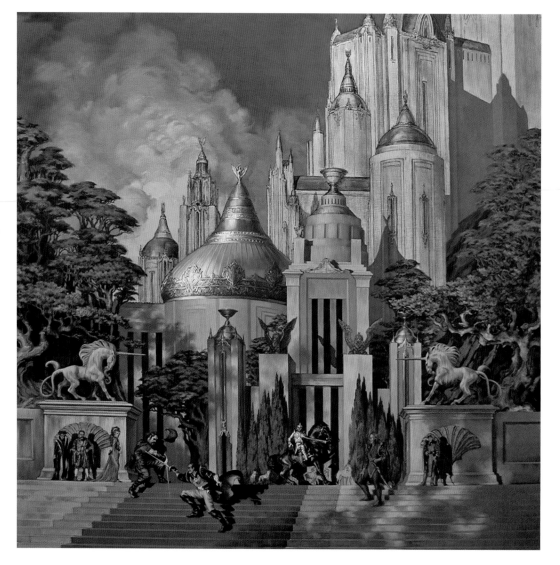

### REFINING THE FIGURES

Compare this close-up of the figures as they looked at this stage with the image of the finished painting. Note the subtle changes that were made in the painting phase in order to move the eye through the composition and create a personality or group dynamic for the figures.

① The woman from (3) has been flipped and moved here, isolating the figures behind her, creating size variation, and group dynamics within the group of three figures, and her green dress now emphasizes the red of the left swordsman.

② The figure's legs have been extended, making him more dynamic, and moving the eye more strongly into the image. The figure is now set off by the dark trees and light buildings behind, breaking the vertical lines.

③ The female figure was moved to (1). This required the introduction of the dark vertical band in the building behind where she had been, to continue the line of the trees down to the central figures.

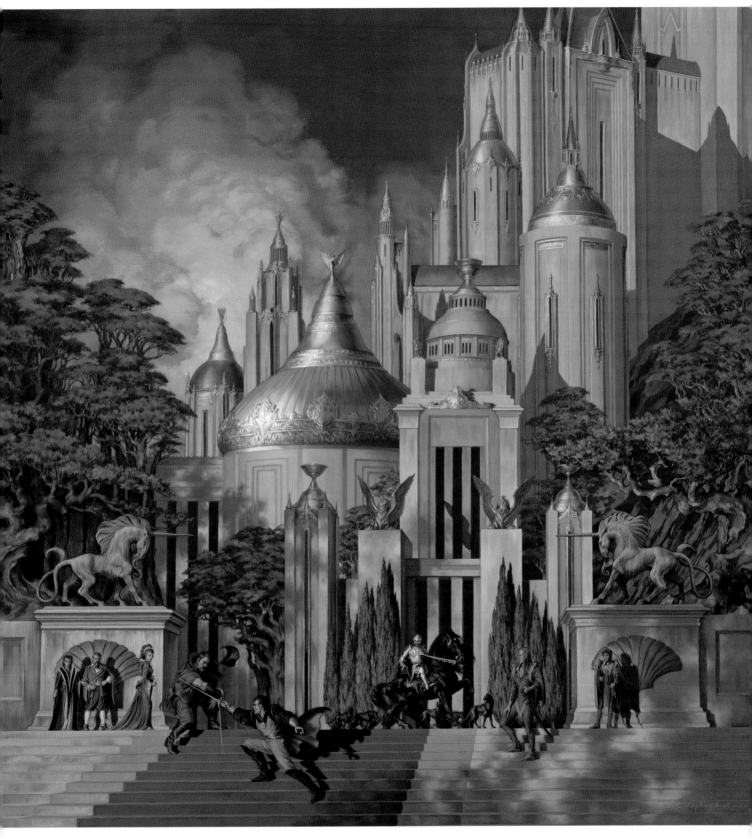

### 6. THE FINAL PIECE: CITY OF AMBER

This is the result of about six weeks of work, on and off, over the space of a year or so. It is a great luxury for an artist to have so much time to complete a work. Coming back to a painting after doing other work enables you to look at it with a more distanced viewpoint, and you are more likely to pick up on areas that need attention. Fortunately for the artist, his client was an exemplary employer in this regard, and he worked hard to make sure the client's patience was rewarded.

*Created for the card game Magic: the Gathering, this image needed to represent death, decay, and abandonment, but also rebirth and growth.*

## ROB ALEXANDER
# ESTABLISHING DEPTH

The concepts were soft lighting and a dark palette, with overhead lights picking out details from the dark background. Setting the stage with a dark palette and soft lighting would allow the sharper foreground details to stand out clearly where the stronger lights hit them, so the question became "What is the light landing on, and where are those things located?" Since the city depicted in the game is a massive, sprawling entity that covers the whole planet, it seemed appropriate to set this image in a dark, forgotten corner of the world. Gothic influences in the design of the room would allow for a massive, soaring chamber with a cavernous, echoingly empty feel, and beams of light piercing the darkness could be used to pick out details where they were needed.

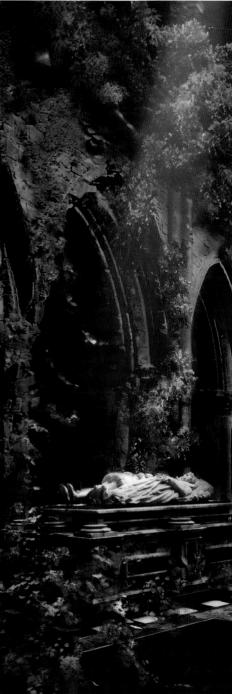

**1. INITIAL SKETCH WITH PERSPECTIVE LINES**
From the outset, the complicated composition, sense of space, depth and scale, and the number of different elements meant keeping perspective and proportion in mind. The simple radiating lines of one-point perspective were drawn, providing the framework within which to begin designing the room. This allowed the ideas and shapes to be explored quickly and loosely without losing the sense of cohesiveness and symmetry in the design.

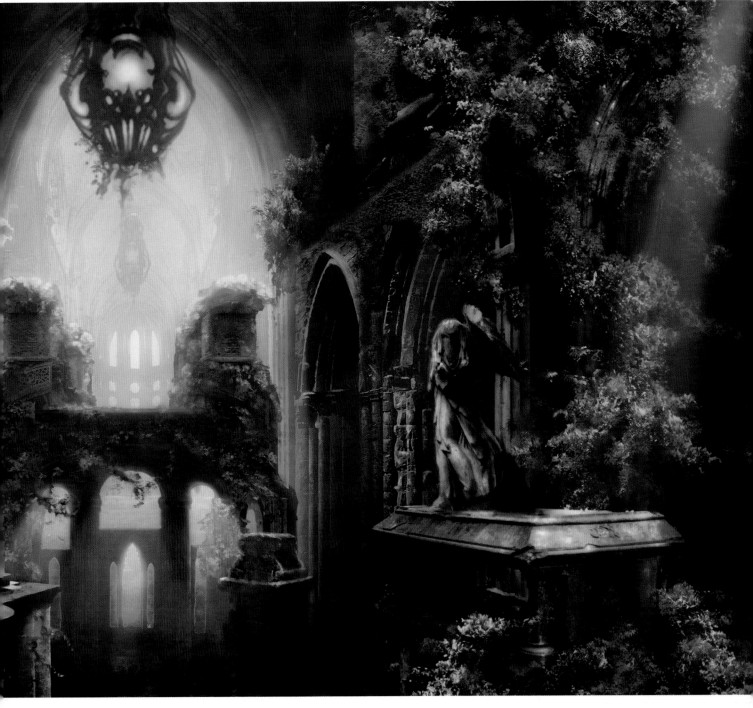

## FINAL PIECE: CITY OF THE DEAD

The soft, warm light generates the mood and provides a sense of atmosphere, life, and growth, exaggerating the scale and depth of the underground chamber, while the dark overall tone of the image helps establish the drama, mystery, and a feeling of abandonment and decay. Note how the shadow shapes are massed and simplified, but in a mid value, rather than a dark one, especially as they recede. It is not necessary for massed shapes and shadows to be extremely dark, just unified. Some elements in the picture are in one-point perspective, and some are in two–point—as long as they all vanish to the same horizon line, they can be mixed without destroying the visual integrity of the image. Compare the values in the final image with those of the tonal study. The image has gotten lighter as it was worked on, in order to generate the soft light and sense of atmosphere necessary and create a stronger sense of scale to the room itself.

### 2. FINAL LINE DRAWING

The initial drawing was enlarged considerably and mounted onto a drawing board with a sheet of mylar or tracing paper placed over it. The final drawing was then worked out, using all the perspective lines and reference points of the original sketch (see page 118). The drawing was fairly large, about 12 x 18 in, in order to allow the details to be drawn accurately. The horizon line still shows clearly in the drawing, along with several other construction lines. Shadows are conceived as large, simple shapes, and they provide both the foundation on which to build the lights as well as the anchors to clearly establish the three crypts in space.

### 3. VALUE STUDY

As the line drawing was being worked out, shadow shapes were established over part of the composition, but more as structural shapes than true value studies. In order to fully work out the values, it was necessary to first establish the full composition, and then add in the values across the entire image. The details of the drawing have not been preserved, only the large shapes, in order to simplify both the light and dark values into large masses.

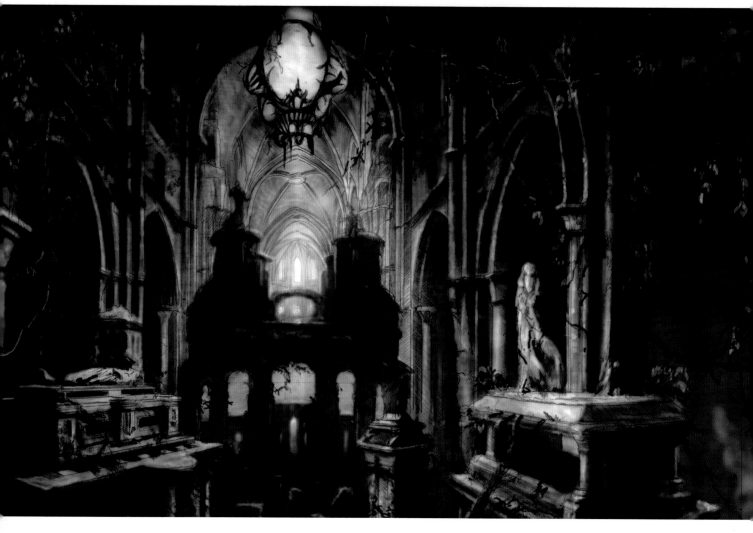

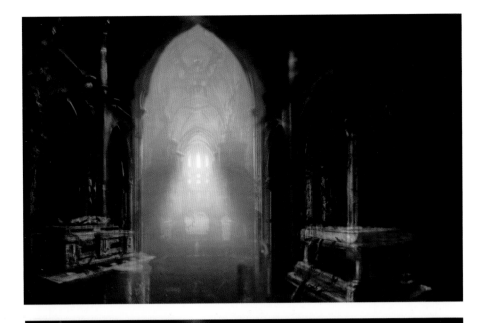

### 4. STARTING TO PAINT

The largest shapes and values are laid in first, establishing the darkest and lightest points of the image, so that there is a range to work within. The number of values is kept to three, and there is no real attempt to paint any details at this point. The paint layers are kept thin and relatively flat, with little blending or mixing to create middle values and transitions. The darkest values are kept transparent, and painted darker than they will be in the final image, since the soft lighting will create exaggerated atmospheric effects and be painted over the top of the shadows, especially in the middle distance. Although they do not show in the reproduction, the construction lines are still visible through the paint, allowing for easy correction of shapes as the image progresses.

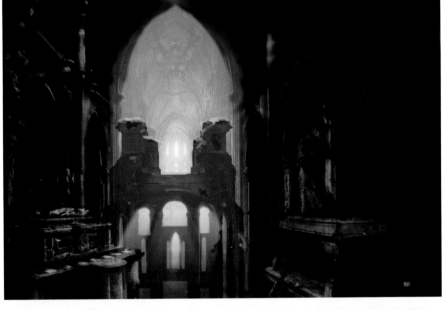

### 5. COLORING BASIC SHAPES

The central altar is painted, again with fairly flat color at first and no attempt to capture details, only the shapes and values, and provide a framework for the light and atmosphere behind and around it. It is painted in the same color range as the space behind it, cooler and muted compared to the foreground, to help it recede in space. Local colors are now introduced in the crypts, and the shapes refined, using the initial layers of paint as a guide for the values. The focus at this point is on creating the sense of three dimensionality in the room and establishing depth and scale.

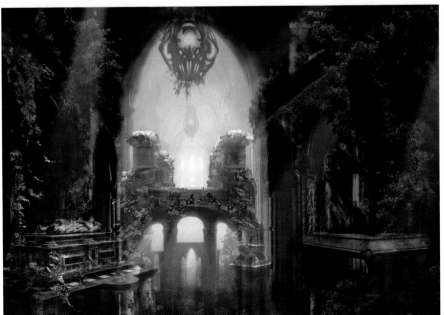

### 6. BUILDING UP THE LAYERS

With all the basic shapes and values clearly established, details and local colors can finally be added, and the soft lighting and atmospheric effects. By continually referring to both the value study and the underpainting, the value relationships can be preserved as the details are added. The walls of the arches end at a point behind the altar, so the values are lightened in their shadows to match that of the altar, before the softening effects of the light are added, and the smallest crypt is roughed in. The center of the image is lightened and opened up, a departure from the value study that creates a stronger sense of scale and distance within the image. Vegetation is added once the structures of the foreground have been firmly established, balancing the colors and the warm cool relationships to increase the sense of depth and space. This process will continue, building layer upon layer as the painting progresses, constantly striving to preserve the value relationships, the central concepts of dark palette and soft lighting, with the final brightest area of the reclining figures being added at the very end.

*Tom Kidd was commissioned to create a book jacket for an anthology of stories. The final painting needed to reflect the overall feeling of the book.*

## TOM KIDD
# CREATING DRAMA

The artist decided to combine architectural and sculptural elements from the stories in a pleasing composition that would give the feeling of an ancient world of the future that is in decline. Although architecture may seem a cold and static subject it is very much a way to elicit emotion and show drama.

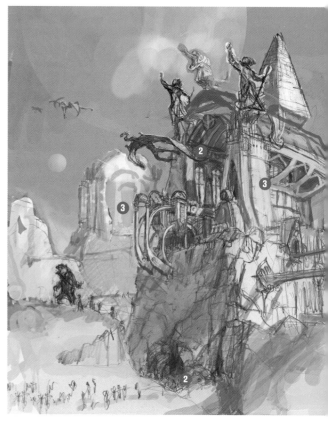

**2. BASIC SHAPES**
The artist prepared his fiberboard surface with gesso stained with a ground color, and laid down a very thin layer of linseed oil. This would make the applied paint more fluid, enabling him to make his forms more intricate by wiping away. Using a large, flat bristle brush to apply umbers (raw and burnt), he then laid down his basic shapes.

While the paint was still wet he started adding opaque colors (burnt sienna, titanium white, and gold ocher) to represent the lit and shadow areas of the subject. The artist wanted to show how time and weather, in particular, rain, change a building. While the paint was still wet, he dunked a brush in turpentine and spattered it on the painting. The turpentine caused the paint to separate, forming little veins and striations as it ran down the painting. He then left the painting to dry.

**1. IDEAS**
The initial concept was mood driven, combining classical architecture and mystery in the ruins to create drama. The thumbnail sketch (top) captured the feeling of decline, but the lack of clear structures meant there was no mood established. The tonal sketch (above) strengthened and simplified the building structures, creating clear light and dark shapes that generated the desired drama.

① Diagonal lines cut across the thumbnail sketch, fragmenting the shapes of the city and leading the eye off the page.

② The large, dark opening unifies the city and cliff, provides a foundation for the lights, and sets the stage for the center of interest.

③ The large light shapes add necessary structure to the city, and frame the darks between them.

## 3. TEXTURE

The key here was to make the structure feel more solid and give it form while keeping the drippy texture where needed. Applying the paint thinly with sable bright brushes is a good way to achieve this. Always start this process with large brushes and work down to smaller ones. At this point the artist added a few lines as guides for perspective that, until now, he was guessing at. He used a number of techniques, often on top of one another, to avoid losing textural character as he painted: dragging the brush across the surface to leave bits of paint; scumbling; pressing anything with a texture into the paint to lift off or add paint; rolling the brush on its edge; and using a malformed brush that applied paint unevenly.

The building structures are still rough, but their basic shapes and values have been clearly established as light and dark planes, creating the desired mood and sense of mystery. The giant sculptures are now resolved to the same degree, capturing their gesture in broad planes and simplified shapes. Details will be worked out as the painting progresses, guided by the mood and letting the paint lead the way.

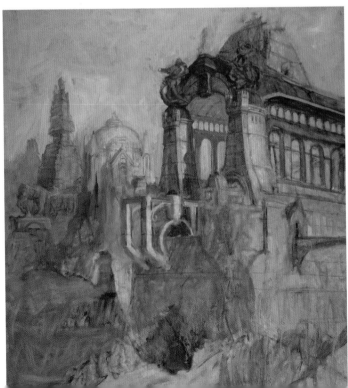

## 4. DEFINING AND REFINING

Once the painting had been completed to the extent of defining its masses, the artist could pay greater attention to any areas that he was not sure of or that he thought might guide the rest of the painting. Touches of viridian were glazed in areas to add color. The thinly applied green worked well to simulate an aged copper roof because its translucency allowed some of the underpainting to show through. The inside of the structure, because it is largely composed of bounced light off a warm surface, is shifted toward orange more than the outside of the structure.

## 5. PLANNING DETAILS

The artist felt that another sculpture was needed. Testing out ideas with a few quick thumbnails will give you confidence, enabling you to paint the details in directly. Note how these sculptures are facing the wrong way. They were planned for another painting but didn't fit in. Flipped, they are ideal in this one. To draw in the central sculpture, the artist thinned down a neutral color with linseed oil. This way it is easy to wipe away any mistakes with a rag. Once the form is there you can add details to it. It's always best to think ahead about what you'll paint next. Some areas can be painted easily in one take but others are best laid in and then painted over again when the paint dries.

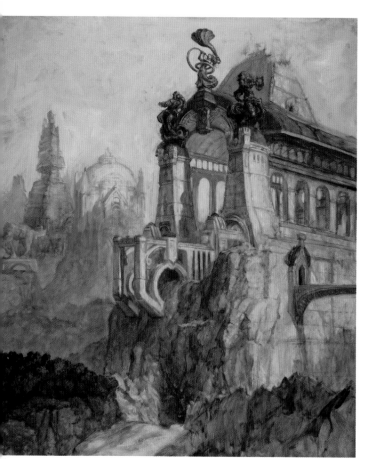

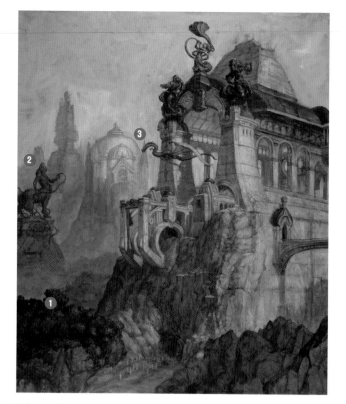

## 6. INSIDE AND OUT

You see a bit of both the inside and the outside of this foreground structure, so the artist had to picture both in his head, even if all the details would not be seen. Typically it makes sense to paint all of the interior first and then the exterior, which here is mostly a continuation of a repeating design; only the back wall had to be newly conceived.

Because the large windows let in so much light, the interior is aglow with warmth. Most of that light is reflected off the marble floor, which can't be seen at all. Your ability to imagine a scene logically will give your picture verisimilitude. It is quite hard to imagine a solid structure, so if you find something is physically impossible, just make a few adjustments, add an overlap or two, and it's all fixed. Here the artist has flipped the sculpture in the background to keep the eye from running off the picture. He has also added a rounded dormer over a balcony to break the straight line of the roof. To make the shadows uniform and create a nice color shift from the lit area toward a cooler color, the artist painted a light semiopaque glaze into the shadows using transparent white, manganese blue, and ultramarine blue (the blues are transparent colors while the white, despite its name, is semiopaque).

## 7. LITTLE DETAILS

With the larger areas painted, the artist then added the small, complicated elements, such as more detail in the trees and structures, and tiny people to give the scene greater scale. The background was pushed back with manganese blue and flake white. An intermediary layer was added between the foreground trees and the background so there isn't a sudden falloff to the background.

① These areas have been darkened, simplified, and merged into more of a single mass, enhancing the mood.

② The dark sculpture of the centaur breaks up the midground, balances the weight of the city, and directs the eye toward the center of interest.

③ The addition of the dragon focuses our attention and creates movement.

## ▷ 8. THE FINAL PIECE: OUR FUTURE'S PAST

It might seem odd to save the sky for last but the advantage here is that the artist could use the sky to cut into all the objects, giving them carefully controlled edges. Notice how the sky is duller toward its bottom. This is to give the picture a dusty, dirty feeling. You'll see this often in polluted areas of the country, but polluted or not, the sky is never a perfect blue. Once the sky was in, it became apparent that the background needed to be even bluer. The artist used a No. 1 sable round brush to paint the final, tiniest touches, such as the details of the crowd of naked people. Because this painting was for a book cover, it needed a bit more space at the top for type. However, it was easy for the artist to add this in digitally, using a rubber stamp tool available in Photoshop.

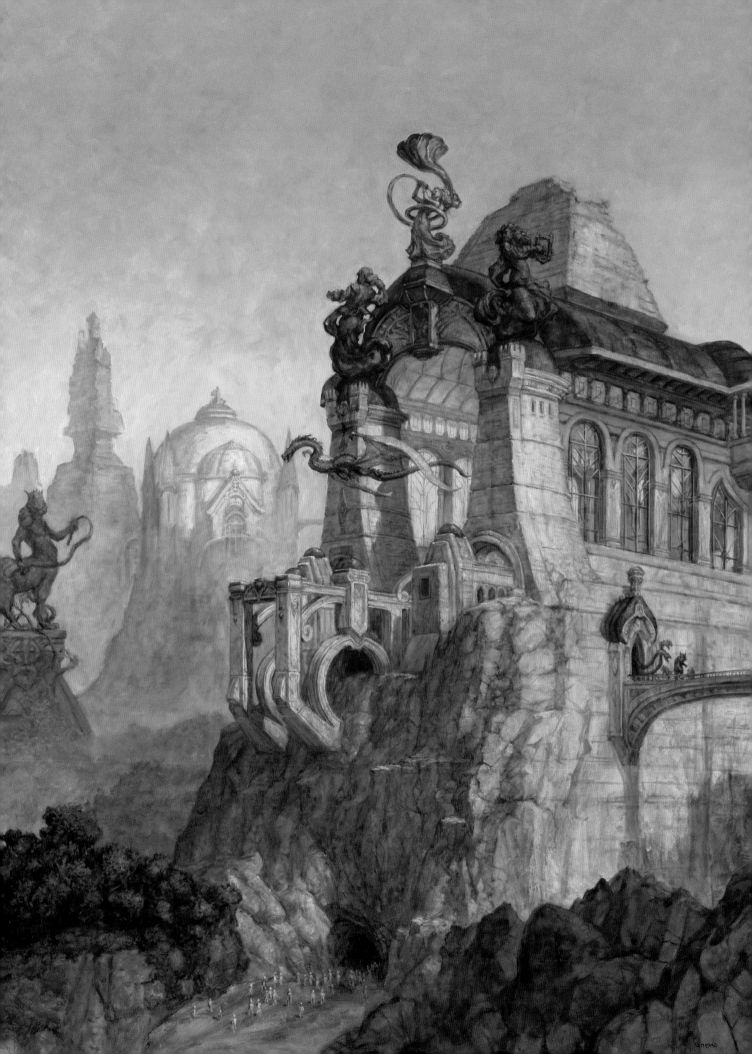

# INDEX

# ACKNOWLEDGEMENTS

Quarto would like to thank the following for kindly supplying illustrations for inclusion in this book:

**Jon Hodgson**  www.jonhodgson.com
**Jamie Jasso**  www.jjassodigitalworks.com
**Don Maitz**  www.paravia.com/DonMaitz
**Lorenz Hideyoshi Ruwwe**  www.hideyoshi-ruwwe.net
**Anthony Waters**  www.thinktankstudios.com
**Paul Bourne**  paul@contestedground.co.uk
**Franco Bambilla**  http://francobrambilla.com
**Stephen Hickman**  www.stephenhickman.com
**Tom Kidd**  http://spellcaster.com/tomkidd

These images by Rob Alexander are used with the permission of Wizards of the Coast LLC and are © **2011 Wizards of the Coast LLC (www.wizards.com)**:

**Magic: The Gathering**
Stomping Grounds 17b, Watery Grave 18b, Hallowed Fountain 20–21, Godless Shrine 22, Overgrown Tomb 23b, Temple Garden 28–29, Oboro, Palace in the Clouds 44–45, Wall of Stone 55t, Flagstones of Trokair 56t, Great Furnace 72l, Mountain 72r
**Dungeons & Dragons**
Mithrendain 2r, Hestavar 11t, Lost Mines of Karak 17t, Ziggurat 31, Giant Arch 60t, c, Endless Maze 73t

This image by Anthony Waters is used with with the permission of Wizards of the Coast LLC and is © **2011 Wizards of the Coast LLC (www.wizards.com)**:

**Magic: The Gathering**
Plains 106–109

Wizards of the Coast, Magic: The Gathering and Dungeons & Dragons are trademarks of Wizards of the Coast LLC.

Names appear alongside work. All uncredited art is by Rob Alexander, except for the image on page 1, which is by Jaime Jasso.

**Alamy**  36cl, 37tr, cr, bl

t = top, b = bottom, l = left, r = right, c = center

All step-by-step and other images are the copyright of Quarto Publishing plc. While every effort has been made to credit contributors, Quarto would like to apologize should there have been any omissions or errors—and would be pleased to make the appropriate correction for future editions of the book.